DATE DUE

NO 6'99		
JY 19'00		
OC 18'00		
My		

DEMCO 38-296

Caves of the Thousand Buddhas
Chinese art from the Silk Route

Sir Marc Aurel Stein (1862–1942)

R

Caves of the Thousand Buddhas

Chinese art from the Silk Route

Roderick Whitfield and Anne Farrer

Edited by Anne Farrer

With contributions by S. J. Vainker
and Jessica Rawson

George Braziller, Inc.
New York

Riverside Community College
Library
4800 Magnolia Avenue
Riverside, CA 92506

N 8193 .C6 W48 1990

Whitfield, Roderick.

Caves of the thousand
 Buddhas

First published in the United States in 1990 by
George Braziller, Inc., New York

© 1990 The Trustees of the British Museum

All rights reserved

First edition

For information address the publisher:

George Braziller, Inc.
60 Madison Avenue
New York, New York 10010

Library of Congress Catalogue Card Number:
89–82042

ISBN 0–8076–1249–9

Designed by James Shurmer

Phototypeset in Apollo by Southern Positives
and Negatives (SPAN), Lingfield, Surrey

Printed in Italy

**The Trustees of the British Museum
acknowledge with gratitude the generosity
of Beji Sasaki for the grant which made
possible the publication of this book.**

Contents

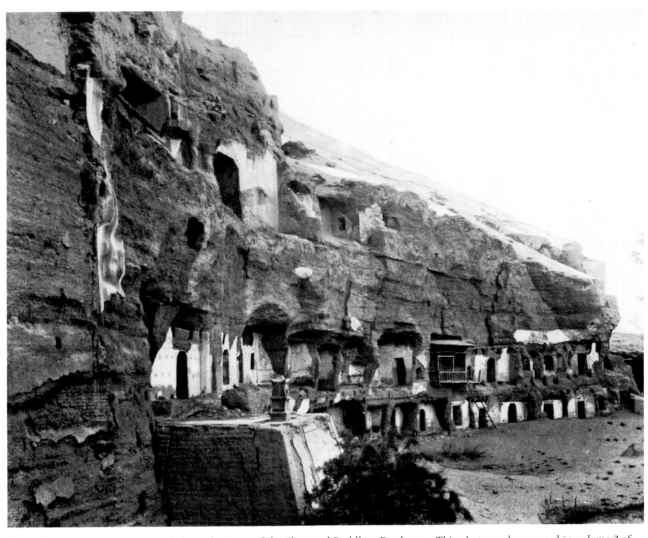

Rows of small cave-shrines at Qianfodong, the Caves of the Thousand Buddhas, Dunhuang. This photograph appeared in volume 2 of Sir Marc Aurel Stein's *Serindia* (fig. 199), published in 1921

Preface

This catalogue of objects from the great Stein collection of Central Asian antiquities at the British Museum has two main purposes. In the first place it is designed to accompany the exhibition 'Caves of the Thousand Buddhas', which is to inaugurate the newly refurbished exhibition gallery of the Department of Oriental Antiquities in spring 1990. It is particularly fitting that this should be the first event to take place in the new gallery, since the last catalogued exhibition of the Stein collection took place in 1914 when the new King Edward VII galleries were opened.

We also hope that this catalogue will continue to be of value once the exhibition is over. It contains colour illustrations of most major works of art in the Stein collection, together with full references to scholarly studies and useful finding lists. Scholars who require the fullest coverage of the Stein collection will still wish to make use of Stein's own reports and Professor Whitfield's massive compilation *The Art of Central Asia*, but we hope that the present work will fill the needs of most students of art history at an affordable price. The fact that it is possible to produce a moderately priced catalogue with so many colour illustrations is wholly due to the generosity of Mr Beji Sasaki, who has contributed a substantial grant towards the production costs.

The entries in this catalogue fall into three groups. The most important of these is the group of paintings on textiles and paper recovered from Cave 17 at Dunhuang. Next there follow the non-painting textile items from Cave 17. The last group contains a wide variety of archaeological finds from Stein's Central Asian expeditions, including one major wall painting.

For the first group of objects, the great majority of catalogue entries are based on Professor Whitfield's three-volume work (here referred to as ACA). His entries obviously required considerable abbreviation to keep within the space available, and it was often necessary to restructure them or add further material to make the content more accessible to the general reader. In this process reference has been made to Stein's original works and to the important study of Dunhuang paintings by Arthur Waley, published in 1931. Entries for the textile section have been written by Shelagh Vainker on the basis of Stein's excavation reports. Entries for the third group of items were written by myself, based in roughly equal measure on descriptions by Professor Whitfield and Stein's own reports. Professor Whitfield has read all of the catalogue entries and other textual material and in a number of cases has been able to bring the entries up to date on the basis of recent research. I am most grateful for all his help in checking and amending the text during the production of this book.

Every effort has been made to render the catalogue descriptions accessible to readers without special knowledge of the artistic and historical background. It is impossible to avoid the use of Sanskrit terms in a work such as this, but the index can be used to find an explanation in nearly every case.

Each of the three main catalogue sections is preceded by an essay which introduces the objects in their historical context. The first, on paintings and prints, is by Professor

Whitfield; the essays on textiles and archaeology are by Shelagh Vainker and Jessica Rawson respectively. In the general introduction to the catalogue, I have included a short summary of Stein's career and expeditions, followed by an account of early Chinese activity on the Central Asian frontier and a description of the Buddhist religious background of the objects from Dunhuang and elsewhere. Finally, I explain briefly the history of the cave-shrines at Dunhuang, including how the contents of Cave 17 came to light and passed in large part into Stein's possession.

As mentioned above, this book would have been impossible to produce in its present form without the generosity of Mr Beji Sasaki. Gratitude is also due to Miss Natsuo Miyashita, who originally proposed to Mr Sasaki that he consider supporting this project and who was unfailingly helpful during subsequent discussions.

In addition, of course, to the contributors, many people deserve warm thanks for their efforts in the production of this book. For the high standard of photographic illustration, prime credit must go to David Gowers and Paul Gardner of the British Museum's Photographic Department. Other ektachromes were generously lent by Kodansha Publications, publishers of Professor Whitfield's catalogue. Ann Searight produced clear maps on the basis of material which was not easy to interpret, and Jim Thorn helped put together the list of exhibits in Japanese. Within the Department of Oriental Antiquities, Shelagh Vainker and Jane Portal gave a great deal of much-appreciated support on many aspects of the production of this catalogue, the former in addition to her work as contributor. Claire Randell was unfailingly helpful in ensuring that the right number of copies of the latest version of the text reached the right people at the right time.

At British Museum Publications, Celia Clear gave her decisive support to the project for a major catalogue for the Dunhuang material. Any work of this kind places great burdens upon its editor, and all contributors have cause to be exceedingly grateful to Nina Shandloff for her efficiency and hard work, in addition to her calmness in weathering all the storms on the way to final publication. Rachel Rogers was most helpful during the early stages of the text production. James Shurmer created the clear and attractive design, and the demanding task of ensuring that the photography resulted in a worthy printed image has been handled by Julie Young. Finally, I would like to thank my husband and two young sons for their endless tolerance of a wife and mother whose evenings and nights were so frequently taken up with tasks associated with this catalogue, even spanning the period during which one of them was born.

Anne Farrer, *October 1989*

Introduction to the catalogue

The paintings, prints, textiles and other objects shown in this exhibition have been selected from the collection of antiquities from Dunhuang and other Central Asian sites held in the Department of Oriental Antiquities at the British Museum. The majority of this collection consists of the finds made by the British archaeologist Sir Marc Aurel Stein (1862–1942) during his three expeditions to Chinese Central Asia.

Stein was born in Budapest. He studied at the universities of Vienna, Leipzig and Tübingen and later at the universities of Oxford and London. In 1888 he was appointed principal of the Oriental College of Lahore in India and over the next ten years he began to form his plans for archaeological exploration of the regions between India and China. Although he knew no Chinese, he was a recognised expert in Sanskrit and Buddhist antiquities.

His first major Central Asian expedition (1900–01), undertaken with the support of the Government of British India, took him to the region of Khotan on the southern Silk Route. His two-volume report, *Ancient Khotan*, was published in 1907. The Indian Government and the British Museum jointly funded his second expedition (1906–09) which enabled him to verify the Chinese historical accounts of Gao Xianzhi's great military expedition across the Pamirs in AD 847. He revisited Khotan and went on to cross the dry salt lake of Lop Nor, reaching Loulan and eventually Dunhuang a year ahead of a French expedition led by the French archaeologist Paul Pelliot (1878–1945). *Serindia* eventually appeared in five volumes in 1921. A third expedition, undertaken in 1913–16, took him once more through the Pamirs, south of the Taklamakan Desert and eastwards as far as Suzhou and Karakhoto. Stein's report of this last expedition was published in 1928 in four volumes entitled *Innermost Asia*.

The antiquities gathered by Stein on his Central Asian expeditions were divided between the British Museum and the Museum of Central Asian Antiquities in New Delhi, India; those of Pelliot are kept in the Musée Guimet and the Bibliothèque Nationale, Paris. Materials collected by the Japanese Otani expedition are housed in the Tokyo National Museum, the National Museum of Korea and at Lüshun in China; a smaller amount, taken to Leningrad by Oldenbourg, is now in the State Hermitage. The documents that still remained in Cave 17 at Dunhuang were transferred to China's Beijing National Library, and more recent finds have been kept in the Dunhuang Research Academy.

Central Asia

The region sometimes called Chinese Central Asia is bounded on the east by the Gobi and Lop deserts and on the south by the Nanshan and Kunlun mountain ranges. To the west lies the Taklamakan Desert with the Karakorum, Pamir and Tianshan mountain ranges to the west and north. This area is today known as the Xinjiang Autonomous Region of the People's Republic of China, but has been known in the past by several other names including Chinese Tartary, Chinese Turkestan, Eastern Turkestan and Serindia. It is

crossed by a number of routes which, since the early years of the Han dynasty (206 BC–AD 220), have served as trading links between China and the cultures to the west. The oasis cities along these routes were very ancient. Early accounts suggest that some were founded by peoples from the Indian sub-continent, and it was these peoples and their descendants who introduced Buddhism to the area and left the great monuments that Stein explored. The cities expanded and flourished as pilgrims and traders travelled across Central Asia in the early centuries AD.

Beginning at Chang'an (present-day Xi'an), which was for long periods the Chinese capital, the route west passed along the Gansu corridor, dividing near Dunhuang into a northern route skirting the Tianshan mountain range and a southern route running along the edge of the Kunlun range. The northern route passed through Hami, Turfan, Kucha, Aksu and Kashgar. The southern route passed through Mirān, Khotan and Yarkand with a subsidiary route looping across the Lop Desert and passing through Loulan to join the northern route west of Turfan. These great connecting routes used for both trade and pilgrimage have come to be known collectively as the 'Silk Route'.

As early as the Western Han dynasty, Emperor Wu (reigned 140–87 BC) established military colonies in the Tarim Basin west of Dunhuang and protected them by an extension of the Great Wall; Chinese documents discovered by Stein describe the organisation and provisioning of these distant posts. Large armies were sent across the Pamirs to Sogdiana and Ferghana, taking Chinese arms as far as the shores of the Caspian Sea. But by the beginning of the later Han (AD 25–220) the Chinese had lost control of the area, and their rule was not re-established until the late 1st century AD. Dunhuang was established as a commandery in 111 BC. A line of military watch-towers built to the north and west of Dunhuang during the Han period was discovered by Stein in 1907, when they still stood between 6 and 10m high.

Towards the end of the 2nd century AD, the Han empire began to collapse under internal political strains and contact with Central Asia was lost. For several hundred years the area was subject to successive waves of invasions: by the Tuyuhun in about 445 AD; the Ruanruan (c.470); the Hephthalites (c.502–56); and the Western Turks (565–631). However, with the reunification of China under the Sui (589–618) and then in the early years of the Tang dynasty (618–906), the Chinese reasserted their authority. By 661 Kashmir, Bokhara and the borders of eastern Iran were administered by Chinese officials, and garrisons were established at Karashar, Kucha, Khotan and Kashgar. But the tide was turning again, and in 751 Chinese armies were defeated by an Arab force at the Talas River. After the chaos of the An Lushan rebellion (755–63) the empire lacked the strength to maintain its westerly possessions; the Tibetans even took the Chinese capital Chang'an in 763. Dunhuang itself passed into Tibetan control from 781 to 847. This meant that the Buddhist shrines there were largely untouched by the great suppression of Buddhism and other foreign religions that wrought such destruction in China between 842 and 845.

Buddhism

Buddhism originated as an Indian religion, and even during the periods of its greatest success in China the stigma of a foreign cult was never fully erased. Early Buddhism offered a response to the particular situation of ancient India where, by the 6th century BC, religion had become increasingly preoccupied with the terrible spectacle of an unceasing

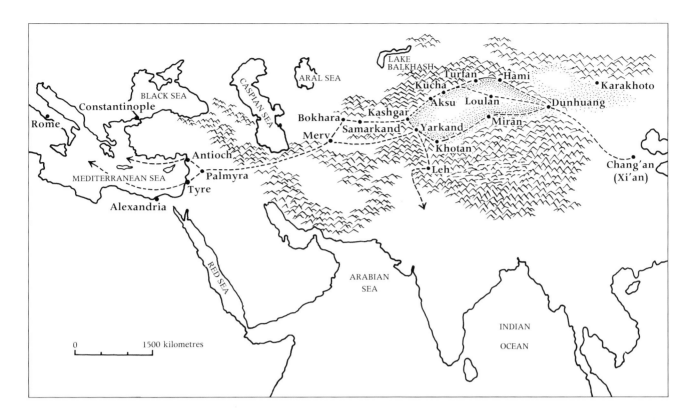

Map showing the northern and southern paths of the Silk Route linking China and the West

round of death and rebirth, driven by the cause-and-effect laws of *karma*. Each new incarnation accumulated a fresh weight of *karma* to be worked out in subsequent existences. Gautama Siddhārtha (*c*.563–*c*.483 BC), a descendant of one of the royal clans of northern India, sought a means of escape from the wheel of rebirth, suffering and death. It is from his claim to have achieved enlightenment, *bodhi*, that he became known as the Buddha or Enlightened One. The core of his teaching was laid down in the Four Noble Truths: the existence of suffering; desire as the cause of suffering; the cessation of suffering; and the eightfold path of self-discipline, through which release from the wheel of rebirth constituted the state of *nirvāṇa*.

The early history of Buddhism is somewhat vague. The Saṃgha or monastic community founded by the Buddha held a number of councils in the first centuries after his death to discuss difficult points of doctrine and discipline. By the time of the fourth of these councils, in the 1st century AD, a powerful school had arisen. The majority group designated itself as the Mahāyāna or 'Great Vehicle (of salvation)', dismissing its opponents as the Hīnayāna or 'Lesser Vehicle'. While Hīnayāna Buddhism has survived in Sri Lanka and Southeast Asia, it was the Mahāyāna doctrine which came to dominate East Asia and is represented in the material from Dunhuang. From a northern European religious perspective, the Hīnayāna doctrine seems more familiar and accessible. The emphasis on salvation brought by a single historical Buddha and the demand for individual effort in the search for *nirvāṇa* bear a superficial resemblance to Christian religious teachings. The Mahāyāna doctrine includes so many elements from its Hindu religious background that it appears more luxuriantly Asian and alien to outsiders. According to the Mahāyāna, Gautama Siddhārtha was only one of many Buddhas existing in both the past and the future; in addition, other powerful beings were active in helping

humanity to attain salvation. These are the Bodhisattvas, who had attained enlightenment but held themselves back from *nirvāṇa* and Buddhahood out of pity for the sufferings of all sentient beings. The ordinary believer's hope was not so much to attain *nirvāṇa* through self-cultivation as to achieve rebirth in one of the paradises centred around a particular Buddha or Bodhisattva. Several such paradises with their divine inhabitants are depicted in great detail in the Dunhuang paintings. Rebirth in a paradise could be attained by simply invoking, with a full faith, the name of the being concerned. A more concrete way of seeking a divinity's favour was to commission a painting in which the devotee appeared in the act of paying homage to the figure whose aid was sought, and many examples of this are to be seen in the present exhibition.

Buddhism did not reach China as the result of a centrally directed missionary effort such as that of the 16th-century Jesuits who brought Catholicism to China. The new religion took root gradually, through initiatives by a number of independent groups of travelling monks and their converts. It is therefore not easy to say when Buddhism actually arrived in China. The first definite evidence for the existence of a community of Buddhist monks comes from an area in what is now Jiangsu and Shandong provinces in AD 65. By the 2nd century AD there was a flourishing Buddhist community in the capital Luoyang, and the great enterprise had begun of translating scriptures from Indian languages into Chinese.

In AD 220 China entered a long period of division between north and south. Buddhism flourished among the aristocracy of the sophisticated but politically weak kingdoms of the south, where semi-independent monastic establishments paralleled the great estates of the nobility. In the north, the still only partly sinicised rulers of the nomad-dominated empires readily adopted the new religion as their state cult. Buddhist rulers of the Northern Wei (AD 386–535) eagerly took on the role of Cakravartin kings, 'protectors of the Law', and great cave-temple sites such as those at Yungang in northern Shanxi and Longmen in northern Henan province testified to the state resources devoted to the new cult. After the reunification of the empire by the Sui in AD 581, succeeded by the Tang in 618, Buddhism continued to flourish in its new territory. Its role as a state church sharply differentiates this period from that of the earlier Chinese empire. In fact, so great did the influence and economic power of Buddhism become that it was felt to be a threat to the structure and function of the state, and in AD 842–5 a severe proscription of foreign religions led to the seizure of Buddhist property and the forcible secularisation of many monks and nuns. The government's readiness to take this action may have been a sign of the decline of Buddhism rather than its cause, but it is certainly true that after this time Buddhism was never again a major force in Chinese society and culture.

The Caves of the Thousand Buddhas (Qianfodong)

To the south-east of the main oasis of Dunhuang, at the foot of a barren dune-covered hill chain, lies the valley of the Thousand Buddhas. It gained its name from the legend of a monk who dreamt he saw a cloud with a thousand Buddhas floating above one side of the valley. From the 4th century AD until the Yuan dynasty (1279–1368) this valley was a centre for Buddhist pilgrims, and many cave-shrines were carved from the gravel conglomerate of the escarpment. From the time of the Northern Liang in the early 5th century the caves were decorated with wall paintings, and by the Tang dynasty (618–906) more than a thousand caves had been completed. The conglomerate which made up the

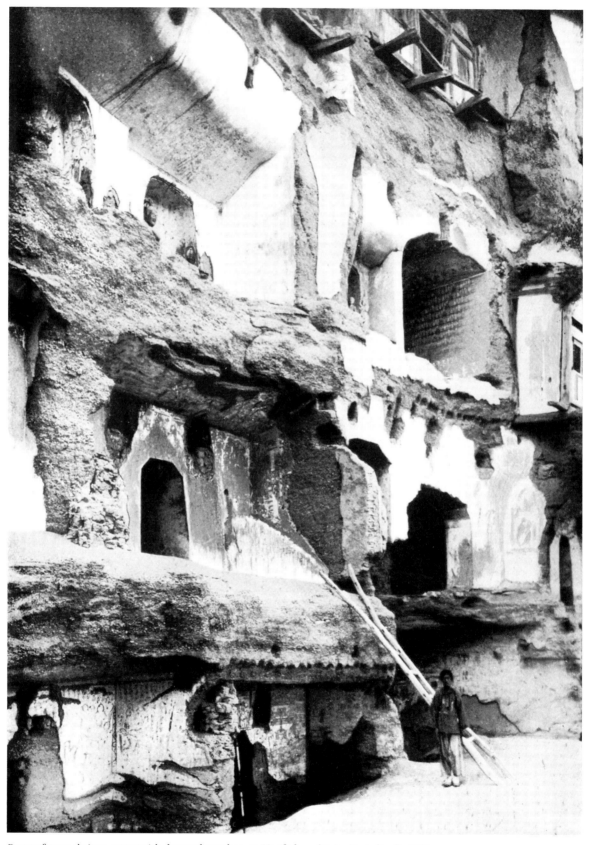

Rows of cave-shrines, some with decayed porches, at Qianfodong (Stein, *Serindia*, fig. 197)

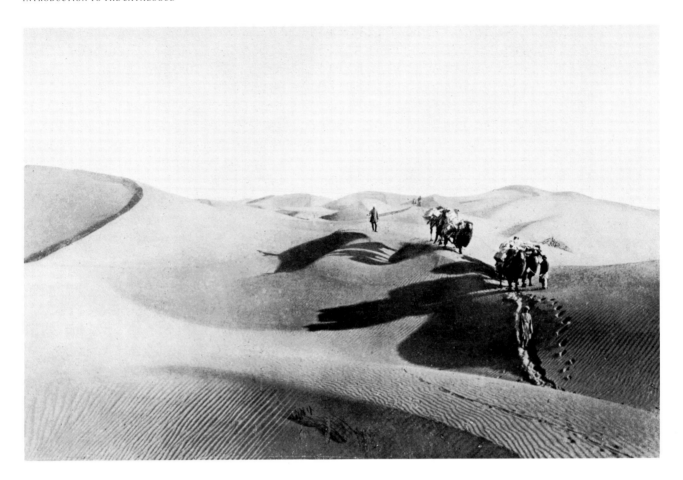

cliff, unlike the stone of the late 5th- and early 6th-century Buddhist cave-temples at Yungang and Longmen, was not suitable for sculpture; what sculpture there is is made of clay moulded over a wooden armature.

One of the last great secular patrons of the Dunhuang cave-shrines in their final period of prosperity during the Tang dynasty was Zhang Yichao, a local magnate instrumental in returning the area to Chinese influence after the expulsion of the Tibetans in the mid-9th century. He seems to have worked closely with the monk Hong Bian, the principal Buddhist dignitary west of the Yellow River. A tablet has been found recording the imperial grant to Hong Bian of the right to wear purple in commemoration of the return of Dunhuang to Chinese control. After his death about 862, a memorial chapel was dedicated in his honour. It contained a stone statue of Hong Bian seated in meditation on a low platform; behind him are painted two attendant figures beneath leafy trees on which hang a leather pilgrim's bag and water-bottle.

About a century and a half later, sometime in the early 11th century, the statue of Hong Bian was removed from the chapel and placed higher up the cliff face. The cave was filled almost completely with a carefully packed deposit of many thousands of manuscript scrolls and hundreds of paintings, together with textiles and other objects. The entrance to the cave was then plastered over; the presence of wall paintings on this plastered surface seems to indicate that the intention was to seal the deposit permanently. It has been suggested that the objects sealed in the cave were put there to protect them from invaders such as the Tanguts, who established the Xixia Kingdom in north-west China in 1038.

Stein's caravan marching over high sand dunes in the Taklamakan Desert, south of the Tarim River (Stein, *Ruins of Desert Cathay*, fig. 281)

However, the painstaking and evidently unhurried way that the packing and sealing were carried out does not fit well with this hypothesis. Judging from the contents of the cave, it seems more likely that it represents a reverent disposal of sacred material no longer required for use or which had simply worn out.

Through succeeding centuries the Dunhuang cave-shrines remained a focus for local devotion, although the days of the great pilgrimages were gone forever. In about 1900, a mendicant Daoist priest named Wang Yuanlu came to Dunhuang from Shanxi province. He seems to have been inspired by the story of the great 7th-century monk Xuanzang, who had started from Chang'an on his journey to India in search of scriptures. Wang saw it as his mission to restore the cave-shrines and to encourage worshippers to come there. The charitable donations he collected paid for labourers to clear sand and other débris from some of the caves, and eventually he was able to erect new images, retouch some frescoes and have new ones painted. These included one telling the legend of Xuanzang's journey to India and back as retold in the 16th-century novel *Xiyuji* (translated under the titles *The Journey to the West* or *Monkey*). During the course of clearance, a workman noticed a crack in a wall of Cave 16 which revealed the presence of the sealed library chamber, Cave 17. Wang removed a few scrolls; news of the discovery was reported to the provincial government in Lanzhou, and the viceroy of Gansu instructed Wang to restore the whole of the find to its original place of deposit.

In 1907 Aurel Stein arrived at Dunhuang as part of his exploration of the Silk Route east of Loulan. He already knew of the existence of the painted cave-temples and had heard rumours of the discovery of the sealed deposit, but he turned first to a survey of the ancient watch-towers, which he named the '*Limes*'. Then, eager to investigate the contents of the cave, he gradually overcame Wang's initial reluctance to let him do more than inspect a few specimens taken from the deposit. Eventually Stein was allowed to remove scrolls and other material in return for contributions towards the renovation of the temples and the improvement of lodging facilities for visiting pilgrims.

Stein was hampered in his choice of scrolls by his ignorance of the Chinese language, and his Chinese assistant Qiang Siya was unfamiliar with Buddhist texts. But Stein did manage to work out a rough method of distinguishing between sūtra manuscripts and miscellaneous documents such as letters, certificates and accounts for Buddhist sculptures. He was particularly interested in acquiring material which could reveal details of daily life, and he also assembled information about the history of the library in an effort to establish when it had been sealed. Together with other material from his second expedition, the bundles acquired by Stein at Dunhuang arrived in London at the Natural History Museum, South Kensington, in January 1909 and were transferred to the basement of the British Museum in Bloomsbury in August of that year. AF

Paintings and prints from Dunhuang

Only now, some eighty years after they first became known in the West and to scholars generally, are the paintings of Dunhuang beginning to revive after their long hibernation in the library cave and their dispersal to distant parts of the globe. Through colour photography and modern printing techniques, the paintings on silk, paper and hemp cloth presented in this exhibition and those still *in situ* on the wall surfaces of the Dunhuang caves can be seen in detail, enjoyed and understood.

Thanks to its new airport, reaching Dunhuang is now easy, and visiting the site itself has become a regimented exercise. Ten caves are permanently open and forty of the rest are accessible to guided groups arriving from the town some 25km away. Yet early in the morning before most of the buses have arrived, the place has a calm which prepares one for the splendour hidden in semi-darkness within the caves. Although the earliest of these have not survived, perhaps due to a collapse of part of the cliff in antiquity, those still intact date from the early 5th until the 14th century AD and present an uninterrupted sequence of styles and subject matter. Whatever the period, innumerable small images of the Buddha cover the walls and ceilings. Their harmony and the close integration between wall paintings and three-dimensional stucco images are features that strike the visitor today, as they must once have encouraged in spirit the pilgrim or traveller of ancient times about to venture along the bleak and savage desert routes. Due to the dryness of the climate and the remoteness of the site, and the fact of being left alone or even sealed away for some nine centuries, documents and paintings were preserved at Dunhuang almost unchanged since they were systematically stacked in a small chamber opening off one of the larger caves in the long cliff face at Mogaoku, popularly known as Qianfodong.

When Aurel Stein came on the contents of Cave 17, the so-called library cave, he must have known that the scale of this find and its importance for scholarship was more significant than the harvest of antiquities from any other single site along the Silk Route. Yet even Stein might be surprised to see the caves today, besieged by tourists. Dunhuang studies have long since become a field of their own, since the documents in particular throw much light on popular literature and the routines of daily life in Tang China.

The wall paintings in the caves

Documents and paintings in the caves are closely associated. There is a further close connection with the caves themselves and the wall paintings and stucco sculptures with which they are adorned. Hollowed out from the gravel conglomerate cliff bordering a stream along the edge of the Mingsha or Singing Sands (still swept melodiously by the winds today), the caves provided no stone for the carving of images. These were therefore either modelled in clay stucco on an armature of pieces of wood or bundles of tamarisk twigs, or painted on the walls and ceilings which had also been coated with clay stucco. The statues, set in niches or stood close to the walls, were decorated in polychrome, no doubt by the same painters who never hesitated to add a radiant painted mandorla edged with flame or flying *apsarasas* trailing long scarves on the wall just behind (*see p. 17*). In this way both sculpture and painting are brought vividly to life, enabling the believer to visualise the beauty of the Buddhist paradise lands and the compassionate nature of Buddhas and Bodhisattvas.

The closeness of this relationship can be shown in the small cave where the documents and paintings were discovered, which originally opened off the corridor leading into Cave 16. The function of this chamber, before its entrance was sealed and painted over with donor figures in the early 11th century AD, was to commemorate Hong Bian, chief of the monks in the mid-9th century AD in the area of Hexi, west of the Yellow River. His portrait statue, after centuries of neglect in a recess higher up the cliff face, has now been restored to the chamber and sits on a low dais opposite the entrance. Nearby is a stone stele with his biography. The portrait is of painted clay stucco, but the attendants behind it are painted on the wall in the shade of two fine trees on which hang his water-bottle and leather pilgrim's bag. The raised platform itself was once painted, although now only the figures of two kneeling deer and the sandals of the monk remain to show this. The painter Zhang Daqian was at Dunhuang around 1940 copying the wall paintings and left an inscription, still on the wall today, praising these two painted attendants above all other paintings at the site. In fact, though unique in subject matter, the paintings might now be rated less highly than many of the earlier ones, but they do provide the perfect foil

for the seated stucco portrait of Hong Bian. Such monk portraits were once no doubt common in China but are now hardly to be found except in Japan, where the most famous is the dry lacquer statue of the 8th-century AD blind Chinese monk Ganjin in the Tōshōdai-ji. Yet among the paintings stored in the cave and recovered by Stein is a drawing on paper of just such a monk, seated in calm composure with his water-bottle, rosary and bag hung on a nearby tree and his sandals set beside him (cat. no. 56). Though anonymous and slightly later in date than the portrait statue of Hong Bian, the inspiration for it must have been the same.

Other images confirm this close association of the paintings discovered in Hong Bian's memorial chapel with the cave-temples and their creators. One panel on thick paper

(cat. no. 68) is painted on both sides and clearly covered a window lattice, probably part of the wooden structures which protected the openings of the caves on the cliff face. Others are pounces or stencils which helped in the production of the countless images on the cave walls and ceilings, especially of the Thousand Buddhas which give the site its popular name. Among these the most spectacular is the large stencil made up of six sheets of thick paper, with a five-figure Buddha assembly (cat. no. 70). Such a group can be found in a central position among the ranks of smaller Buddhas on the sloping faces of the ceiling of Cave 61, dating from the late 10th century AD early in the Northern Song dynasty. Here we see one of the tools which helped in the creation of so many images not only at this date but probably throughout the entire period of artistic activity at Dunhuang.

Seated Buddha with standing Bodhisattva attendant and flying *apsaras*; Northern Wei dynasty (AD 386–535). From the north wall of Cave 259, Dunhuang (*photo* Dunhuang Research Academy)

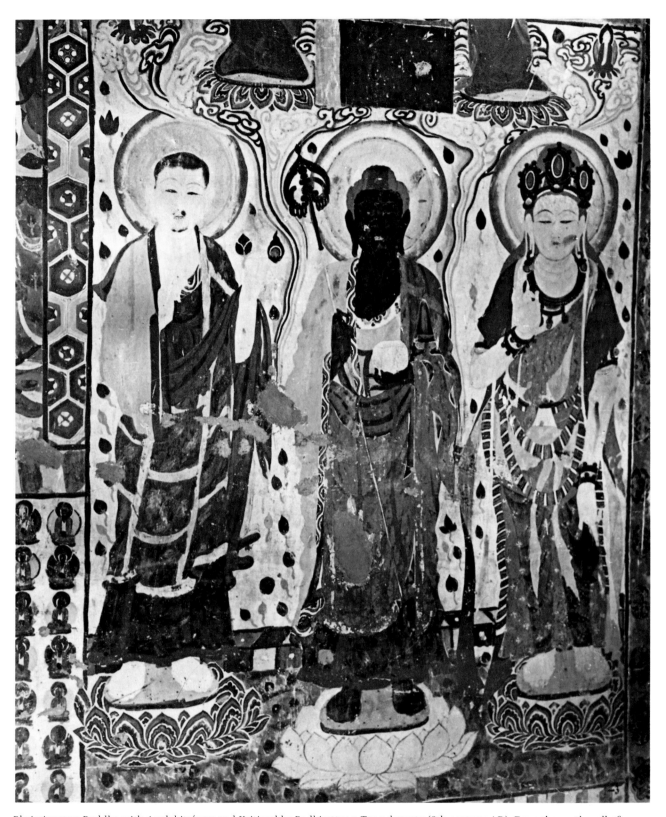

Bhaiṣajyaguru Buddha with Avalokiteśvara and Kṣitigarbha Bodhisattvas; Tang dynasty (8th century AD). From the south wall of Cave 205 (*photo* Dunhuang Research Academy)

Paintings on silk and paper

We cannot be sure exactly how these paintings were intended to be hung, but for the most part they must have been given by individuals for use in the monasteries, perhaps to be displayed when masses were said for a particular deceased relative or on the occasion of other Buddhist ceremonies. Such paintings come in different sizes according to the subject and the means of the donors. Since they were assembled by sewing together pieces of silk, with the edges protected by a sewn-on border of silk or hemp cloth, the width to which the silk was originally woven tends to govern the eventual size of the painting; these range from a single width (about 60cm) for a painting of a single Bodhisattva up to three widths for a larger group of Buddha and heavenly assembly in the Pure Land or paradise paintings. The height of the painting is generally somewhat greater than the width so that a similar proportion is kept between them.

No such restriction operated for the decoration of the cave-temple walls, yet on these too the same canon of proportion is recognisable, especially for the larger panels of Buddha accompanied by Bodhisattvas but also for the countless much smaller figures of the Thousand Buddhas which surround them. In the Sui and Tang dynasties small, medium and large panels often appear in combination, all related in size and proportion (*see p. 18*). Other spaces on the cave walls, especially the narrow ones on either side of a main niche on a rear wall, required a different treatment (*see right*). Such a figure of an attendant Bodhisattva offering flowers may be compared to the narrow banner paintings found in such numbers by Stein and Pelliot, each banner bearing a single Bodhisattva or guardian king (*see* cat. no. 39). Moreover, the narrow decorative borders around both single figures and groups, generally decorated with some variety of floral motif, can be compared to the borders that were sewn around the edges of the silk paintings. Some of the latter also have floral borders, though the majority are plain; but the painter of the wall painting could be as lavish as he liked in the decorative details, while the maker of the silk paintings was limited by the materials to hand. By the same token, the painters of both silk and wall painting could of course be equally imaginative when it came to the splendour of the actual scene depicted, especially in the Pure Land paintings and their architectural settings, as elaborate perhaps as the lost riches of the great monasteries at Dunhuang or even at the capital Chang'an.

For the donors who paid for the caves themselves, their decoration, and individual votive paintings on paper or silk for their own use, we have but to look at most of the paintings shown here, where the donors are separately shown at the bottom. Modestly garbed and demure in attitude at first, there is a tendency for them to become more prominent and more richly attired in the late Tang dynasty and after the fall of the dynasty, when Dunhuang was controlled by a few powerful families and there was infrequent contact with metropolitan China. The dedications accompanying constantly repeated images of Ava-

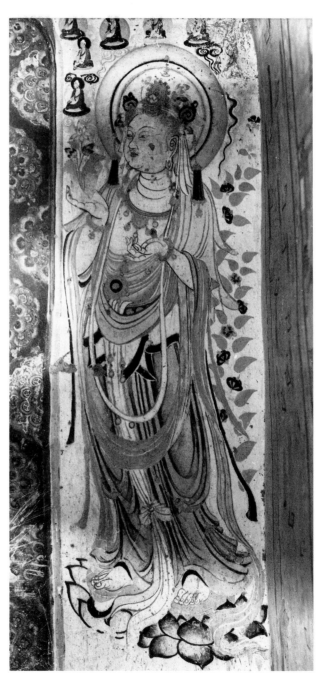

Bodhisattva offering a flower; Tang dynasty (9th century AD). From Cave 199 (*photo* Dunhuang Research Academy)

lokiteśvara and of Kṣitigarbha, the Bodhisattva Guide of Souls, also reflect an increased concern for personal well-being in the present life in the paintings of this period.

While the silk and other portable paintings and wood-block prints reflect almost the whole range of iconography to be found in contemporary wall paintings at Dunhuang, they cannot do the same over the whole period represented by the latter. The earliest cave-temples still extant date from the early 5th century AD, the latest from the Yuan dynasty in the 14th century AD. The paintings in the Stein and Pelliot collections show that the whole deposit must have been sealed away at the latest early in the 11th century AD, for the last dated paintings are from the closing decades of the 10th century AD. Nor do any of the paintings brought to London and Paris appear to date before the late 7th century AD: there are none of Sui or earlier date, if we except some isolated examples of uncertain provenance in other collections, which bear specific dates but whose style is quite different, and indeed suspect. The manuscripts, however, more numerous and more easily preserved than the paintings since the tight rolls of paper were more compact than the loose bundles of silk, include a number of examples from as early as the 5th century AD.

Distinctions of style and period

The Dunhuang paintings in the Stein collection cannot show us the earlier stylistic phases, as in the Northern Liang and Northern Wei caves of the 5th century AD, in which the bright colours and shading or highlighting, characteristic of traditions current in Central and Western Asia, mingle uncertainly with such typically Chinese forms as the gateway with watch-towers, familiar since the Han dynasty. Yet Dunhuang's remoteness from metropolitan China ensured that even during the 8th century AD, when traffic along the Silk Routes between the capital Chang'an and the West must have been at its busiest, paintings made there retain distinct characteristics of the Western tradition perhaps not found in the Buddhist paintings of the monasteries of the capital. These are shown in the orange-shaded flesh tones and schematic shading of the central Buddha in the scene of the Buddha preaching under a tree (cat. no. 1), or in the net-like web of musculature indicated by colour alone in some of the Vajrapāṇi figures (cat. no. 40). In such examples, however, these more Western light- and colour-conscious techniques are fully integrated with the linear modelling characteristic of Chinese work. This can be seen in the sensitive delineation by continuous contour lines of the shaven heads of the monks accompanying the Buddha in the

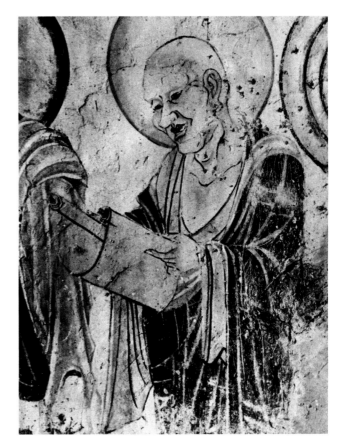

Monk chanting a sūtra; Tang dynasty (8th century AD). From Cave 201 (*Dunhuang bihua*, pl. 109)

first example, and in the short, discontinuous strokes of the second, both executed in ink and reflecting different traditions within China. Among examples in wall painting, the early Tang (8th-century AD) monk from Cave 201 (*see above*), attentively intoning from the sūtra unrolled in his hands, shows how it was possible to combine the continuous contour line with shorter ink strokes to achieve a convincing representation of an elderly and perfectly composed figure. The changing aspect of the colour modelling technique can be appreciated from the grief-stricken but restrained appearance of Buddha's disciples in a Northern Zhou rendering of the *nirvāṇa* of the Buddha (*see p. 21*), and the wild grief of some of the Indian mourners on the same occasion, depicted on an enormous scale in the 9th-century AD murals of Cave 158 (*see p. 22 top*), the latter closely paralleled in the modelling of the Vajrapāṇi and other guardian figures (cat. no. 40).

Clues to distinguishing style and period within the overwhelming numbers of Dunhuang Buddhist imagery may be found in the range of colours used and the manner in which groups of figures are disposed. During the 8th century AD, as in the previously mentioned Buddha preaching under the

tree (cat. no. 1), clear distinctions are maintained between the various classes of figures such as Buddha, Bodhisattvas, attendants adoring with flowers, flying *apsaras* figures, monks and finally donors and their families. Monk disciples take their places discreetly behind the main Buddha and Bodhisattva images but are clearly related to them in the spatial configuration. Much later, in the 10th century AD, the representation of space and depth is neglected and the various members of the assembly are arranged to fill the surface of the painting with few gaps between them. At the same time, fairly simple decorative features such as the haloes behind the figures become more complex in patterning. Also by the 10th century AD, as noted above, the donor figures have lost the demure stance of their earlier Tang forebears and seem to display themselves in all their finery:

wearing richly embroidered garments, standing on patterned rugs or carpets, with many fine pins in the ladies' headdresses, and so on. These features can be seen at their best in two large paintings dated 980 and 983 in the Pelliot collection in Paris, but there are examples of the same ostentation in the Stein collection as well. At this time there was little or no contact between Dunhuang and the capital and, despite the profusion of ornament and self-importance of the donors, the actual colours used seem to be fewer and lacking in the nuances and refinement characteristic of those employed when the Tang dynasty was at its height. Some of the extremely long banners favoured during the Five Dynasties are in fact depicted with only one or two colours, often on a coloured ground, with swift, rough delineation (cat. nos. 47, 48).

Mourners at the *nirvāṇa* of the Buddha; Northern Zhou dynasty (6th century AD). From Cave 428 (*Dunhuang bihua*, pl. 24)

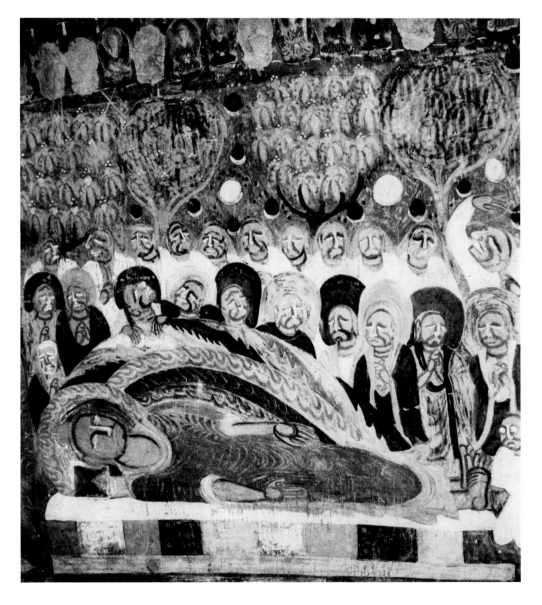

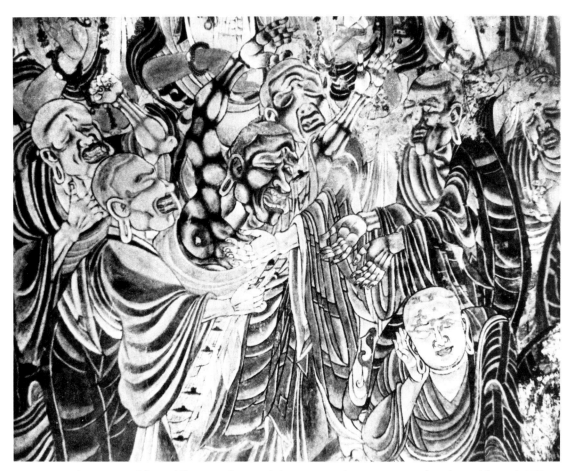

Mourners at the *nirvāṇa* of the Buddha; Tang dynasty (9th century AD). From Cave 158 (*Dunhuang bihua*, pl. 171)

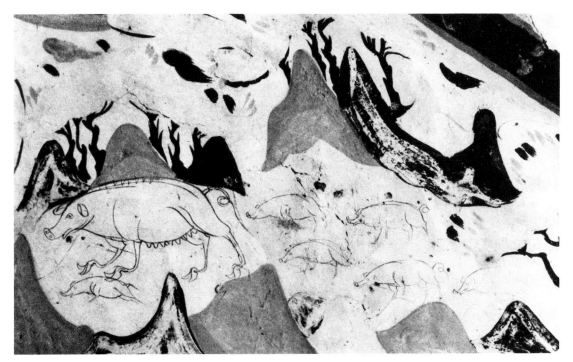

Sow and piglets foraging; Western Wei dynasty (mid-6th century AD). From Cave 249 (*Dunhuang bihua*, pl. 49)

A similar pattern of development may be observed in the landscape subjects depicted at Dunhuang. In the context of Buddhist imagery landscape naturally played a subordinate role to figure painting, but this role was nonetheless important, particularly in the case of narrative themes; these are numerous in both the wall paintings and those on silk. Once more it is only possible to see examples from the early period in the wall paintings, especially in the caves of the Northern Wei (5th century AD) and Northern Zhou (mid-6th century AD); motifs such as ranges of hills are used as setting for the *jātaka* tales of the previous incarnations of Śākyamuni, dividing successive episodes so that the story can be more easily followed. In such early examples the basic form is a triangle with a rounded peak. This is repeated, alternating in colour and each slightly overlapping the next, to surround the narrative space. In some examples bands of colour, often quite striking ones such as bright blue and green, are used to echo the outer contours or even to slice diagonally across them as a means of indicating distance. At times when a rural setting was called for, the painters reveal a keen eye for natural observation, as in the scene of a foraging sow and her piglets, deftly characterised in ink outline on the sloping faces of the ceiling of Cave 249 of the Western Wei dynasty, mid-6th century (*see p. 22 bottom*). By the Tang dynasty the bright blue of the early dynasties has disappeared, but red and green are used in combination with ink to model height and depth or to distinguish steep banks from level areas of grass. Whether in the margins of paradise paintings on silk (cat. no. 2), or in the larger areas of the cave walls, the landscape settings become quite elaborate, incorporating distant views of sunsets and receding streams as well as steep cliffs and peaks clothed with clumps of trees. As with figure painting, however, there is a decline at the end of the Tang and during the Five Dynasties in the 10th century AD. A more schematic treatment tends to diminish the importance of recession and distance even where the subject would seem to require it, as in the topographical representation in Cave 61 of the early Northern Song dynasty of the famous monasteries of Wutaishan in Shanxi province.

By the late 10th century AD, then, the painting of Dunhuang seems definitively separate from that of the artistic talent gathering in the capital of a China once more united under a great emperor, Zhao Guangyin, Emperor Taizu (reigned AD 960–76). But this in no way diminishes its importance for, with a slackening of pace to the final caves of the Yuan dynasty, Dunhuang encompasses an unbroken Buddhist painting tradition of a thousand years. RW

1 Buddha preaching the Law

From Cave 17, Dunhuang. Tang dynasty, early 8th century AD.
Ink and colours on silk. H. 139cm, W. 101.7cm.
OA 1919.1–1.06 (Ch. liii. 001).

Stein, *Serindia* pp. 839, 842n., 851, 884, 885, 896, 984, 1049, 1054–6, 1407; Waley (1931) cat. no. VI; Whitfield, ACA vol. 1, pl. 7, figs. 15–17.

This painting shows Buddha preaching beneath an elaborate canopy. Behind him are the jewelled trunks and foliage of the bodhi tree under which Śākyamuni sat when he attained enlightenment. The Buddha is accompanied by four seated Bodhisattvas and six monk disciples. At the bottom of the painting on the left is the seated figure of a female donor and on the right a part of the headdress of a male donor, together with a few wisps of smoke from what must have been a hand-held censer. The vertical cartouches by the subsidiary figures and the stele below the Buddha, the latter presumably intended for a dedicatory inscription, are blank. The identity of the central Buddha figure is not certain though it seems likely that it is the historical Buddha Śākyamuni. While it is true that similar portrayals of Amitābha are known, there is no sign here of the fully developed trappings of the Western Paradise such as lotus tanks and *garuḍa* birds. Furthermore, the presence of the six monk disciples strongly suggests that this is Śākyamuni. Perhaps the earliest ancestors of this type of scene are the preaching groups seen in the wall paintings of the late 6th- and early 7th-century Sui dynasty caves at Dunhuang (Cave 390). These are succeeded by groups from the early Tang (Caves 103, 321, 329). The neat hair and high-waisted dress of the female donor are similar to wall paintings of court ladies in imperial tombs of the early 8th century. RW, AF

2 Paradise of Śākyamuni, with illustrations of episodes from the Baoen sūtra

From Cave 17, Dunhuang. Tang dynasty, early 9th century AD.
Ink and colours on silk. H. 168cm, W. 121.6cm.
OA 1919.1–1.01 (Ch. xxxviii. 004).

Stein, *Serindia* pp. 888, 1042–3, 1410, 1468; Waley (1931) cat. no. I; Whitfield, ACA vol. 1, pl. 11, figs. 34, 35, 38, 72.

This painting depicts the paradise of the historical Buddha Śākyamuni with scenes at the sides illustrating the story of Prince Sujāti. Śākyamuni, with both hands in the gesture of discussion (*vitarka-mudrā*), appears seated between two Bodhisattvas on a platform with a dancer below and groups of musicians to either side. Below them, on golden islands in a lotus lake, stand on the left a *jīva-jīva*, a mythical bird with two human heads, and on the right a *kalaviṅka*, with one head. In the foreground another Buddha is shown accompanied by a Bodhisattva and a shaven-headed monk. This Buddha bears cosmological emblems on his robe, including the sun and moon on his shoulders and Mount Sumeru on his breast. It is possible that this Buddha is Vairocana, the Cosmic Buddha, but he may also represent the cosmic aspect of Śākyamuni as expounded in the Lotus Sūtra.

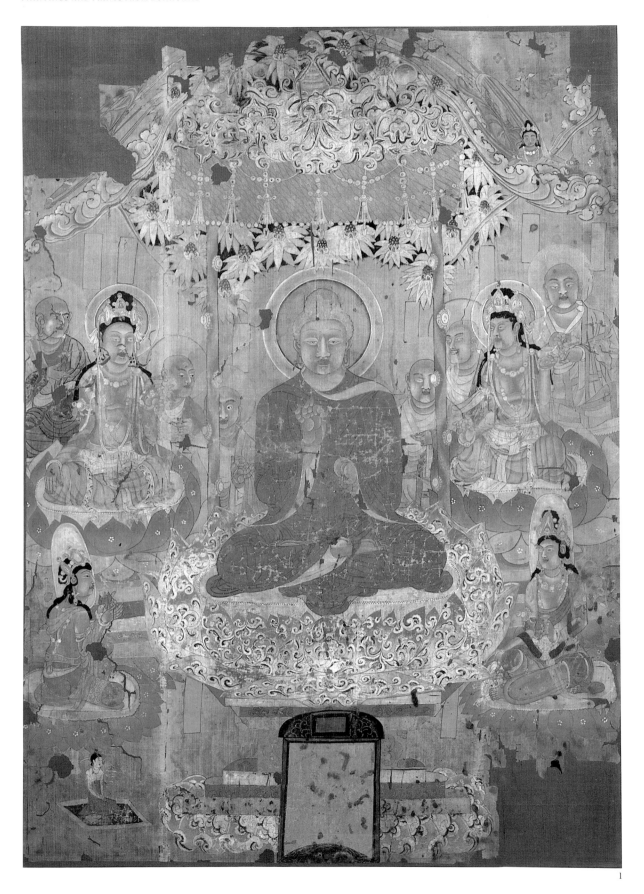

1

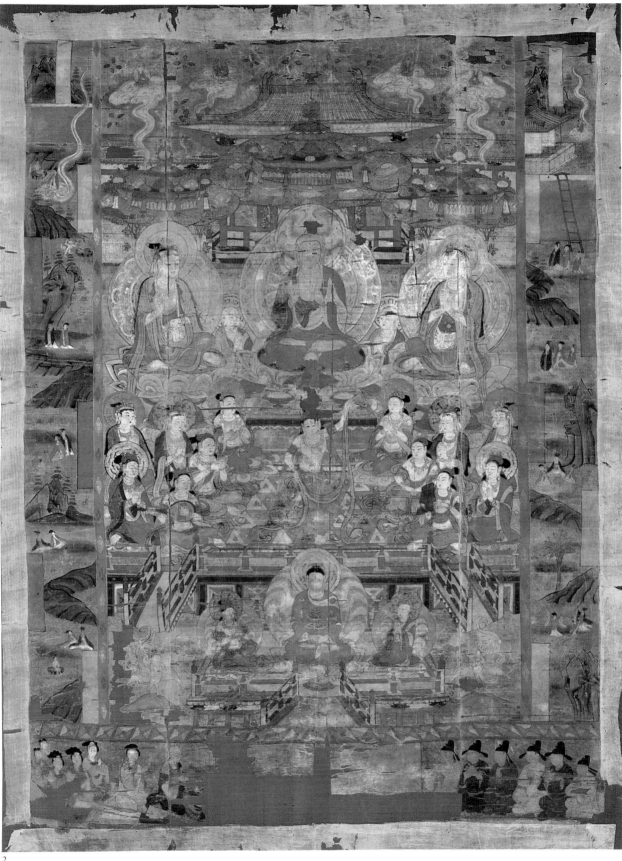

2

On the two sides of the painting is a sequence of episodes taken from the *Baoen-jing* (the Sūtra of Requiting Blessings Received), depicting one of the many *jātaka* stories which recount events in Śākyamuni's previous incarnations. The story begins at the top right margin and continues downwards. On the left margin the illustrations go upwards from the bottom. According to the story, Śākyamuni was once Prince Sujāti, the grandson of a king of Vārānasī (Benares in India). A treacherous minister revolted and slew the king with five of his sons. Sujāti's father, however, was warned by the tutelary spirit of his palace and took flight with his wife and their small son, Sujāti. The first three scenes show the warning and their escape. In the fifth scene on the right, their provisions have run out and Sujāti's father is about to slay his wife in order to share her flesh with the boy. Sujāti intervenes and offers his own flesh to his parents. At last there are only three pieces of flesh left on the child's body. The parents each take one and leave Sujāti by the roadside with the third piece of flesh. This is the ninth illustration in the series, the third counting upwards from the bottom left. At this point the god Indra appears in the form of a lion and begs Sujāti for food; Sujāti offers his last piece of flesh. Indra then appears in his true shape on a pedestal of cloud and restores Sujāti to strength and wholeness.

At the bottom of the painting kneel two groups of donor figures. The women on the left wear simple headdresses without pins and three have plain combs above the forehead. The male donors on the right wear close-fitting caps without the stiffened ribbons standing out at right angles which are typical of 10th-century dress. Both these features suggest that the painting dates from the 9th century. There are other features which point to a date in the first half of the 9th century. The composition of the paradise scene is still simple and uncluttered, with the principal figures depicted prominently against the background; the robes of the figures hang in smooth curves undisturbed by sudden twists or turns; the haloes of the figures are chiefly composed of patterns derived from lotus petals in contrast to the more geometric patterns used in the 10th century.

RW, AF

3 Samantabhadra

From Cave 17, Dunhuang.
Tang dynasty, late 8th–early 9th century AD.

Ink and colours on silk. H. 57cm, W. 18.5cm.
OA 1919.1–1.0131 (Ch. xlvi. 006).

Stein, *Serindia* p. 1046; Waley (1931) cat. no. CXXXI; Whitfield, *ACA* vol. 1, pl. 12.

The Bodhisattva Samantabhadra is shown on his usual mount, the white elephant, which is advancing towards the right with head turned to the left. Samantabhadra sits beneath a canopy with hands in the gesture of giving (*varada-mudrā*). Although the accessories belonging to this painting have not survived, it is probable that it was originally a banner intended to hang as a pair with Mañjuśrī, the Bodhisattva of Wisdom, who would have been portrayed

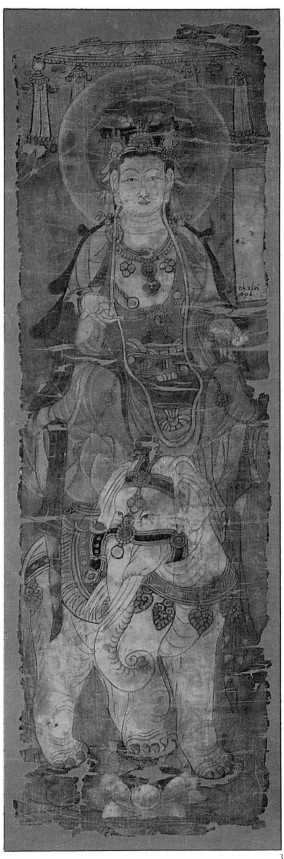

3

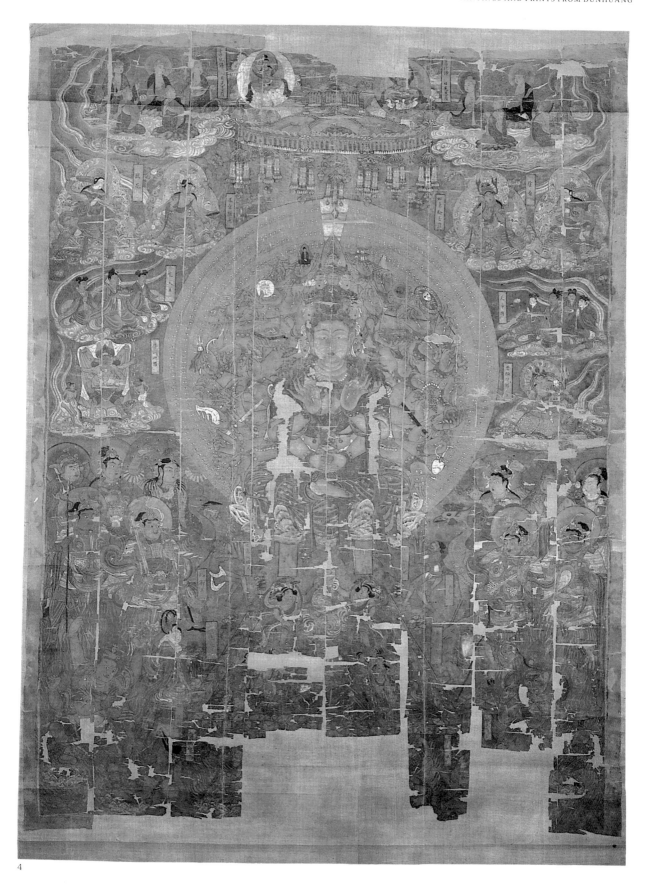

4

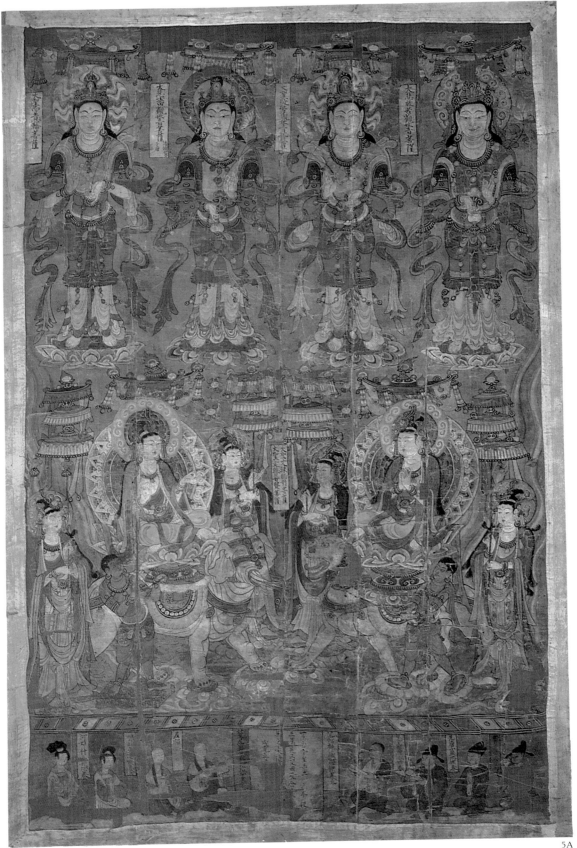

5A

seated on a lion walking towards Samantabhadra (*see* cat. nos. 5, 17, 18). Like many other banners, this painting had dark brown borders down each side and a band of lozenges at the bottom. RW, AF

4 Thousand-armed, Thousand-eyed Avalokiteśvara

From Cave 17, Dunhuang. Tang dynasty, early 9th century AD.

Ink and colours on silk. H. 222.5cm, W. 167cm.
OA 1919.1–1.035 (Ch. lvi. 0019)

Stein, *Serindia* pp. 869, 1077–9, 1412, 1415, 1420, 1423–4, pl. LXIII; Waley (1931) cat. no. XXXV; Whitfield, ACA vol. 1, pl. 18, figs. 53, 54.

The period of Tibetan domination at Dunhuang (AD 781–847) was marked by the increasing popularity of Vajrayāna or Esoteric Buddhism. This painting is one of the finest surviving masterpieces inspired by this school. The Bodhisattva Avalokiteśvara is shown seated on a lotus which grows from a pool at the bottom of the painting. His instantaneous perception of all who call on him by name, as well as his capacity for immediate aid, are symbolised by the huge halo of hands which surrounds him, each bearing a single eye. Against the background of these multiple limbs, larger arms and hands display his principal attributes either by the objects they hold or by their *mudrā* (gestures).

The rest of the painting is occupied by beings related to his cult with each group identified by a cartouche. Such a painting would have to have been executed exactly according to the description of the deity and his attendants in a particular sūtra; only then could it be efficacious. Transmission of the doctrine in the Esoteric sect was directly from master to initiate through the *abhiṣeka* ritual, and ceremonies were screened from ordinary believers. Perhaps for this reason there are no donors depicted in this painting. The detailed attributes of the Bodhisattva and the accompanying figures, which include Cintāmaṇicakra Avalokiteśvara (*see* cat. no. 11), are described by Waley and Whitfield. RW, AF

5 Four manifestations of Avalokiteśvara, with Samantabhadra and Mañjuśrī

From Cave 17, Dunhuang.
Tang dynasty, dated 5th year of Xiantong (AD 864).

Ink and colours on silk. H. 140.7cm, W. 97cm.
OA 1919.1–1.05 (Ch. v. 0023).

Stein, *Serindia* pp. 839n., 880–1, 1068, 1398, 1416–7, 1420–1, 1423; Waley (1931) cat. no. V; Whitfield, ACA vol. 1, pl. 23, figs. 71, 73.

This votive painting depicts four manifestations of Avalokiteśvara in the upper register. Each of the four figures, wearing Indian-style dress, is identified by a cartouche. Below are Samantabhadra, special patron of followers of the Lotus Sūtra, and Mañjuśrī, Bodhisattva of Wisdom, riding their respective mounts, the elephant and the lion. They are accompanied by Bodhisattvas in flowing robes of Chinese-

5B (detail)

style dress carrying three-tiered canopies, and by dark-skinned Indian grooms leading their mounts. At the bottom of the painting, the donors (all members of one family) are shown as a single monk and three laymen on the right, and two nuns and two women on the left of a central inscription which dates the work: 'First, on behalf of the present Emperor; second, on behalf of his envoy . . . third, on behalf of his departed parents and all his family . . . May they [escape] both earthly disasters and obstacles to salvation. Xiantong 5th year [AD 864].' As Waley has noted, the ladies in the donor group wear only a single comb in their hair without the hairpins common at a later date. The chief donor Tang, a minor official, has indicated his special devotion to one of the four Avalokiteśvaras by adding his name to the identifying cartouche. This deity should be the 'Eleven-headed' Avalokiteśvara of Esoteric Buddhism, but the painter has not distinguished the figure from the other three. RW, AF

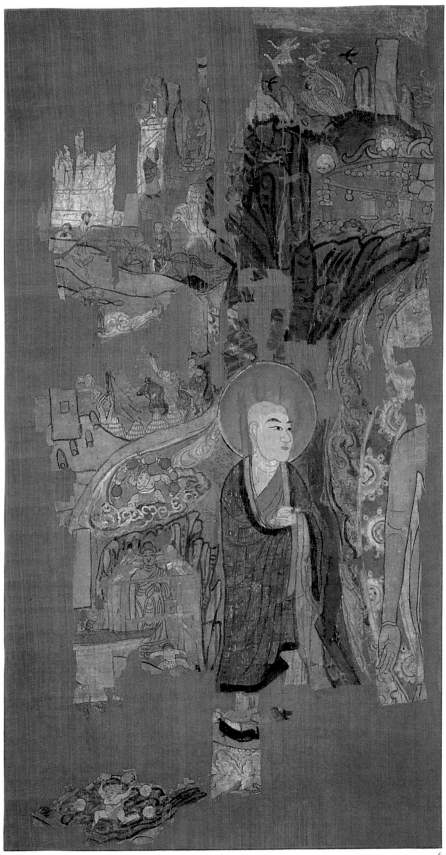

6

6 Liu Sahe and scenes from the story of the miraculous image of Mount Yugu

From Cave 17, Dunhuang. Tang dynasty, 8th–9th century AD.

Ink and colours on silk. H. 95.9cm, W. 51.8cm.
OA 1919.1–1.020 (Ch. 0059).

Stein, *Serindia* pp. 878–9, 895, 951–2; Waley (1931) cat. no. XX; Whitfield, ACA vol. 1, pl. 22.

This is a fragment of a considerably larger painting. Only the right arm survives of what must have been a central standing figure of Śākyamuni against a rocky background. The Buddha is identifiable by his extended right arm which hangs down with open palm in the gesture of Śākyamuni seen in the great embroidery of the sermon on the Vulture Peak (*see* cat. no. 88). The haloed monk and the series of narrative scenes on the lefthand side represent the 5th-century monk Liu Sahe and one of the legends connected with him. The monk prophesied that a statue would appear on the slopes of Mount Yugu, and that the statue's completeness or incompleteness would signify peace or turmoil in the world (Whitfield, 1989). In AD 519 a headless image is said to have appeared. Thirty-eight years later the head was discovered and restored to the body. This story explains details of the present painting such as the scaffold erected around the image, the city wall representing Liangzhou where the head was discovered, and the indication of Mount Yugu shown in the rocky setting. A fragment in the Pelliot collection in Paris is another part of this silk painting (*Bannières*, No. 25). A number of episodes from this story are also found on the south wall of Cave 72 at Dunhuang, and it is likely that further episodes were depicted on the missing right half of the silk painting. RW, AF

7 Two Avalokiteśvaras

From Cave 17, Dunhuang. Tang dynasty, mid-9th century AD.

Ink and colours on silk. H. 147.3cm, W. 105.3cm.
OA 1919.1–1.03 (Ch. xxxviii. 005).

Stein, *Serindia* pp. 880, 1043, pl. LXXXI; Waley (1931) cat. no. III; Whitfield, ACA vol. 1, pl. 24, fig. 75.

This painting shows two facing Avalokiteśvaras in almost exact mirror image, bearing figures of Amitābha Buddha in their crowns and standing on lotus-petal bases. Both figures stand under canopies. The figure on the left holds a yellow flower, probably a lotus, with the right hand in the gesture of discussion (*vitarka-mudrā*). The Bodhisattva on the right carries a flask in one hand and holds a spray of willow in the other, also in the *vitarka-mudrā*. The central four lines of the inscription (7B) consist of the same two-line text, repeated to read from either side. It states that the painting was made by '. . . the disciple of pure faith, Yiwen, on his own behalf, having fallen [into the hands of the Tibetans], that he return to his birthplace . . .' The implied reference to the Tibetans dates the work to the period between AD 781 and 847 when Dunhuang was under Tibetan control. At some later time the light area of the original inscription was extended to the left and right to accommodate additions in which other persons

7B (detail)

claim credit for the painting and apply its benefits to their deceased parents. RW, AF

8 Fragment of Christian figure

From Cave 17, Dunhuang. Tang dynasty, 9th century AD.

Ink and colours on silk. H. 88cm, W. 55cm.
OA 1919.1–1.048 (Ch. xlix. 001).

Stein, *Serindia* pp. 1050–1; Waley (1931) cat. no. XLVIII; Whitfield, ACA vol. 1, pl. 25, fig. 76.

At first sight this fragment of a magnificent figure of nearly half life-size seems to represent a Bodhisattva. However, closer examination of the face shows that the person depicted is not Chinese. The nose is somewhat aquiline and the red moustache and sparse beard are unusual among Dunhuang figures. In fact, the figure is of Christian origin, as is made clear by the pectoral cross, the cross worn in the headdress and the cross-patterned collar. The style of the halo and the drawing of the mouth indicate a 9th-century date. Any Christians in 9th-century China would have been members of the Nestorian church founded by Nestorius, Bishop of Constantinople (AD 428–31). He held that Jesus Christ united in one body two separate 'persons', a divine and a human. This view was condemned as heretical at the Council of Ephesus in AD 431 but spread widely in Syria and

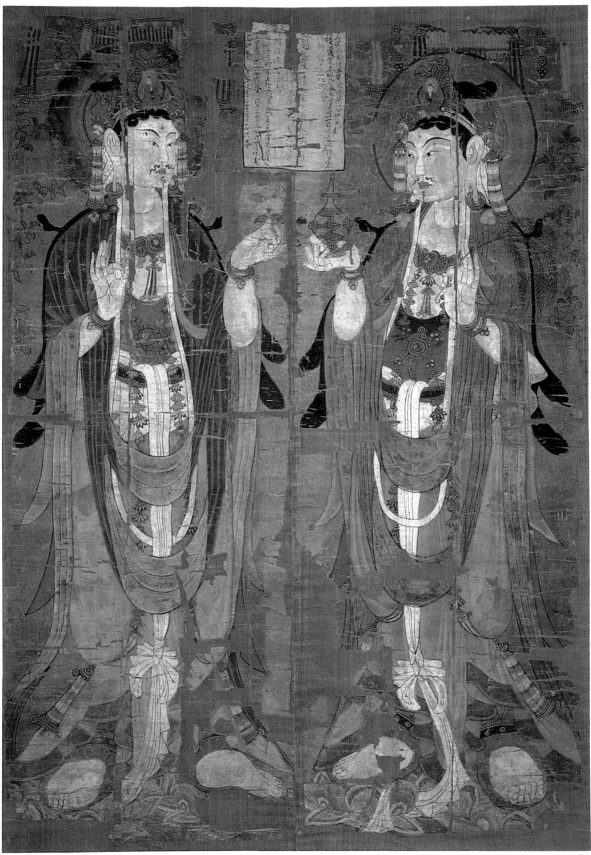

7A

8

Mesopotamia, and missionaries were sent to India and China as attested by the famous Nestorian stele dated AD 781, now in the Beilin or Forest of Stelae at Xi'an. In China Nestorianism was forbidden at the time of the great proscription of foreign religions, including Buddhism, in the years AD 842 to 845 and seems subsequently to have disappeared completely. How a Christian painting found its way into the collection found in Cave 17 must remain a mystery.

RW, AF

9 Vaiśravaṇa riding across the waters

From Cave 17, Dunhuang. Five Dynasties, mid-10th century AD.

Ink and colours on silk. Painted area: H. 61.8cm, W. 57.4cm.
OA 1919.1–1.045 (Ch. 0018).

Stein, *Serindia* pp. 181, 842n., 874–5, 942–3, pl. LXXII; Waley (1931) cat. no. XLV; Whitfield, ACA vol. 2, pl. 16.

This is one of the best paintings from Cave 17, depicting Vaiśravaṇa, the Guardian King of the North. He is one of the four Devarājas or kings of the points of the compass, who are accompanied by large forces of supernatural warriors. The Devarājas, important figures in the Buddhist pantheon, acted as protectors of the Law and fought against the forces of evil. Vaiśravaṇa, the most frequently represented of the Devarājas at Dunhuang, is here shown crossing the sea with his retinue. In his right hand he carries a golden halberd and in his left a purple cloud supporting a stūpa inside which there appears to be a seated Buddha. In front of him his sister Śrī Devī, Goddess of Material Blessings, holds a shallow golden dish of flowers. On the other side is the rishi Vasu portrayed as a white-haired old man. The stout figure in a green robe holding a flaming pearl may be one of Vaiśravaṇa's five sons. It has been suggested that the unarmed figure wearing a four-pronged crown is that of a donor, but since it is unusual for such figures to be so closely integrated into a composition, it may be another of Vaiśravaṇa's sons. At the rear of the group an archer prepares to shoot down the winged thunder monster flying in the sky above.

RW, AF

10 Lokapāla (fragment)

From Cave 17, Dunhuang. Tang dynasty, 9th century AD.

Ink and colours on silk. H. 63cm, W. 67cm.
OA 1919.1–1.069 (Ch. liv. 003).

Stein, *Serindia* pp. 875, 1058; Waley (1931) cat. no. LXIX; Whitfield, ACA vol. 1, pl. 66.

This fragmentary painting shows how splendid the finest paintings at Dunhuang could be. In its complete state it must have been over 2m high with a width of at least 75cm. The painting shows a Lokapāla or guardian king who, from the arrow he is carrying, may be identified as Dhṛtarāṣṭra, Guardian of the East. His face is outlined in thick heavy ink and a luxuriant beard flows in smooth lines from the ends of his mouth, chin and temples. His dress corresponds to that of other guardian kings, but it is more richly decorated with

rows of scale armour, each of a different colour, borders of embroidered flowers, and a blue jewel at the neck. RW, AF

11 Cintāmaṇicakra Avalokiteśvara

From Cave 17, Dunhuang. Tang dynasty, late 9th century AD.

Ink and colours on silk. H. 111cm, W. 74.5cm.
OA 1919.1–1.010 (Ch. xxvi. 001).

Stein, *Serindia* p. 1030; Waley (1931) cat. no. X; Whitfield, ACA vol. 2, pl. 5, figs. 1–4.

The Bodhisattva Avalokiteśvara appears in a number of special forms described in Tantric sūtras. One of these is Cintāmaṇicakra Avalokiteśvara, described in a sūtra translated into Chinese in AD 709 (Nanjiô, 324). His six arms represent his power to save in different ways (*see* cat. no. 20). In this painting the Bodhisattva is identified by the *cakra* or talismanic wheel, originally an ancient Indian weapon, which he rotates with the fingers of his upper left hand, and by the lasso or rope coiled in his lower right hand. The middle left hand should hold the *cintāmaṇi* or pearl symbolising a response to every prayer; here it is hardly visible. As with all manifestations of Avalokiteśvara, he wears a triangular crown containing the figure of his spiritual father Amitābha Buddha. His stance shows the influence of Tantric Buddhism: head inclined, graceful curves of the shoulders and arms, slender waist, and the *lalitāsana* pose with one raised knee and the other leg bent at the knee on the lotus base. The original golden yellow pigment of the Bodhisattva's body has largely disappeared. Two small Bodhisattva figures appear in the upper corners of the painting supported by a scrolling lotus stem, and another pair can be seen indistinctly in the lower corners. Two other paintings in the British Museum collection showing Cintāmaṇicakra Avalokiteśvara have similar characteristics (*see* cat. no. 4; Whitfield op. cit. vol. 1, fig. 68). RW, AF

12 Avalokiteśvara

From Cave 17, Dunhuang.
Five Dynasties, but dated 10th year of Tianfu (AD 910).

Ink and colours on silk. H. 77cm, W. 48.9cm.
OA 1919.1–1.014 (Ch. liv. 006).

Stein, *Serindia* pp. 838n., 867, 1059, 1397, pl. LXIX; Waley (1931) cat. no. XIV; Whitfield, ACA vol. 2, pl. 7, figs. 7, 8.

This fine votive painting shows the Bodhisattva Avalokiteśvara standing on a scarlet and white lotus which floats on a stream. The Bodhisattva's raised left hand holds a willow spray, and the right hand hangs by his side and carries a flask. A figure of Amitābha Buddha is in the Bodhisattva's headdress, identifying him as Avalokiteśvara. On the left and right stand the two deceased persons mentioned in the inscriptions, against a background of six bamboo stems. Of the three inscriptions on the face of the painting and the two on the back, the most important is in the green cartouche on the front. It reads: 'Praise to the great merciful, great compassionate saviour from hardship Avalokiteśvara Bod-

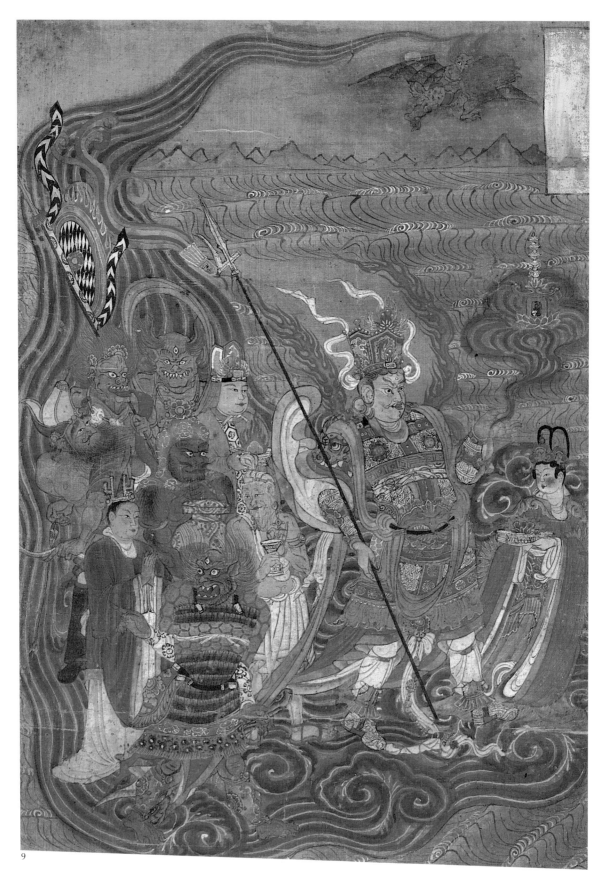

9

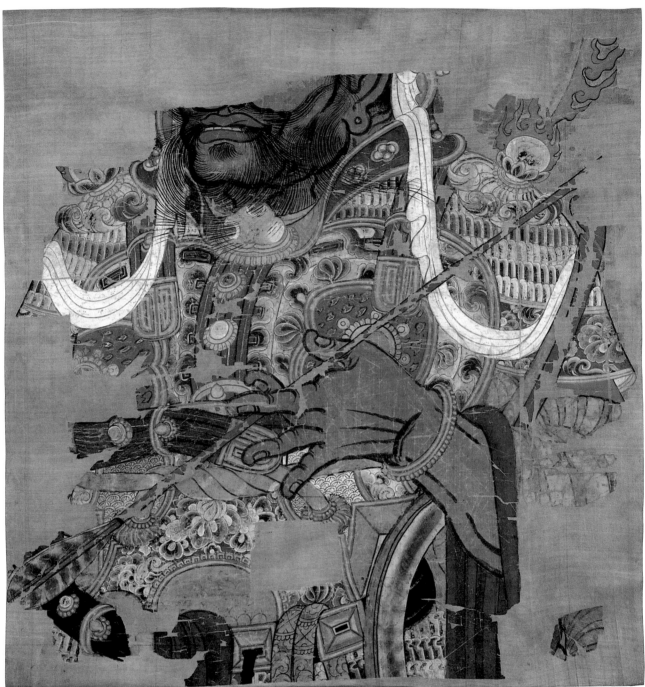

10

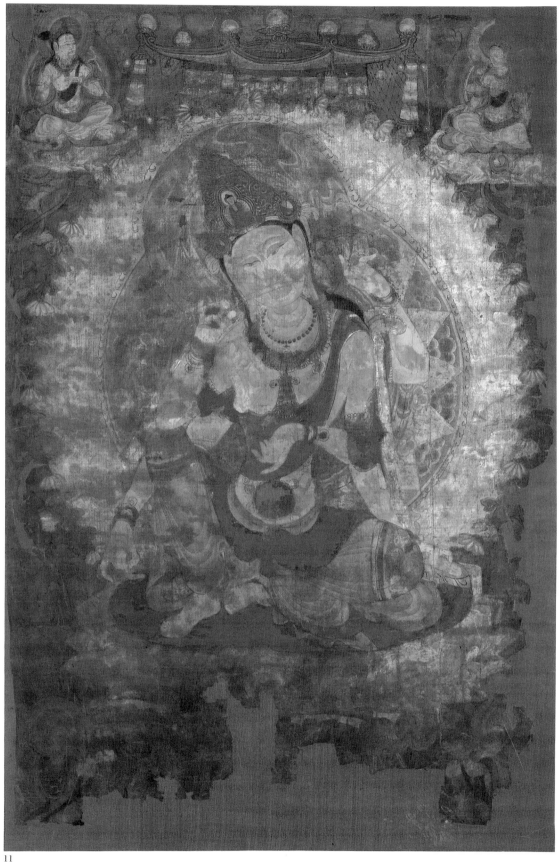

11

hisattva, in perpetual offering. Offered in the hope that the Empire may be peaceful and that the Wheel of the Law may continually turn therein. Secondly, on behalf of my elder sister and teacher, on behalf of the souls of my deceased parents, that they may be born again in the Pure Land, I reverently made this great Holy One and with whole heart dedicated.' (Translation from Whitfield, adapted from Waley. The inscription is here read from left to right rather than from right to left, as Waley had read it.)

An inscription on the back identifies the shaven-headed figure holding the incense burner and standing on Avalokiteśvara's right as the deceased Very Reverend nun Yanhui, 'elder sister and teacher', admitter to the Dharma and Vinaya in the monastery of Universal Light. The young man holding a plate with a lotus flower on the other side of Avalokiteśvara is the deceased probationary Chamberlain Zhang Youcheng, identified in the white cartouche above his head. He is the younger brother of the writer of the inscriptions. The large inscription above Yanhui is dated '. . . the tenth year of the Tianfu reign period, year gengwu, seventh month, fifteenth day . . . [22 August AD 910]'. Perhaps it was on account of Dunhuang's remoteness that the Tianfu reign period was still in use, although that period had ended officially in AD 904 and the Tang dynasty had itself been deposed in AD 906. RW, AF

13 Kṣitigarbha

From Cave 17, Dunhuang. Five Dynasties, early 10th century AD.
Ink and colours on silk. H. 55.5cm, W. 39.8cm (including border).
OA 1919.1–1.04 (Ch. 0084).

Stein, Serindia pp. 865, 955, 1399, pl. LXXX; Waley (1931) cat. no. IV; Whitfield, ACA vol. 2, pl. 8.

The Bodhisattva Kṣitigarbha is shown seated on a red and white lotus holding the khakkhara, a mendicant's staff, and a cintāmaṇi jewel, his usual attributes. He wears his customary dress of a monk's patched robe, but is portrayed in an unusual way, with his cape covering his head as a monk would wear it when travelling. This iconographic feature has only been found at Dunhuang and in Korean paintings. The upper half of the donor shown at the bottom of this painting is of particular interest since the hairstyle reveals him as still a young boy. RW, AF

14 Bodhisattva as Guide of Souls

From Cave 17, Dunhuang. Tang dynasty, late 9th century AD.
Ink and colours on silk. H. 80.5cm, W. 53.8cm.
OA 1919.1–1.047 (Ch. lvii. 002).

Stein, Serindia pp. 867, 1081–2, pl. LXXI; Waley (1931) cat.no. XLVII; Whitfield, ACA vol. 2, pl. 9.

This painting and the one following show a theme, popular from the late Tang dynasty until the early Song, which also appears in four other paintings on silk from Dunhuang now in the Pelliot collection in Paris (Bannières, Nos. 130–33). This is the only one of the group with an explicit title, which

is Yinlu pu ('Bodhi[sattva] Guide of Souls'). The scene shows a Bodhisattva leading a finely dressed figure to the palaces of paradise depicted in the clouds in the top lefthand corner of the painting. The Bodhisattva carries a hand-censer in his right hand. In his left hand is a lotus flower from which hangs a white banner with side and tail streamers. The Bodhisattva most frequently depicted as a guide of souls is Kṣitigarbha, who is sometimes shown as a monk carrying a staff (see cat. no. 65). Here the ever-popular Bodhisattva Avalokiteśvara seems more likely, although the identifying figure of Amitābha in his headdress is missing. RW, AF

15 Avalokiteśvara as Guide of Souls

From Cave 17, Dunhuang. Five Dynasties, early 10th century AD.
Ink and colours on silk. H. 84.8cm, W. 54.7cm.
OA 1919.1–1.046 (Ch. lvii. 003).

Stein, Serindia pp. 867, 1082; Waley (1931) cat. no. XLVI; Whitfield, ACA vol. 2, pl. 10.

Although there is no identifying inscription in the cartouche, this scene is identical to that of the previous painting. It shows a Bodhisattva leading the soul of a secular figure to the halls of paradise, here depicted as three bands each with tiny buildings. Unlike the previous painting, in this one the Bodhisattva is clearly identified as Avalokiteśvara by the figure of Amitābha in his headdress. In his left hand is a censer; from a long staff in his right hand a banner is suspended by a hook. The small figure following Avalokiteśvara is an aristocratic lady wearing a coat with decorative roundels common in late Tang textiles and seen on some of the patches of the kaṣāya (see cat. no. 89).

RW, AF

16 Paradise of Maitreya

From Cave 17, Dunhuang.
Late Tang or early Five Dynasties, late 9th–early 10th century AD.
Ink and colours on silk. H. 138.7cm, W. 116cm.
OA 1919.1–1.011 (Ch. lviii. 001).

Stein, Serindia pp. 890, 1082–3, 1408, 1414, 1419, 1423, pl. LVIII; Waley (1931) cat. no. XI; Whitfield, ACA vol. 2, pl. 12, figs. 10–13.

This complex painting shows the paradise of Maitreya, the Buddha of the Future. Above and below the main images are a series of smaller pictures showing scenes taken from the Mile xiasheng jing (Sūtra of Maitreya's Birth). This is the best-known Chinese text dealing with Maitreya, first translated into Chinese in AD 303. According to the scriptures, Maitreya is the Future Buddha. At present he is still only a Bodhisattva and waits in the inner court of the Tuṣita Heaven until the time comes for him to be born on earth and attain to Buddhahood.

In this painting, the main paradise scene shows Maitreya at the centre accompanied by two Bodhisattvas and two disciple monks, one young and one old. Flanking them are two guardian kings, Virūpākṣa with a sword and Vaiśravaṇa

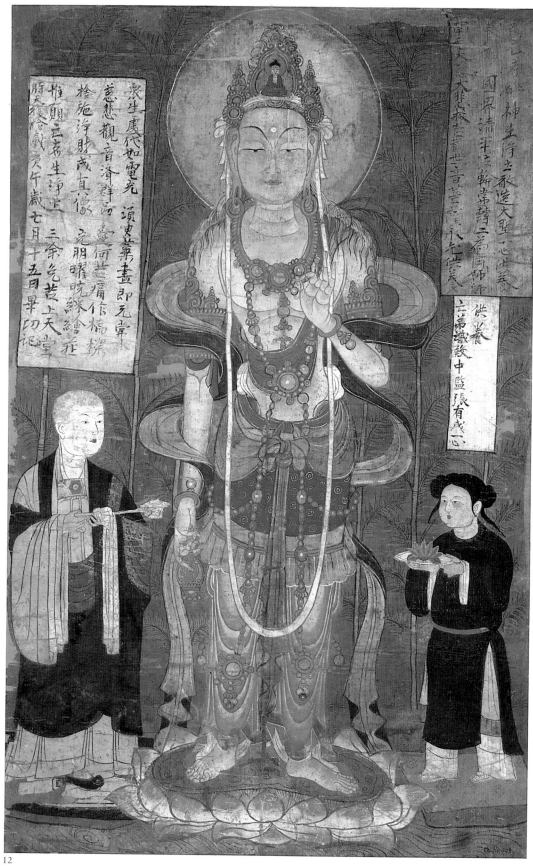

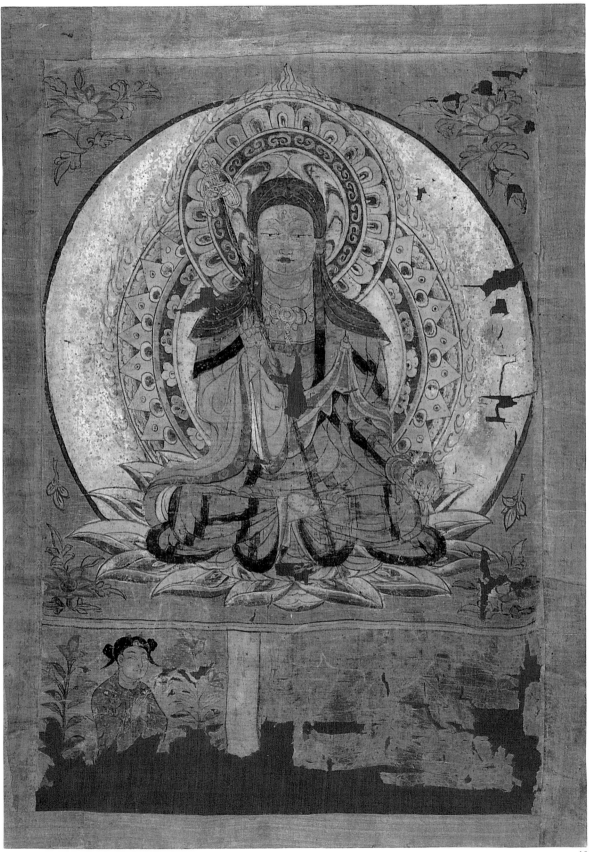

13

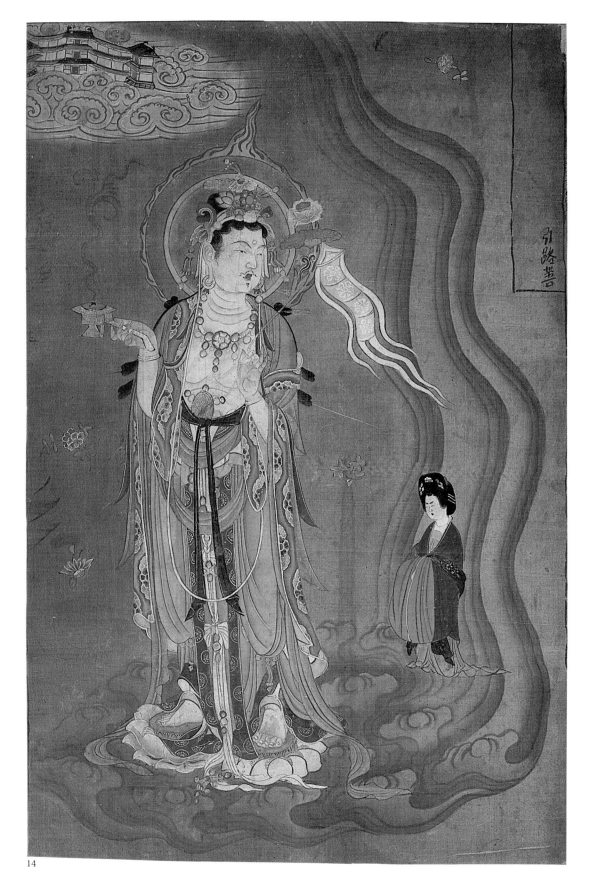

引路菩

14

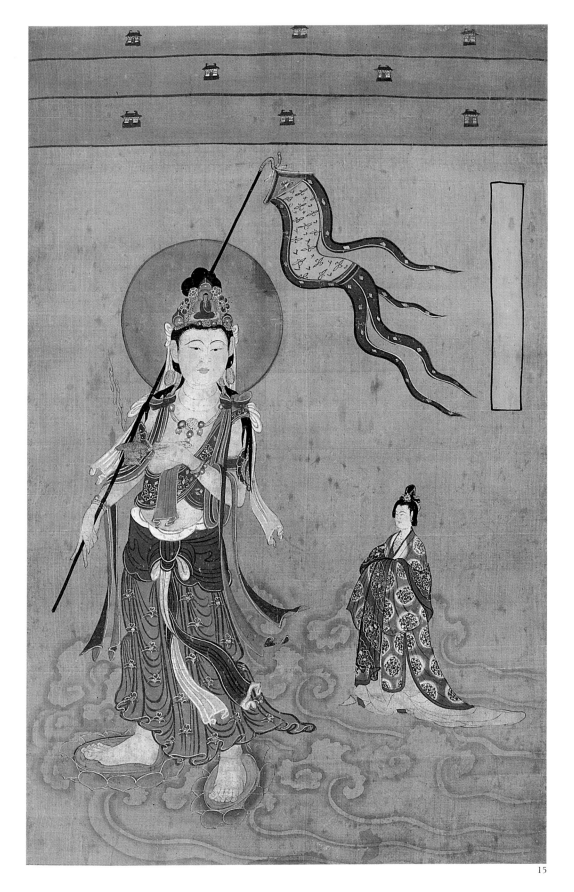

15

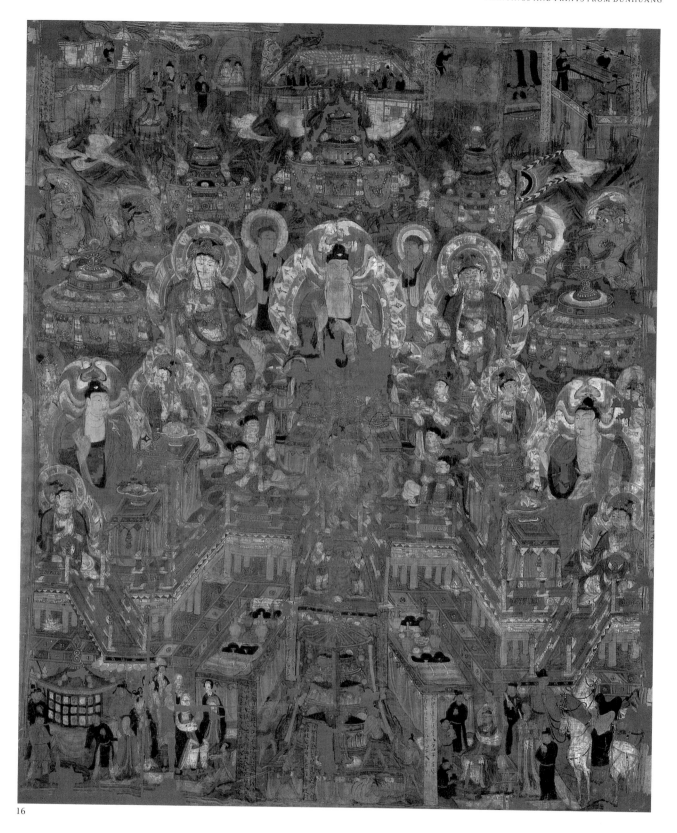

16

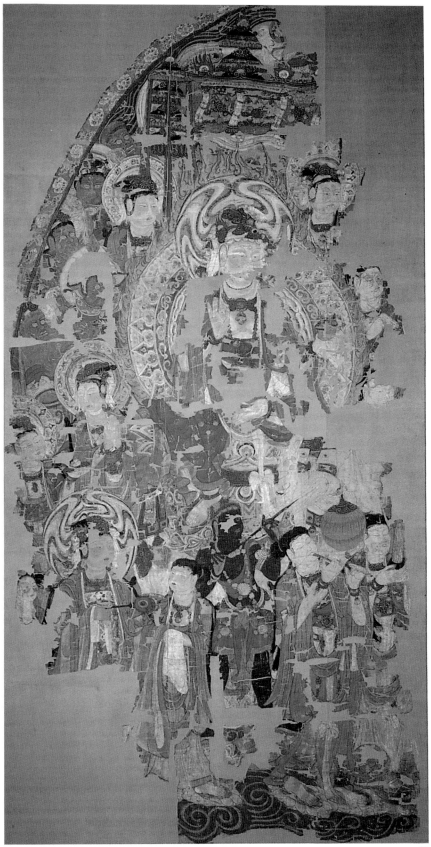

17

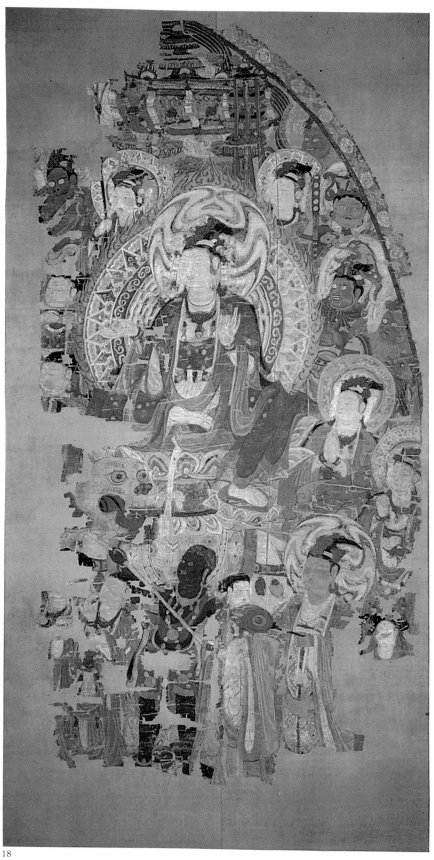

18

with a banner, and two Dharmapālas or Law guardians of the five Dhyāni Buddhas. Below, two *devis* offer flowers while a partly obliterated dancer is attended by four musicians. Below the dancer two little boys hold up dishes of flowers. To the left and right are two further Buddhas each attended by pairs of Bodhisattvas. The sequence of subsidiary scenes seems to begin at the top right of the painting. The first three scenes and the accompanying texts taken from the *Mile xiasheng jing* show the age of peace and prosperity to come, and others show the conversions effected by the newly descended Buddha.

RW, AF

17 Samantabhadra

18 Mañjuśrī

From Cave 17, Dunhuang.
Late Tang or early Five Dynasties, late 9th–early 10th century AD.

Ink and colours on silk.
17: H. 219.4cm, W. 115.2cm. **18**: H. 218.7cm, W. 114.8cm.
17: OA 1919.1–1.033 (Ch. xxxvii. 003).
18: OA 1919.1–1.034 (Ch. xxxvii. 005).

Stein, *Serindia* pp. 843, 881, 1040–1; Waley (1931) cat. nos. XXXIII, XXXIV; Whitfield, ACA vol. 2, pls. 13, 14.

These two paintings are unique among those from the Stein collection in having a curved upper border. On the right Mañjuśrī, the Bodhisattva of Wisdom, advances on his customary mount, the lion. On the left Samantabhadra, a patron of followers of the Lotus Sūtra, is seated on his white elephant. Each animal is led by a dark-skinned Indian groom. The retinues are very similar: the heads of a number of Bodhisattvas emerge beyond the borders of the aureoles, together with the faces of three red-faced Dharmapālas, Guardians of the Law of the Dhyāni Buddhas. In the foreground corners, to the left and right respectively, are Bodhisattvas accompanied by smaller figures, and leading the procession in the front are musicians. These two paintings were possibly designed to flank a central image of Śākyamuni. However, a painting in the British Museum collection showing these two Bodhisattvas advancing towards one another without a central figure (*see* cat. no. 5) suggests that these paintings may be complete by themselves. The curved upper borders would be explained if the paintings were intended to be displayed in a barrel-vaulted space, but the caves at Dunhuang do not have this type of ceiling. A possible explanation is that the paintings were brought to Dunhuang from another site.

RW, AF

19 Kṣitigarbha as Lord of the Six Ways

From Cave 17, Dunhuang.
Northern Song dynasty, dated 4th year of the Jianlong period (AD 963).

Ink and colours on silk. Painted area: H. 56.1cm, W. 51.5cm.
OA 1919.1–1.019 (Ch. lviii. 003).

Stein, *Serindia* pp. 866, 1083, 1396, 1402, 1422, pl. LXVII; Waley (1931) cat. no. XIX; Whitfield, ACA vol. 2, pl. 22.

19B (detail)

In this painting Kṣitigarbha appears alone as Lord of the Six Gati or Ways of Rebirth, emphasising his power to save souls from hell. Here he is unaccompanied by the Ten Kings of Hell shown in some other works (*see* cat. nos. 20, 65). The Six Ways are represented by six small figures, separated from each other by striped bands. From the top on the right they include a man for the Way of Men; a four-armed deity holding up discs of the sun and moon for the Way of Asuras or titanic demons; and an emaciated figure among flames for the Way of Pretas or hungry ghosts. From the top on the left they are a small Bodhisattva for the Way of Devas or divine beings; a horse and an ox for the Way of Animals; and a demon with a pitchfork for the Way of Hell.

RW, AF

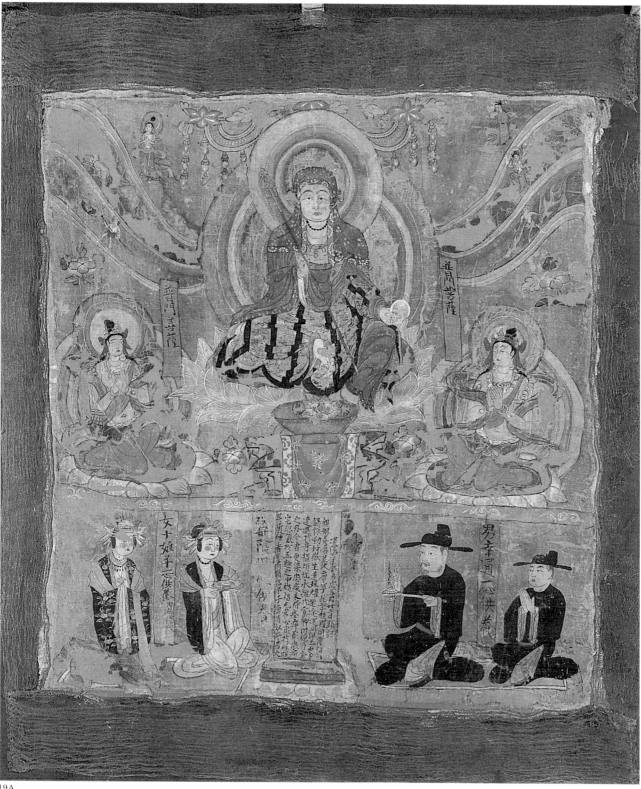

19A

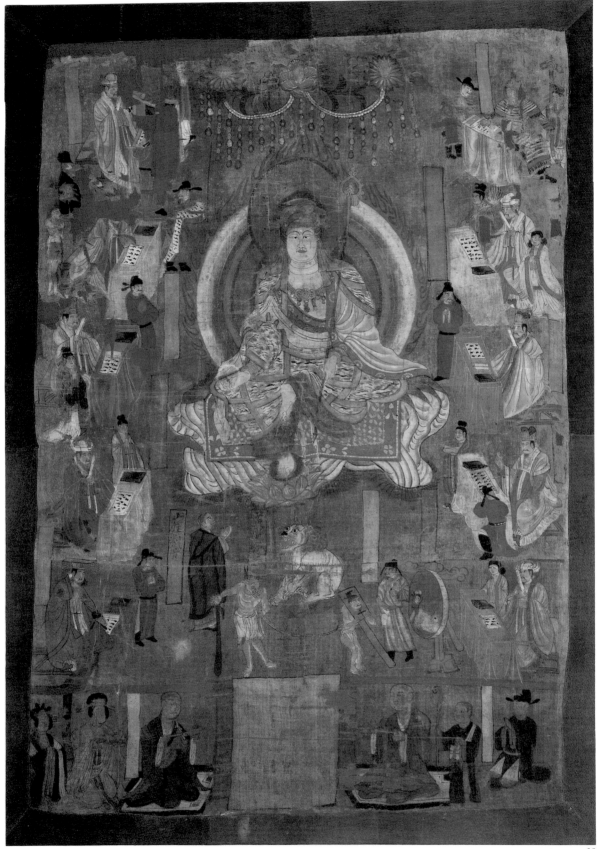

20

20 Kṣitigarbha with the Ten Kings of Hell

From Cave 17, Dunhuang. Five Dynasties, mid-10th century AD.

Ink and colours on silk. Painted area: H. 91cm, W. 65.5cm.
OA 1919.1–1.023 (Ch. 0021).

Stein, *Serindia* pp. 169, 866, 943, 1422; Waley (1931) cat. no. XXIII;
Whitfield ACA vol. 2, pl. 24, figs. 33, 34.

This painting of the Bodhisattva Kṣitigarbha and the Ten
Kings of Hell illustrates the Chinese Buddhist concept of the
judgement of the soul after death in its most fully developed
form. When Buddhism came to China, this concept followed
a relatively simple scheme: after death the soul passed forty-
nine days in an intermediate state before coming to Yama,
Judge of the Dead, for its fate to be decided. It would then be
allotted to one of the Six Gati or Ways of Rebirth. These
comprised the Ways of Men, Asuras (demons), Pretas
(hungry ghosts), Devas (divine beings), Animals and Hell.
By the late 9th century AD, the Bodhisattva Kṣitigarbha had
come to be regarded as having special powers to rescue souls
in danger of falling into the less desirable of the Six Ways.
In AD 903 the apocryphal sūtra of the Ten Kings describes
the ten successive spheres, each presided over by a king,
through which a soul must pass on its way to rebirth. The
soul comes before the first seven kings at seven-day
intervals, before the eighth on the hundredth day, before
the ninth on the first anniversary of death, and before the
tenth on the third anniversary of death.

In this painting, Kṣitigarbha is seated on a rocky outcrop
in the centre with the kings on either side. Below, accom-
panied by the lion with which he is usually shown, is the
priest Daoming, who went down to Hell and returned to tell
of what he had seen there. Below these figures an ox-headed
jailor with a huge club is leading in the soul of a man wearing
a cangue. In a mirror the soul is shown slaying an ox as an
example of the man's evil actions in life. RW, AF

21 Avalokiteśvara and donors

From Cave 17, Dunhuang.
Northern Song dynasty, dated 4th (*recte* 5th) year of Kaibao,
renshen (AD 972).

Ink and colours on silk. H. 103cm, W. 69cm (including border).
Painted area: H. 91.5cm, W. 59.1cm. OA 1919.1–1.052 (Ch. 00167).

Stein, *Serindia* pp. xxiii, 838n., 867, 970–1, 1336, 1395, 1402, 1417,
pl. LXI; Waley (1931) cat. no. LII; Whitfield, ACA vol. 2, pl. 26, fig.
35.

The Bodhisattva Avalokiteśvara is shown seated behind an
altar in company with six Bodhisattvas ranged in groups of
three on each side. Above the central figure a flowered
canopy is flanked by two putti-like infant *apsarasas*. The
label on the altar-hanging bears the usual inscription *Nanwu
guanshiyin pusa* ('Praise to the Bodhisattva Avalokiteśvara'),
but the calligrapher planned the layout so badly that the last
few characters had to be crammed in at a reduced scale. On
the left of the altar an inscription reads: 'Praise to the
Bodhisattva who offers up precious incense' and on the right
'Praise to the Bodhisattva who makes offering'. Below the

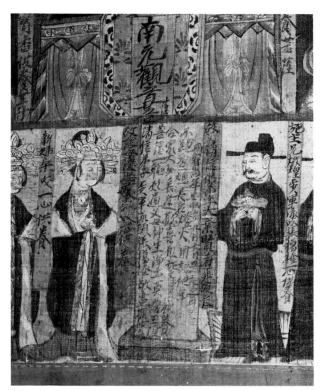

21B (detail)

main scene six donor figures are shown. The man and
woman to the right and left of the central inscription are
identified as the father and mother of Zhang Geqiao who is at
the centre of the group of three men. The man on the right is
his younger brother. The other two women are referred to as
'new wives' though it is not clear whose.

Zhang Geqiao was the captain of unmounted troops at
Dunhuang. The inscription is dated as the fourth year of the
Kaibao reign period, a *renshen* year (ninth in the sixty-year
cycle), the ninth month, sixth day. The *renshen* year was in
fact the fifth year of Kaibao. As Waley points out, it is much
more likely that the writer of the inscription should mistake
the start of the Kaibao period than the cyclical sign of the
year. On this assumption the painting is dated 15 October
AD 972. Even without this information there are a number of
obvious features which mark it as coming from the late 10th
century. Among these are the predominant bright green and
orange colours and the prominent figures of the donors
below. Both of these are paralleled in contemporary wall
paintings from Dunhuang caves. The lack of technical
sophistication shown in the execution of this work may be
a reflection of the isolation of Dunhuang around this
period. RW, AF

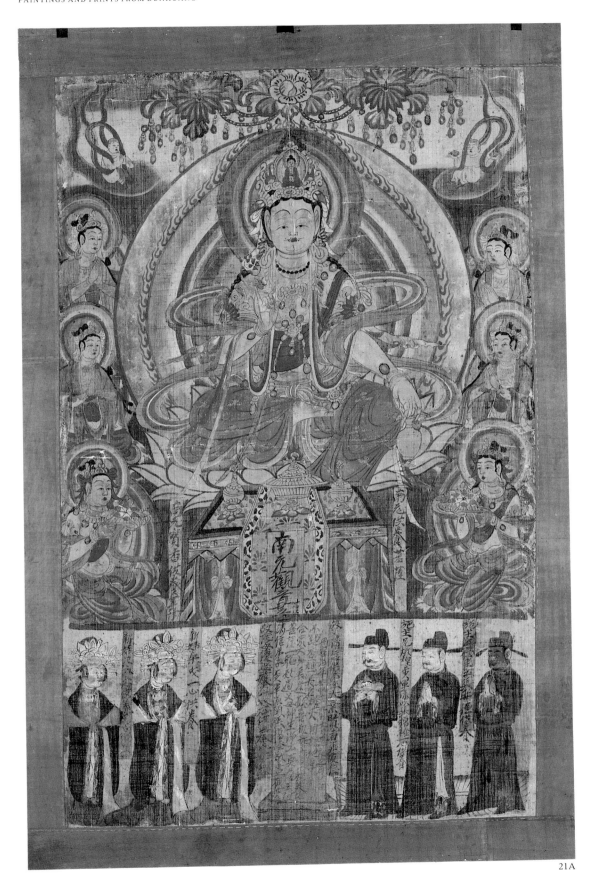

21A

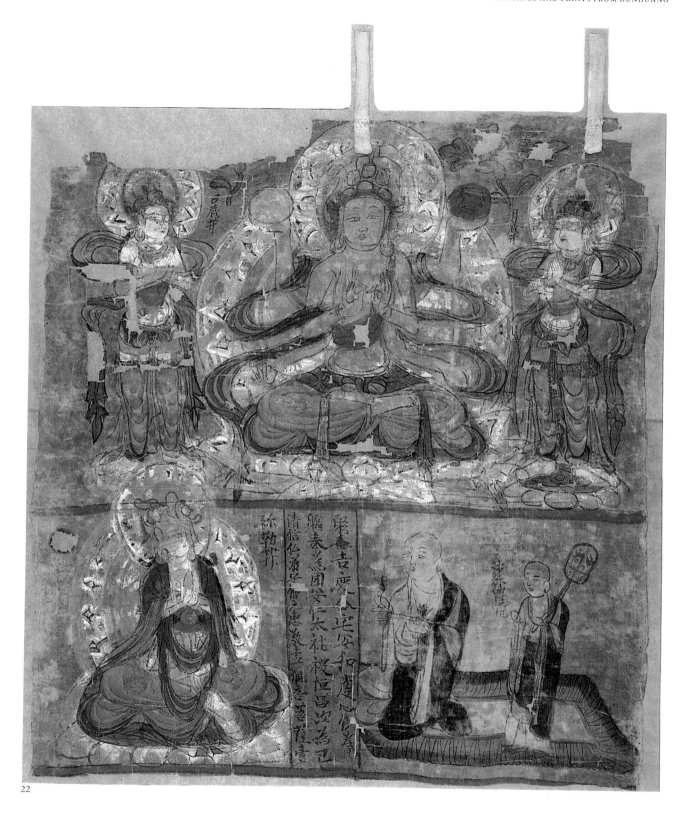

22

22 Avalokiteśvara with Sūryagarbha, Candragarbha and Maitreya Bodhisattvas

From Cave 17, Dunhuang. Five Dynasties, mid-10th century AD.

Ink and colours on silk. H. 61cm, W. 57.5cm.
OA 1919.1–1.059 (Ch. xx. 004).

Stein, *Serindia* pp. 868, 1017–8, 1398, 1408; Waley (1931) cat. no. LIX; Whitfield, ACA vol. 2, figs. 41–2.

Although this clumsily executed painting is not in the classic banner form familiar from other Dunhuang examples, the two lemon-coloured tabs at the top show that it was intended to be hung for display. A six-armed Avalokiteśvara sits cross-legged, attended by the Bodhisattvas of the Sun, Sūryagarbha, to his right, and the Moon, Candragarbha, to his left (the inscriptions identifying these figures have been reversed). Below to the left is shown Maitreya, the Buddha of the Future. On the right the painting's donor, priest Yuanhui, is attended by a figure whom an inscription identifies as the novice Liutong. The inscription reads: 'The Buddhist disciple of pure faith the priest Yuanhui reverently painted one figure of the Bodhisattva Avalokiteśvara and offered it with the prayer that the country might enjoy peace, benevolent rule and prosperity and that the harvests might be always abundant. Next, that he himself might be fortunate and that his whole household might enjoy harmony and peace. To this end dedicated with devout heart.' RW, AF

23 Bodhisattva with a glass bowl

From Cave 17, Dunhuang. Tang dynasty, late 9th century AD.

Ink and colours on silk. Whole banner: H. 172.5cm, W. 18cm.
Painted area: H. 58cm, W. 18cm. OA 1919.1–1.0120 (Ch. 0025).

Stein, *Serindia* pp. 864, 944, pl. LXXVII; Waley (1931) cat. no. CXX; Whitfield, ACA vol. 1, pls. 28, 55.

24 Vajrapāṇi

From Cave 17, Dunhuang. Tang dynasty, late 9th century AD.

Ink and colours on silk. Whole banner: H. 187.5cm, W. 18.6cm.
Painted area: H. 67.5cm, W. 18.6cm. OA 1919.1–1.0134 (Ch. 004).

Stein, *Serindia* p. 938, pl. LXXXVI; Waley (1931) cat. no. CXXXIV; Whitfield, ACA vol. 1, pls. 28, 59.

These are two of the best-preserved banner paintings from Dunhuang and typify a large group of votive works recovered from the depository of Cave 17. The typical construction of a banner is as follows: the top of the banner was a triangular headpiece of bordered silk with a hanging loop at the apex. Along the base of the triangle ran a bamboo splint or stiffener wrapped in silk. Below this came the main part of the banner in the form of a long rectangle of silk, linen or paper. A second bamboo stiffener was sewn into the lower end of the painting. From this hung silk streamers fixed into a weighting board; two long streamers were also attached to the upper stiffener at the base of the triangular headpiece. Wall paintings at Dunhuang show banners hanging from pagodas or high canopies (in Cave 220, *Flying Devis*,

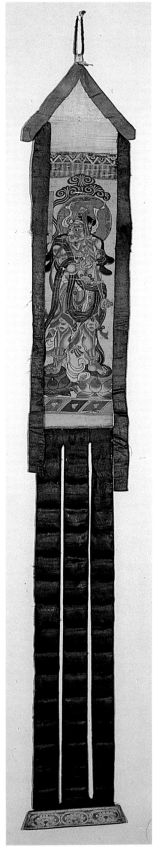

23 24

1980, pl. 52), and they were also presumably intended to be carried or displayed for worship. Two paintings in this exhibition show such a banner being carried, suspended from a lotus flower or a hook at the end of a long staff (*see* cat. nos. 14, 15).

The paintings on these two banners are on thin silk so that the painted image can be seen from both sides. Both banners have lost the triangular piece of silk from the centre of their headpieces. One banner shows an unidentified Bodhisattva portrayed in three-quarter back view. In his hand is a dimpled glass beaker containing a lotus flower. The beaker is similar to one portrayed in another banner (*see* cat. no. 39), and both were probably imports from Iran. The second banner shows a Vajrapāṇi. RW, AF

25–30 Scenes from the Life of the Buddha

An important group of banners from Dunhuang depicts scenes from the life of the Buddha. According to tradition, the Buddha was born into the Śākya clan who occupied a territory on the slopes of the Nepalese hills and on the plains to the south. The title Śākyamuni means the Sage of the Śākyas. The Buddha's personal name was Siddhārtha. Since the Śākya clan was part of the larger Gautama grouping, he is also referred to by the secular name of Gautama Siddhārtha. In Mahāyāna Buddhism, the person conventionally referred to as 'the Buddha' is only one of a great number of en-lightened beings extending into the future as well as back into the remotest past. It is said that before Śākyamuni's final rebirth in India he had undergone several hundred incarnations on his course towards enlightenment. The so-called *jātaka* stories which tell of these previous lives played a prominent role in Buddhist popular preaching and can be seen in the paintings at Dunhuang.

The main events of the Buddha's early life in India, as depicted at Dunhuang and elsewhere, can be quickly summarised. His mother Queen Māyā conceived him mir-aculously when she saw a vision of the child descending from the Tuṣita Heaven as a white elephant or as a child riding a white elephant. In the following year he was born painlessly from her right side as she stood in the Lumbinī Garden. The child took his first steps immediately after his birth while proclaiming his identity and the nature of his mission on earth. Water for his first bath was provided miraculously. Śākyamuni showed superhuman intellectual and physical abilities as a child and young man, but he was kept by his father from any contact with the world outside the palace. Finally he rode out from the gate and for the first time encountered examples of old age, sickness and death. Having perceived the inevitability of human suffering in this existence, he abandoned his rank and possessions and lived as a hermit in search of enlightenment. AF

25 Scenes from the Life of the Buddha: Departure of Chandaka; the Search

From Cave 17, Dunhuang. Tang dynasty, 8th century AD.

Ink and colours on silk. Upper part: H. 18.5cm, W. 19cm.
Lower part: H. 14cm, W. 19cm. OA 1919.1–1.095 (Ch. lxi. 002).

Stein, *Serindia* pp. 852, 858, 1085, pl. LXXVI; Waley (1931) cat. no. XCV; Whitfield, ACA vol. 1, pl. 29, fig. 85.

The incomplete cartouche at the bottom of the third scene suggests that this banner was originally in four sections. The three scenes remaining show incidents shortly after Śāk-yamuni's departure from his father's palace. In the first is depicted a tearful farewell between the young prince, his groom Chandaka, and his horse Kaṇṭhaka. The second shows the groom riding down a rocky valley while Śākyamuni watches from a ledge. The last shows the five messengers sent out by Śākyamuni's father to look for him. The organ-isation of the banner resembles the side scenes in paradise paintings: the figure groups are in landscape settings with the slopes of the landscape serving to divide the individual scenes. RW, AF

26 Scenes from the Life of the Buddha: Dīpaṃkara's (?) Prediction; Old Age, Sickness and Death; the Conception

From Cave 17, Dunhuang. Tang dynasty, 9th century AD.

Ink and colours on silk. H. 60cm, W. 16.5cm.
OA 1919.1–1.096 (Ch. lv. 009).

Stein *Serindia* pp. 850, 852, 854–5, 857, 1062–3, pl. LXXIV; Waley (1931) cat. no. XCVI; Whitfield, ACA vol. 1, pl. 30, fig. 85.

This banner is one of a pair, the other of which is in New Delhi (Ch. lv. 0010, *Serindia*, pl. LXXIV). It shows four scenes relating to the birth of the Buddha and his call to the religious life. In the first (26A) a Buddha, accompanied by two attendants, touches the head of a young hermit. It is almost certain that this scene represents one of the many Buddhas of the Past, possibly Dīpaṃkara, predicting that in a future existence the young man would be born as Śāk-yamuni. The next scene depicts Old Age, Sickness and Death, represented as emblems of the evils from which Śāk-yamuni was to release mankind. They are shown as an old man supported by a boy, then on his sick bed, and last as a corpse with his soul flying up to a paradise represented by buildings in the sky. The third scene (26B) shows the con-ception of Śākyamuni as his mother Māyā dreams of the descent of a white elephant with a naked infant on its back. Two explanations have been offered for the last scene. Waley suggests that it shows the return of Māyā to her father's palace, in which case she would be the slightly larger figure wearing the golden hair-ornament. Whitfield suggests that the two women are attendants keeping watch outside the pavilion in which Māyā awaits the birth of her child. RW, AF

53

25

26B

26A

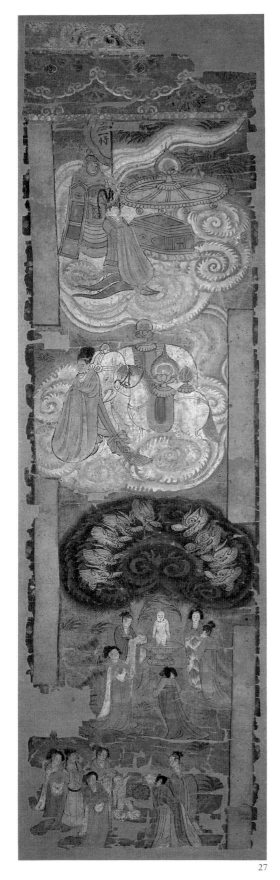

27

28

29

27 Scenes from the Life of the Buddha: the Bath in the Lumbinī Garden and the First Steps, together with the Seven Treasures of the Cakravartin

From Cave 17, Dunhuang. Tang dynasty, 9th century AD.

Ink and colours on silk. H. 65.5cm, W. 19cm.
OA 1919.1–1.099 (Ch. 00114).

Stein, *Serindia* pp. 852, 855–6, 962–3, pl. LXXIV; Waley (1931) cat. no. XCIX; Whitfield, ACA vol. 1, pl. 32.

This banner shows scenes on two apparently unrelated themes. The upper half depicts the Seven Treasures of the Cakravartin, who is the ideal type of righteous Buddhist ruler. The treasures consist of the ruler's skilled general; his royal consort; his *maṇi* stone, symbol of the accomplishment of wishes, in a box; the wheel, symbol of the Perfection of the Law; his civil minister; his elephant and his horse. The lower two sections show scenes from the birth of the Buddha. First is depicted his bath in the Lumbinī Garden, for which the water was provided miraculously by nine water spirits. In Indian mythology these would be *nāga* serpents, but they appear here as heads of Chinese dragons. In the second and last scene the child makes his first seven steps: to the north, east, south, west, upwards, downwards and to the centre. As he paced them out, leaving lotus footprints (in this and other Chinese renderings), the child proclaimed: 'Ended are birth, old age, sickness and death'. RW, AF

28 Scenes from the Life of the Buddha: seated Buddha; Śākyamuni in Discussion; the Iron Targets

From Cave 17, Dunhuang.
Tang dynasty, 8th or early 9th century AD.

Ink and colours on silk. H. 42.5cm, W. 17.5cm.
OA 1919.1–1.090 (Ch. xlix. 006).

Stein, *Serindia* pp. 850, 854, 856–7, 1051; Waley (1931) cat. no. XC; Whitfield, ACA vol. 1, pl. 34.

29 Scenes from the Life of the Buddha: The Four Encounters: Old Age and Sickness

From Cave 17, Dunhuang.
Tang dynasty, 8th or early 9th century AD.

Ink and colours on silk. H. 37.5cm, W. 17.7cm.
OA 1919.1–1.088 (Ch. lv. 0016).

Stein, *Serindia* pp. 850n., 853, 857, 1065–6; Waley (1931) cat. no. LXXXVIII; Whitfield, ACA vol. 1, pl. 35.

The similarity of these two finely executed fragments of banners suggests that they once formed part of a series representing Śākyamuni's life in sequence. Each scene is framed and divided by a striped band with individual florets. The first fragment (cat. no. 28) shows the Buddha seated on a red lotus with one hand in the gesture of banishing fear (*abhaya-mudrā*) and the other in the gesture of giving (*varada-mudrā*). Below this is a scene in which the

30

eight-year-old prince is shown displaying his wisdom in discussion with the teachers of civil and military science brought to instruct him in the palace. The next picture below is damaged and its caption incomplete, but the row of black objects can be identified as the iron target drums used in an athletic contest in which Śākyamuni took part. He alone was able to shoot an arrow through all of them.

During his boyhood the young prince led a life of sheltered luxury in the palace. The second fragment (cat. no. 29) shows two of the Four Encounters which first make him aware of the existence of human suffering. These are the Encounter with Old Age as he meets an aged man in the upper scene, and the Encounter with Sickness showing a sick man below. RW, AF

30 Scenes from the Life of the Buddha: the Farewell; the Cutting of the Locks; the Life of Austerities

From Cave 17, Dunhuang.
Tang dynasty, 8th–early 9th century AD.

Ink and colours on silk. H. 58.5cm, W. 18.5cm.
OA 1919.1–1.097 (Ch. lv. 0012).

Stein, *Serindia* pp. 847n., 852sq., 858sq., 1064, pl. LXXV; Waley (1931) cat. no. XCVII; Whitfield, ACA vol. 1, pl. 38.

This banner depicts three scenes from the Buddha's entry into the religious life. From top to bottom the scenes represented are the young prince's farewell to his horse and groom, the cutting of his hair and the beginning of his life as an ascetic. A banner in New Delhi (Ch. lv. 0011, Stein, *Desert Cathay* vol. II, pl. VI) shows scenes preceding those on this banner and seems to match it in style. What makes this painting unique among the contents of Cave 17 is its sophisticated depiction of landscape, particularly in the upper two scenes. These are perfect early examples of two of the three categories of distance described two centuries later by the Northern Song painter Guo Xi (c.1020–90). In the uppermost scene, distant mountains appear beyond a level expanse of water seen round the edge of a high cliff. This is what Guo Xi calls 'deep distance'. The towering mountains of the middle scene with swirling clouds among their peaks represent what he calls 'high distance'. The lowest scene is stylistically cruder than the others. It attempts somewhat unsuccessfully to give an impression of depth through the use of two parallel receding mountain ridges. Guo Xi's third category of 'level distance', in which the view is from one mountain peak to another, is not represented here. Another important feature of this banner is the way in which *cun*, short textured strokes, are used to give three-dimensionality to the mountain ridges. RW, AF

31 Bodhisattva with cintāmaṇi

From Cave 17, Dunhuang. Tang dynasty, late 9th century AD.

Ink and colours on silk. H. 71cm, W. 17.5cm.
OA 1919.1–1.0136 (Ch. lv. 0026).

Stein, *Serindia* p. 1069; Waley (1931) cat. no. CXXXVI; Whitfield, ACA vol. 1, pl. 42, fig. 87.

This banner of an unidentified Bodhisattva has retained its headpiece although its streamers are lost. It closely resembles two other paintings in the British Museum collection (cat. no. 32 and Whitfield, ACA vol. 1, fig. 94) and like them may have been made using a stencil. Contrasting colours have been used for the portrayal of the garments and their linings with the effect of dividing the draperies into narrow bands of colour. This tendency anticipates a mannerism which was carried even further in the wall paintings of the Song and the Yuan. RW, AF

32 Bodhisattva with censer

From Cave 17, Dunhuang. Tang dynasty, late 9th century AD.

Ink and colours on silk. H. 68.2cm, W. 19cm.
OA 1919.1–1.0125* (Ch. i. 005).

Stein, *Serindia* p. 1009; Waley (1931) cat. no. CXXV*; Whitfield, ACA vol. 1, pl. 43.

This banner shows an unidentified Bodhisattva carrying a censer in his left hand. The headpiece belonging to it is now kept separately from the painting. This is one of the works showing clear evidence for the use of stencils at Dunhuang: the Bodhisattva is in an identical but reversed pose to the one in another banner in the British Museum collection (Whitfield, ACA vol. 1, fig. 94). Both figures must have been outlined using the same stencil, though from opposite sides. The British Museum collection includes examples of pricked paper stencils probably used for transferring images for wall paintings (*see* cat. nos. 70, 71), but a different type of stencil may have been used for transferring a design to silk. A stencil portraying a Bodhisattva, found at Dunhuang and now in New Delhi, may have been the type used in this case. Made of paper, it has all the details drawn in and the main parts cut out (Stein, *Serindia* Ch. 00425, p. 999; *The Silk Route and the Diamond Path*, 1982, pp. 149–50, pl. 74). RW, AF

33 Kṣitigarbha

From Cave 17, Dunhuang. Tang dynasty, 9th century AD.

Ink and colours on silk. H. 63.7cm, W. 17cm.
OA 1919.1–1.0118 (Ch. lxi. 004).

Stein, *Serindia* p. 1085; Waley (1931) cat. no. CXVIII; Whitfield, ACA vol. 1, pl. 45.

Kṣitigarbha, a Bodhisattva who was most popular in the late Tang dynasty, is identified by the inscription in the cartouche on the left which reads: 'Praise to the Great Wise Kṣitigarbha Bodhisattva'. In this painting he is dressed as a travelling monk with a water-sprinkler but without his usual attributes of a staff and *cintāmaṇi* jewel. RW, AF

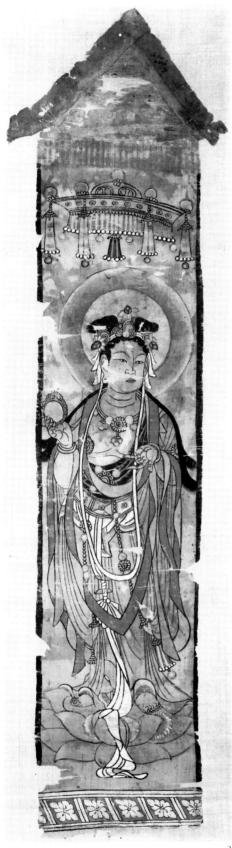

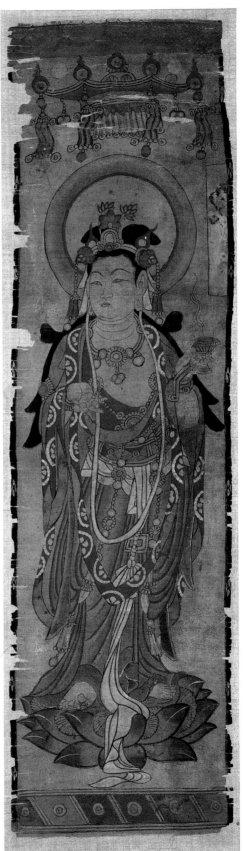

31

32

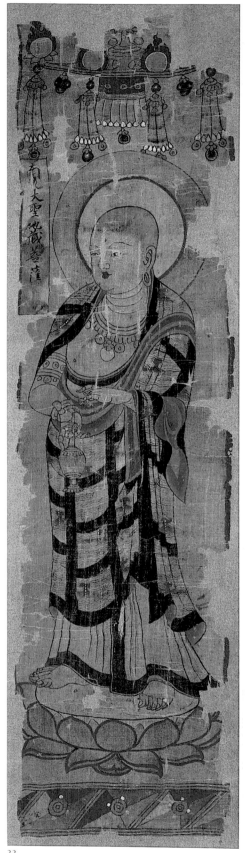

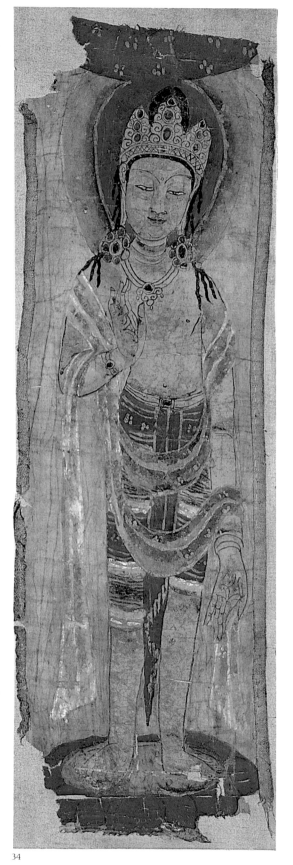

33

34

34 Bodhisattva

From Cave 17, Dunhuang. Tang dynasty, early 9th century AD.

Ink and colours on silk. H. 44.5cm, W. 14.5cm.
OA 1919.1–1.0101 (Ch. lvi. 008).

Stein, *Serindia* pp. 862, 1075; Waley (1931) cat. no. CI; Whitfield, ACA vol. 1, pl. 46.

This and the following two works come from a closely related series of ten items, the other seven of which are in New Delhi (several are illustrated in Matsumoto, 1937, pls. 201–2). They have marked non-Chinese characteristics which may relate to the art of Khotan or western Tibet. In these works the Bodhisattvas stand with feet close together and legs almost straight. The otherwise naked torsos bear floral shawls and all wear tightly wrapped dhotis. The three-pronged tiara is found in figures from the period of Tibetan occupation of Dunhuang (AD 781–847). The construction of the banners differs markedly from that of other Dunhuang banners. The weave of the silk is close and balanced whereas the majority are on silk of a relatively open weave with paired warp threads. The strips of silk are narrower and are hemmed on both edges with a selvedge on the lower end. The figures are therefore at right angles to the original warp rather than in line with it. These differences of manufacture suggest that the banners were executed elsewhere and later brought to Dunhuang, rather than painted there.　RW, AF

35 Bodhisattva with Lotus (Padmapāṇi?)

From Cave 17, Dunhuang. Tang dynasty, early 9th century AD.

Ink and colours on silk. H. 51cm, W. 14cm.
OA 1919.1–1.0102 (Ch. lvi. 003).

Stein, *Serindia* pp. 862, 1074, pl. XXXVII; Waley (1931) cat. no. CII; Whitfield, ACA vol. 1, pl. 47.

This Bodhisattva figure holding a lotus may represent Padmapāṇi, a form of Avalokiteśvara. In this painting it is clear that the three-quarter view of the face has been drawn according to the principles of foreshortening laid down in Indian handbooks on wall painting. These dictate that the receding parts of the face are contracted and the nearer parts enlarged (Bussagli, 1963, p. 32).　RW, AF

36 Bodhisattva Vajrapāṇi

From Cave 17, Dunhuang. Tang dynasty, early 9th century AD.

Ink and colours on silk. H. 55cm, W. 14.5cm.
OA 1919.1–1.0103 (Ch. lvi. 002).

Stein, *Serindia* pp. 862, 1074, 1474, pl. LXXXVII; Waley (1931) cat. no. CIII; Whitfield, ACA vol. 1, pl. 48.

This figure may be identified as the Bodhisattva Vajrapāṇi, as he holds a small *vajra* or thunderbolt in his left hand. There is a Tibetan inscription under the right tassel of the canopy. The silk has the same characteristics as the two previous items (*see* cat. no. 34).　RW, AF

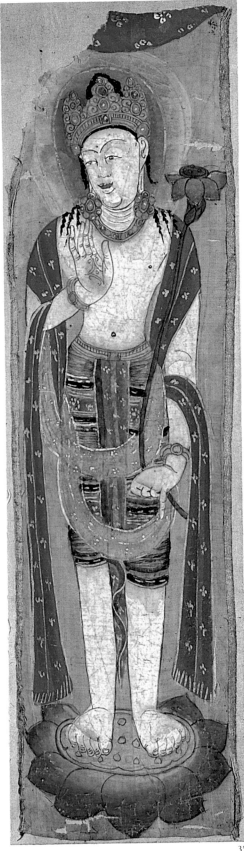

35

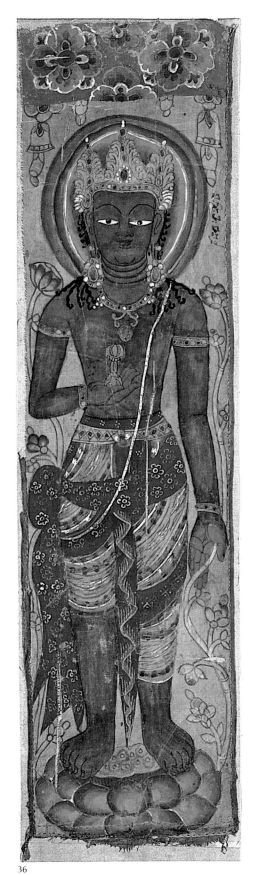

36

37 Avalokiteśvara

From Cave 17, Dunhuang. Tang dynasty, 9th century AD.

Ink and colours on silk. H. 46cm, W. 18cm.
OA 1919.1–1.0130 (Ch. lv. 0032).

Stein, *Serindia* p. 1071; Waley (1931) cat. no. CXXX; Whitfield, ACA vol. 1, pl. 51.

The figure of Avalokiteśvara has been painted on top of another design which shows through on the Bodhisattva's left side and on his feet. Waley commented: 'This is one of the few paintings of the collection which seem to be the product of an artist and not a mere workman . . .' The painting has been skilfully executed with crisp outlines; colour shading and highlighting give the work a sculptural quality. Some features of the figure such as the straight, almost stiff legs and the large relatively long arms suggest associations with the art of Khotan. Although high quality is generally characteristic of work of an early date, the smooth ellipse of the face and the matching curves of the torso point to a mid-9th century date for this painting. RW, AF

38 Bodhisattva Mañjuśrī

From Cave 17, Dunhuang. Tang dynasty, 9th century AD.

Ink and colours on silk. H. 66cm, W.24.8cm.
OA 1919.1–1.0141 (Ch. 0036).

Stein, *Serindia* pp. 946–7; Waley (1931) cat. no. CXLI; Whitfield, ACA vol. 1, pl. 54.

The identity of this banner painting puzzled Waley, who felt that its wholly Indian style must suggest a Bodhisattva of Indian origin. Whitfield has pointed out the similarities between this and a banner in the Pelliot collection in Paris (*Bannières*, No. 126) showing Mañjuśrī, the Bodhisattva of Wisdom, but portrayed in Chinese style with a heavy-bodied figure concealed in ample draperies. In this painting the Bodhisattva sits on a scarlet lotus supported on a gold pedestal on the lion's back. The Bodhisattva's right hand is in the gesture of giving (*varada-mudrā*) and his left hand, resting on a lotus seat, holds a long-stemmed lotus. His legs are in the *lalitāsana* pose. The physical type, dress and stance of this figure are Indian. The advancing lion, whose motion is shown in the swaying tassels of the canopy above the Bodhisattva's head, is accompanied by a dark-skinned attendant as found in the large-scale compositions of Mañjuśrī and Samantabhadra (*see* cat. nos. 3, 5, 17, 18). It is possible that this banner was originally one of a matching pair, faced by Samantabhadra riding an elephant. RW, AF

39 Bodhisattva with glass bowl

From Cave 17, Dunhuang. Tang dynasty, late 9th century AD.

Ink and colours on silk. H. 81.5cm, W. 26.3cm.
OA 1919.1–1.0139 (Ch. 001).

Stein, *Serindia* p. 937, pl. LXXIX; Waley (1931) cat. no. CXXXIX; Whitfield, ACA vol. 1, pl. 56.

This painting of a Bodhisattva was originally the central

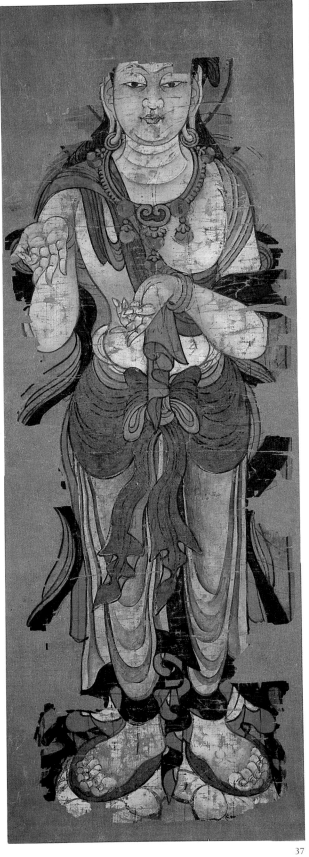

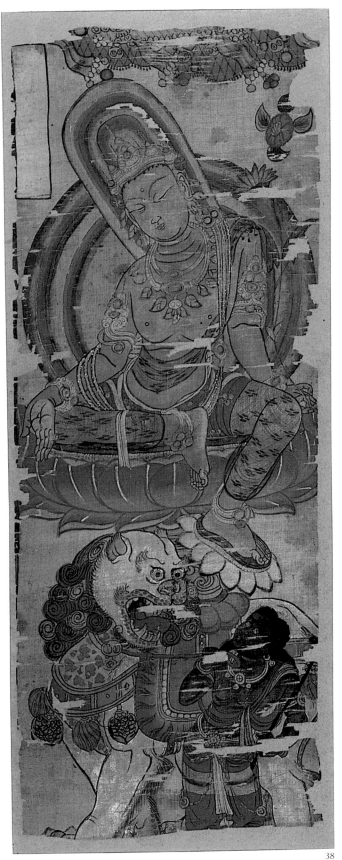

37

38

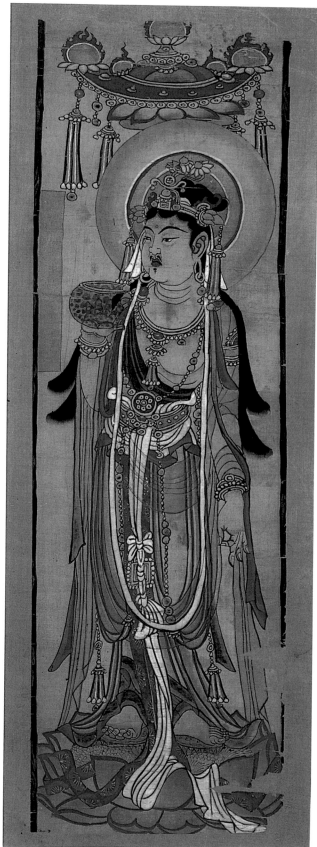

39

portion of a banner of which all the accessories are now lost. The painting is closely related in style and colour to a Vajrapāṇi in this exhibition (see cat. no. 40). This Bodhisattva already shows the full-fleshed features seen in Buddhist figures under the Song dynasty. Although the outlines are much more slender than those used for the Vajrapāṇi, the same short discontinuous strokes of the brush can be seen in the more exaggerated lines of the Vajrapāṇi. Especially interesting here is the large dimpled glass bowl held in the Bodhisattva's upturned right hand. A similar example is found in the 8th-century depository of the Shōsō-in at Nara in Japan (Shōsō-in no garasu, pl. 1). The glass bowl of the painting resembles examples excavated in Iran which were evidently traded eastwards along the Silk Route and incorporated into the iconography of Buddhist art at Dunhuang. RW, AF

40 Vajrapāṇi

From Cave 17, Dunhuang. Tang dynasty, late 9th century AD.

Ink and colours on silk. H. 79.5cm, W. 25.5cm.
OA 1919.1–1.0132 (Ch. xxiv. 002).

Stein, *Serindia* p. 1028, pl. LXXXVI; Waley (1931) cat. no. CXXXII; Whitfield, ACA vol. 1, pl. 58.

This painting of a Vajrapāṇi or thunderbolt-bearer was the central part of a banner whose four grey silk damask streamers (now separately preserved in the British Museum) would originally have brought the length of the banner to just over 2m. The Vajrapāṇi stands with flexed muscles, holding a thunderbolt in his left hand, with firmly planted heels and clenched toes in a pose commonly found in renderings of this figure from the Tang and Five Dynasties. The figure is outlined with short, highly inflected brush strokes whose boldness considerably enhances the figure's frightening appearance. The body is covered in a network of modelling in pink to suggest the musculature. This technique is also found on attendant and demonic figures at Dunhuang dating from the mid-Tang to the Five Dynasties period, being used to particular effect in the figures of the mourners at the *nirvāṇa* of the Buddha in Cave 159. RW, AF

41 Vajrapāṇi

From Cave 17, Dunhuang. Tang dynasty, late 9th century AD.

Ink and colours on silk. H. 64cm, W. 18.5cm.
OA 1919.1–1.0123 (Ch. xxvi. a. 005).

Stein, *Serindia* p. 1032; Waley (1931) cat. no. CXXIII; Whitfield, ACA vol. 1, pl. 57, fig. 101.

This banner has four bottom streamers of dark blue silk and side streamers of bluish green and plain green (not illustrated here), but the weighting board, which would have held the whole assembly fully extended, is missing. The bottom streamers and one side streamer are stamped with motifs of flowers and insects, which suggests that the plain green streamer may be a replacement. The headpiece remains, but its centre is decayed. This Vajrapāṇi holds a

thunderbolt in his right hand and, as in the previous painting, the musculature of his body has a striking network of modelling in cherry-pink colour. RW, AF

42 Virūpākṣa, Guardian of the West

From Cave 17, Dunhuang. Tang dynasty, 9th century AD.

Ink and colours on silk. H. 45.5cm, W. 16cm.
OA 1919.1–1.0106 (Ch. xlix. 007).

Stein, *Serindia* p. 1052; Waley (1931) cat. no. CVI; Whitfield, ACA vol. 1, pl. 61.

43 Dhṛtarāṣṭra, Guardian of the East

From Cave 17, Dunhuang. Tang dynasty, 9th century AD.

Ink and colours on silk. H. 40.5cm, W. 15.5cm.
OA 1919.1–1.0129 (Ch. xxvi. a. 006).

Stein, *Serindia* p. 1032–3, pl. LXXXVII; Waley (1931) cat. no. CXXIX; Whitfield, ACA vol. 1, pl. 62.

These two banners depict Virūpākṣa, Guardian King of the West, and Dhṛtarāṣṭra, Guardian King of the East, who is identified by his bow and arrow. Stein suggested that these two banners belonged to the same series since they are both unusual in having a selvedge at the bottom so that the warp threads are horizontal instead of vertical. They also have similar sage-green streamers. Virūpākṣa is shown with his face tinted in red, the distinctive colour which is his attribute, while the painting of Dhṛtarāṣṭra seems originally to have involved copious use of the white colouring appropriate to him. Both figures stand on demons. RW, AF

44 Vaiśravaṇa, Guardian of the North

From Cave 17, Dunhuang. Tang dynasty, 9th century AD.

Ink and colours on silk. H. 50.5cm, W. 17.5cm.
OA 1919.1–1.0138 (Ch. lv. 0018).

Stein, *Serindia* pp. 1066, 1261, pl. LXXXV; Waley (1931) cat. no. CXXXVIII; Whitfield, ACA vol. 1, pl. 65.

Vaiśravaṇa, Guardian King of the North (*see* cat. nos. 9, 85), is often shown with a large retinue but here he appears alone. In all probability this banner was one of a series showing each of the Guardian Kings. Vaiśravaṇa may be recognised by the small stūpa poised above his right hand. RW, AF

45 Bodhisattva of the Sun

From Cave 17, Dunhuang. Tang dynasty, 8th century AD.

White outline and colours on silk. Length (total): 213.0cm.
Painted area: H. 89.6cm, W. 25.5cm. OA 1919.1–1.0121 (Ch. 00303).

Stein, *Serindia* pp. 911n., 987, pl. CXIII; Waley (1931) cat. no. CXXI; Whitfield, ACA vol. 2, pl. 30, fig. 44.

This banner is complete apart from some damage to the headpiece and foot. The Bodhisattva is identified by the inscription in the cartouche as *Ri yao pu sa* ('Bodhisattva of

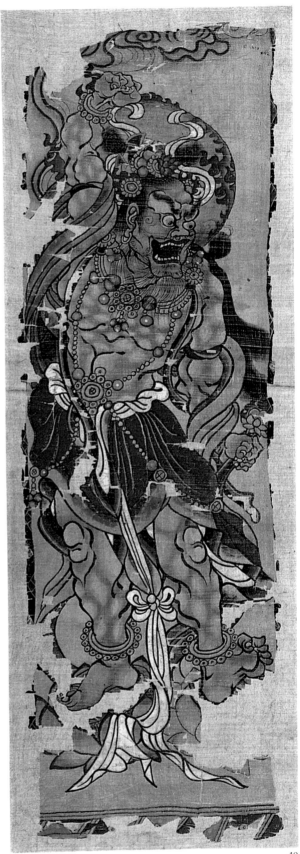

40

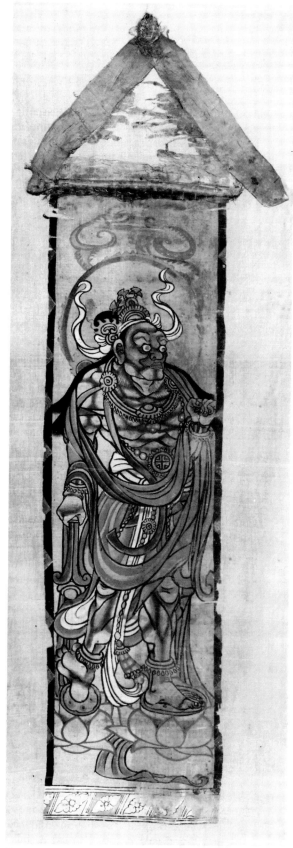

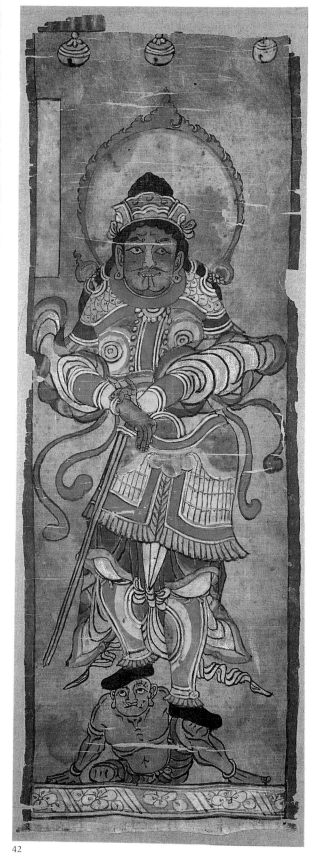

41

42

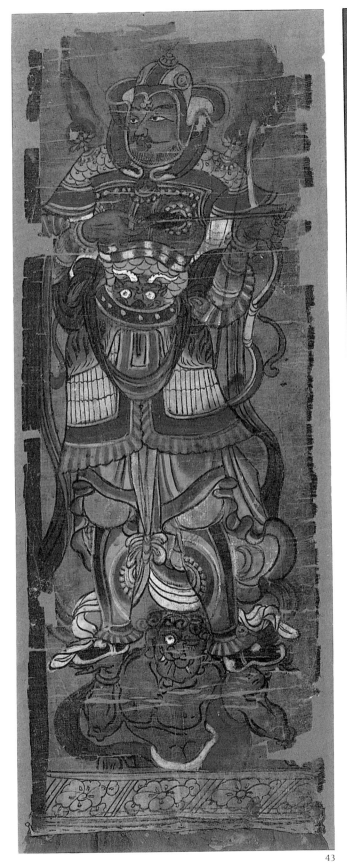

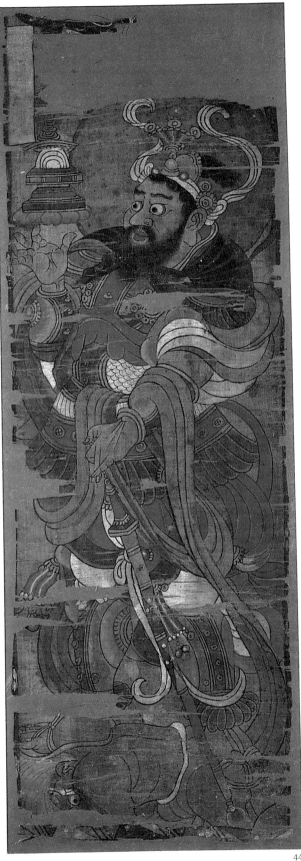

43

44

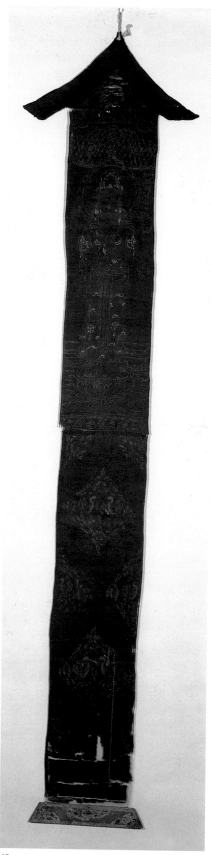

45

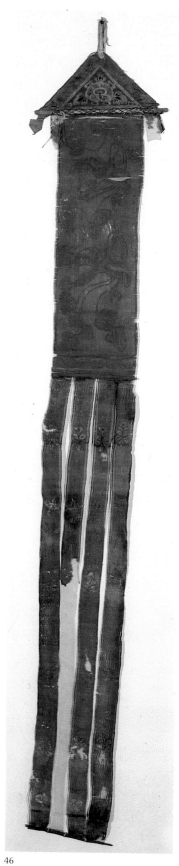

46

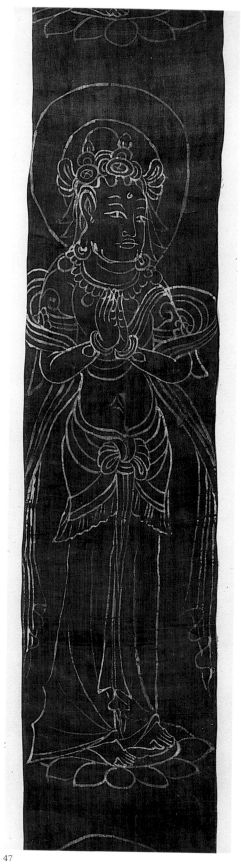

47

the Sun') who Waley suspects is identical with *Ri guang pu sa* or Sūryaprabha. This Bodhisattva together with Candraprabha, Bodhisattva of the Moon (*see* cat. no. 22), were the chief attendants on Bhaiṣajyaguru (Whitfield, ACA vol. 1, pl. 9). Here the Bodhisattva stands on a lotus holding a disc containing a cockerel which is a symbol of the sun. The Bodhisattva is outlined in white to represent silver, and yellow is used for gold to show the ornaments and patterns on the dress. The Bodhisattva has been painted on both sides of the banner. On many banners the silk used for the painted areas is thin enough to allow the image on one side to be visible from the back, but the closely woven dark blue silk used for this banner is not translucent so the image has been painted twice.

Separating the Bodhisattva from the lower part of the banner is a border of lozenges. The lower part of the banner is an undivided piece of silk of the same dark blue as above, which has been painted with a motif of confronting ducks within a flower-and-leaf border. The pattern of confronting ducks is similar to that of an 8th-century printed textile in the Shōsō-in at Nara in Japan (Matsumoto, 1974, pl. 19) and the technique of painting on to a darker background recalls other works in the Shōsō-in. The weighting board is painted in green and black on a red ground. RW, AF

46 Banner with flying ducks

From Cave 17, Dunhuang. Tang dynasty, 8th century AD.
Silver on silk. Length (total): 131cm.
Painted area: H. 43.8cm, W. 14.2cm. OA 1919.1–1.0127 (Ch. 0024).
Stein, *Serindia* p. 944; Waley (1931) cat. no. CXXVII; Whitfield, ACA vol. 2, pl. 31, fig. 45.

The flying ducks carrying sprays of leaves were painted in silver which has now oxidised. Waley has suggested that the pairing of ducks might signify that this was a marriage banner. However, there is a clear similarity between this and three larger banners in the Pelliot collection in Paris (*Bannières*, Nos. 205, 212, 213). One shows a *kalaviṅka* or musician with the body of a bird, playing a *pipa*, and each of the other two shows a bird with a spray of leaves and flowers. This suggests that these paintings were all intended to show birds and musicians dwelling in the Western Paradise as depicted in large paradise scenes (*see* cat. no. 16). RW, AF

47 Long banner of Bodhisattvas (detail)

From Cave 17, Dunhuang. Five Dynasties, mid-10th century AD.
Colour on silk. Length (total): 347.5cm, W. 28.5cm.
OA 1919.1–1.0214 (2) (Ch. 00475).
Stein, *Serindia* pp. 1004–5; Waley (1931) cat. no. CCXIV; Whitfield, ACA vol. 2, pl. 35, fig. 50.

The silk used for the finer banners was available in very long rolls, so occasionally banners of great length are found. One text called the *Guanding jing* and connected with the cult of Bhaiṣajyaguru, the Medicine Buddha, calls for banners of 49 *chi* (Chinese feet) in length (translated by Alexander Soper,

1959, p. 171). This is equivalent to 12.25m allowing 25cm for each *chi* in Tang China. This banner fragment and its pair are much shorter. By comparison with more complete specimens it seems they may have been joined at the top and intended to hang side by side from a triangular headpiece. Other banner fragments in the Pelliot collection in Paris (*Bannières*, Nos. 182, 182 bis) are very similar in material, width, colour and line. If they are all assumed to be part of the same original banner, a length approaching 49 *chi* might have been attained. RW, AF

48 Long banner of Bodhisattvas (detail)

From Cave 17, Dunhuang. Five Dynasties, mid-10th century AD.
Ink on silk. Length (total): 835cm. OA 1919.1–1.0205 (Ch. 00474).
Stein, *Serindia* p. 1004; Waley (1931) cat. no. CCV; Whitfield, ACA vol. 2. pl. 36, fig. 52.

This long banner on yellow silk shows nine Bodhisattvas painted in ink with a floral motif above each figure and an accompanying laudatory inscription. A narrow strip of red silk is sewn across the top of the banner. The repeated horizontal breaks seen near the waists and hips of the Bodhisattvas are repeated three or four times over the length of the banner. They may have been caused by irregularities on the surface on which the silk was placed for drawing the successive sections. RW, AF

49 Long banner of seated Buddhas (detail)

From Cave 17, Dunhuang. Five Dynasties, mid-10th century AD.
Ink on silk. Length (total): 538cm, W. 18cm.
OA 1919.1–1.0195 (Ch. 00476).
Stein, *Serindia* p. 1005; Waley (1931) cat. no. CXCV; Whitfield, ACA vol. 2, pl. 37, fig. 51.

This banner is narrower than the previous examples of long banners. Both edges have been sewn to prevent fraying. Bearing in mind that the standard width for silk was about 60cm, it would seem that this is the central portion of a banner divided into three long strips. It is possible that the flanking strips of silk may have shown Bodhisattvas or *apsarasas* attending the Buddhas shown in the central strip. There is an equally narrow banner painted in red in the Pelliot collection in Paris (*Bannières*, No. 204). RW, AF

50 Avalokiteśvara

From Cave 17, Dunhuang.
Late Tang or early Five Dynasties, late 9th–early 10th century AD.
Ink and colours on paper. Length (total): 98cm.
Painted area: H. 38.5cm, W. 11.5cm.
OA 1919.1–1.0142 (Ch. xx. 0013).
Stein, *Serindia* p. 1019, pl. XCIX; Waley (1931) cat. no. CXLII; Whitfield, ACA vol. 2, pl. 45.

The best-quality votive banners found at Dunhuang were made of silk, but devotees who could not afford silk were also catered for. This Avalokiteśvara banner is made of

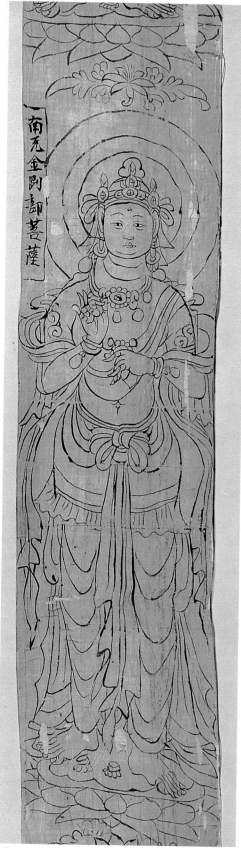

48

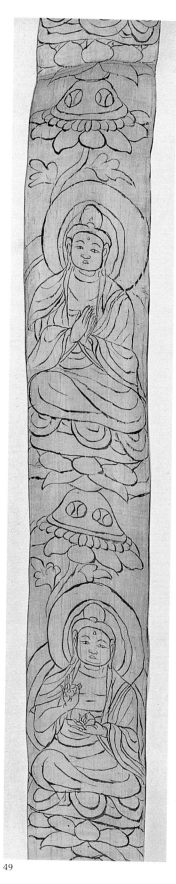

49

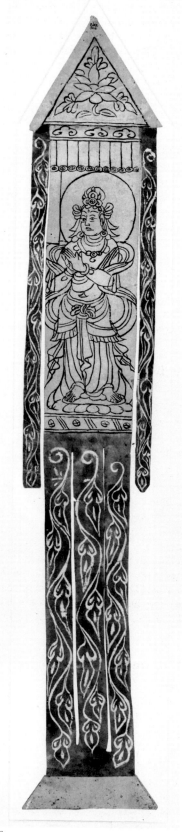

50

paper and shows all the features and appurtenances of more expensive silk versions. Its good condition suggests that it may have been painted but not yet purchased or used by the time it was stored in Cave 17.　　　　　　RW, AF

51 Avalokiteśvara

From Cave 17, Dunhuang.
Late Tang or early Five Dynasties, late 9th–early 10th century AD.

Ink and colours on paper. Length (total): 99cm.
Painted area: H. 42cm, W. 16cm. OA 1919.1–1.0144 (Ch. lxiv. 003).

Stein, *Serindia* p. 1086; Waley (1931) cat. no. CXLIV; Whitfield, ACA vol. 2, pl. 46.

This banner depicting Avalokiteśvara is made of local paper and is a further example of the more humble votive paintings found in Cave 17. As well as using a cheap material, the banner has been slightly simplified in structure by indicating the tail streamers with ink lines instead of cutting them into strips.　　　　　　RW, AF

52 Avalokiteśvara

From Cave 17, Dunhuang.
Tang dynasty, early to mid-9th century AD.

Ink and colours on paper. H. 30cm, W. 26cm.
OA 1919.1–1.0160 (Ch. 00401).

Stein, *Serindia* pp. 891, 997; Waley (1931) cat. no. CLX; Whitfield, ACA vol. 2, pl. 47.

This figure of Avalokiteśvara is the first of a group of three paintings with Tibetan donor inscriptions that seem to come from the period between AD 781 and 847 when Dunhuang was under Tibetan control (*see* cat. nos. 53, 54). All three have broad margins painted in brown and similar canopies and haloes. However, in this painting the top and bottom have been lost so that only a tassel from the canopy and a single stroke of the donor's inscription (bottom right) remain. A number of features of this painting are distinctively Tibetan such as the inclination of the head, the positioning of the feet and the flowing feminine curves of the figure. The fact that the two paintings with surviving inscriptions bear numerals corresponding to 38 and 94 suggests that the corpus of works of this type at Dunhuang must originally have been quite extensive.　　　　　　RW, AF

53 Bodhisattva (Ākāśagarbha?)

From Cave 17, Dunhuang.
Tang dynasty, early to mid-9th century AD.

Ink and colours on paper. H. 42.5cm, W. 26cm.
OA 1919.1–1.0168* (Ch. 00377).

Stein, *Serindia* pp. 993–4; Waley (1931) cat. no. CLXVIII*; Whitfield, ACA vol. 2, pl. 48.

The second of these three Tibetan paintings depicts a frowning Bodhisattva accompanied by the emblems of the sun and moon. This figure may be tentatively identified as

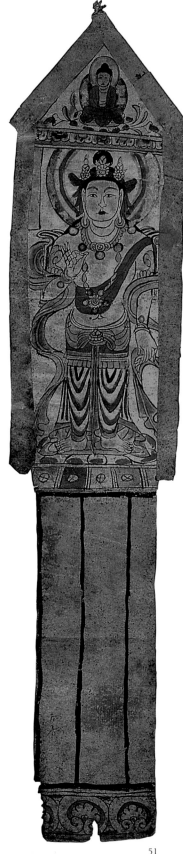

51

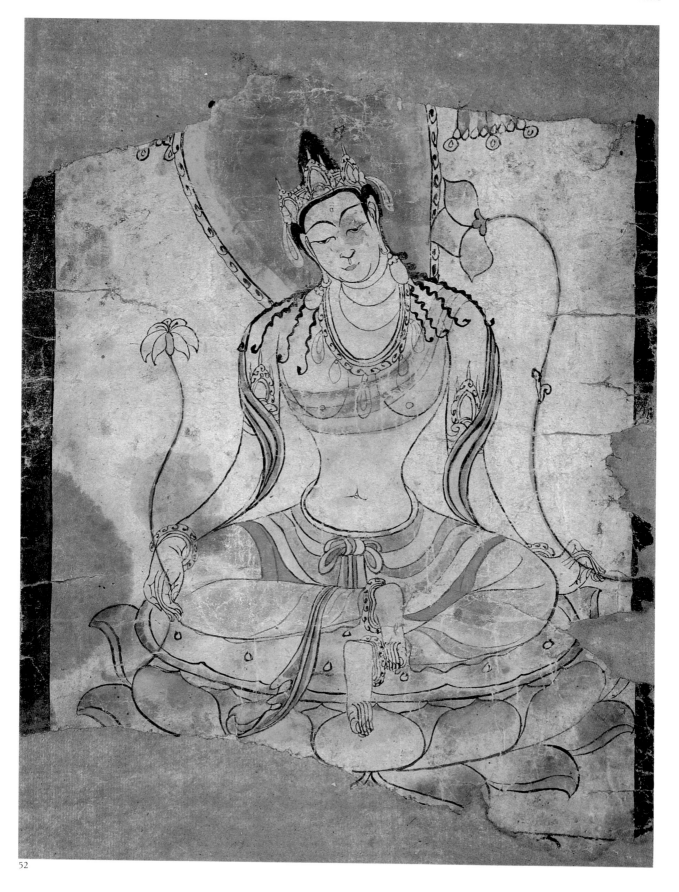

52

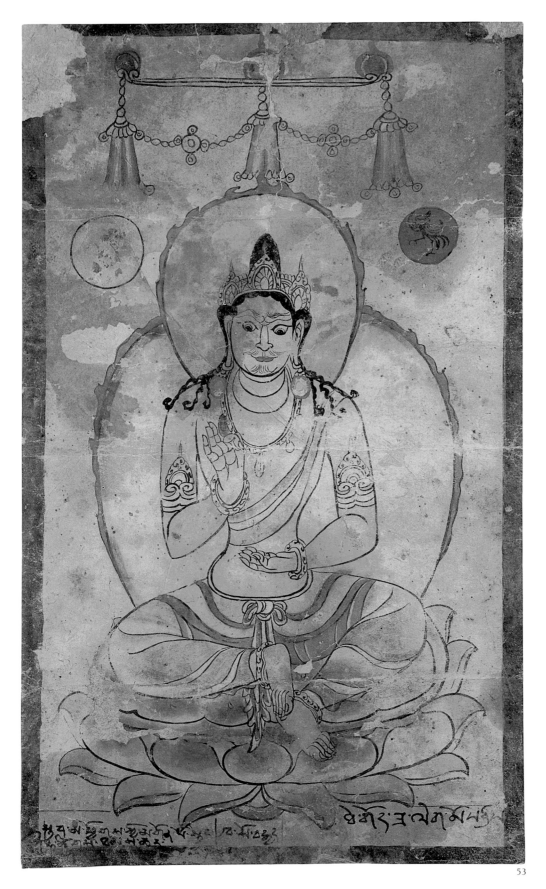

53

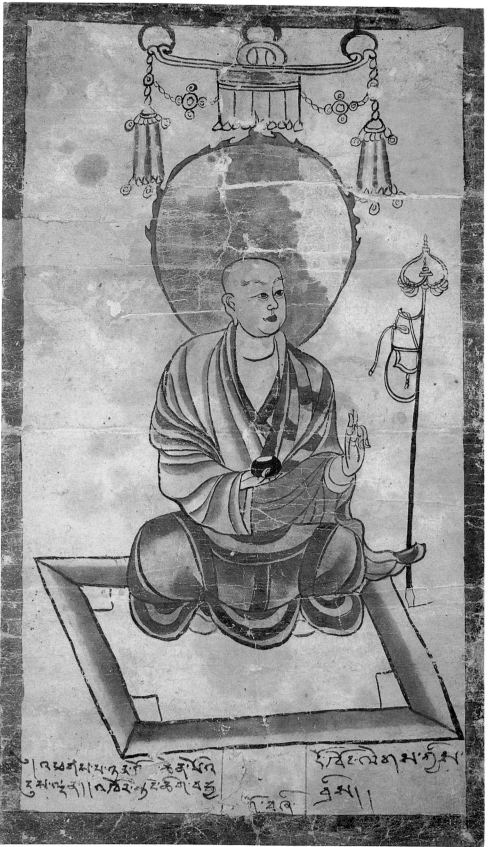

54

Ākāśagarbha, Lord of the Sky, who is sometimes shown with a fierce countenance. The inscription in Tibetan may be translated as, 'The Holy Lord of the Directions [who is accompanied by] all the *Hūṃ* mantras of the space above . . . painted (?) by Leg-mo, the noble lady (?) of The-god.'

RW, AF

54 The Arhat Kālika

From Cave 17, Dunhuang.
Tang dynasty, early to mid-9th century AD.
Ink and colours on paper. H. 43.5cm, W. 26cm.
OA 1919.1–1.0169* (Ch. 00376).
Stein, *Serindia* pp. 891, 993, 1472; Waley (1931) cat. no. CLXIX*; Whitfield, ACA vol. 2, pl. 49.

This is the third of the group of Tibetan paintings. It shows a Chinese travelling monk seated on a mat accompanied by his customary equipment. The Tibetan inscription states that he is the Arhat Kālika, one of the Buddha's early disciples, and gives the artist's name as Do-khon-legs. This person may have been a Tibetan resident at Dunhuang: his family name is common among those named as copyists of religious works in documents from Dunhuang. There is also the possibility that rather than being an ethnic Tibetan, he belonged to one of the many local tribes who took Tibetan names. RW, AF

55 Fragment of a Paradise Scene

From Cave 17, Dunhuang. Tang dynasty, 8th–9th century AD.
Ink and colours on paper. H. 57cm, W. 38cm.
OA 1919.1–1.0178* (Ch. 00373.a).
Stein, *Serindia* p. 993; Waley (1931) cat. no. CLXXVIII*; Whitfield, ACA vol. 2, pl. 50.

This is a fragment of a large paradise scene painted on several sheets of thick paper joined together. Nothing remains of the presiding Buddha, but parts of a bodhi tree and an elaborate canopy give an idea of the size of the original Buddha figure. Below the canopy can be seen the headdress of a Guardian King, adorned with the head and antlers of a white stag. Behind him stands a demonic figure with blue body and red and blue hair, holding aloft a naked child. This child suggests that Vaiśravaṇa, the Guardian of the North, may have been present in the painting. A child carried by a demon is also seen in a woodblock print of Vaiśravaṇa from Dunhuang (*see* cat. no. 85). The association of Vaiśravaṇa with the child is explained by a story which tells how a king of Khotan lamented his childlessness in the temple of Vaiśravaṇa, whereupon the forehead of the god's statue split open and a baby emerged. A number of small fragments remain from this painting: one shows a standing Bodhisattva whose long smooth locks framing his shoulders suggest an 8th- or 9th-century date (Whitfield, op. cit. fig. 83). RW, AF

56 Monk seated in meditation

From Cave 17, Dunhuang.
Tang dynasty, late 9th–early 10th century AD.
Ink on paper. H. 46cm, W. 30cm. OA 1919.1–1.0163 (Ch. 00145).
Stein, *Serindia* pp. 891, 967, pl. XCVII; Waley (1931) cat. no. CLXIII; Whitfield, ACA vol. 2, pl. 51.

This fine painting shows a monk seated with his hands in the gesture of meditation (*dhyāna-mudrā*). He is portrayed with the equipment of a travelling monk: the mat on which he sits, the stoppered vase for water, leather bag and rosary which hang from the thorn tree, and the monk's shoes in front of him. The hooked mouth line and the outline of the face broken by the eye are features which suggest a late 9th- or early 10th-century date. Several of the items of monk's equipment shown here also appear in the wall paintings of Cave 17, originally a memorial chapel to Hong Bian, the chief of the monks in Hexi who died *c.*AD 862. A seated portrait statue of Hong Bian has now been discovered and restored to Cave 17. RW, AF

57 Avalokiteśvara

From Cave 17, Dunhuang. Five Dynasties, mid-10th century AD.
Ink and colours on paper. H. 82.9cm, W. 29.6cm.
OA 1919.1–1.015 (Ch. i. 009).
Stein, *Serindia* pp. 867, 1010, pl. LXXIX; Waley (1931) cat. no. XV; Whitfield, ACA vol. 2, pl. 52.

Avalokiteśvara is seated on a ledge of rock against a rising full moon. The small figure on the cloud in the lefthand top corner is probably the deceased person on whose behalf the painting was dedicated, while the donor is shown at the bottom of the picture. Although this scene bears no inscription, it is very similar to a painting dated AD 943 in the Pelliot collection in Paris (*Bannières*, No. 101). That painting has the inscription *Shuiyue Guanyin* ('Water Moon Avalokiteśvara'). The illusory nature of the moon's reflection signifies the unreality of all phenomena. The 9th-century catalogue of painting *Li dai ming hua ji* ('Record of Famous Paintings in Successive Ages') by Zhang Yanyuan states that Zhou Fang (fl. AD 780–810) painted a picture on this subject at the Shengguang Temple of Chang'an. RW, AF

58 Mañjuśrī visiting Vimalakīrti

From Cave 17, Dunhuang. Five Dynasties, mid-10th century AD.
Ink and colours on paper. H. 73.2cm, W. 30.7cm.
OA 1919.1–1.031* (Ch. 0054).
Stein, *Serindia* p. 950; Waley (1931) cat. no. XXXI*; Whitfield, ACA vol. 2, pl. 53.

This painting depicts the popular story of the visit of the Bodhisattva Mañjuśrī to Vimalakīrti. Vimalakīrti is not shown in what is probably the righthand painting of a pair; he would have appeared in the lost lefthand illustration. Vimalakīrti was a rich Indian layman skilled at argument and with a profound knowledge of the Buddha's teachings.

55

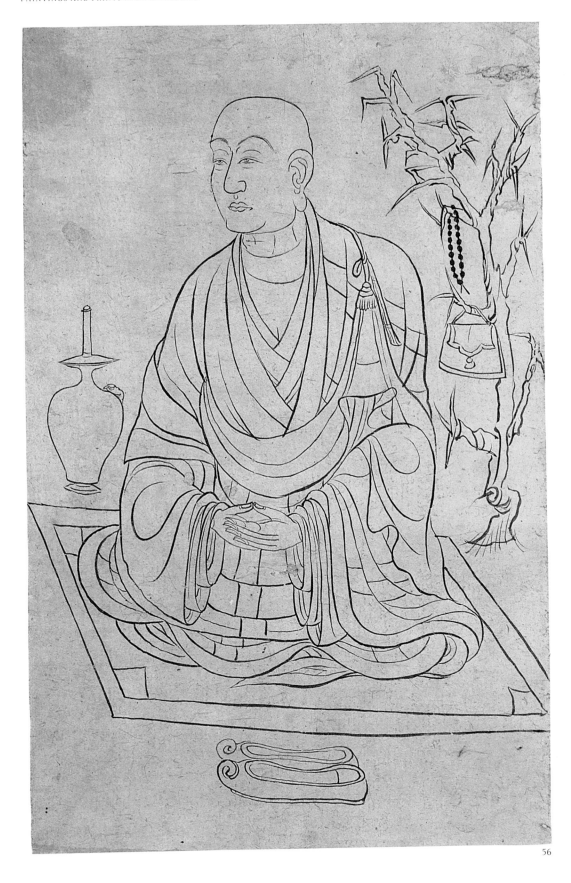

56

57

58

Mañjuśrī, the Bodhisattva of Wisdom, is shown seated on the dais with his hands in the gesture of discussion (*vitarka-mudrā*). He was the only one of Buddha's disciples who dared to visit Vimalakīrti on his sick bed for a discussion of the Law. In the foreground, the richly robed figure of a ruler is one of the multitude who came to witness the confrontation of these two intellectuals. On Mañjuśrī's right a Bodhisattva is shown pouring an inexhaustible supply of rice from a bowl to feed the assembly of the faithful, this being one of the miracles worked by Vimalakīrti during the visit. The group of three small boys playing musical instruments under the canopy may depict the episode when the sons of the elders of the city of Vaiśālī offered precious canopies to the Buddha Śākyamuni. Although Mañjuśrī's headdress and costume follow 9th-century prototypes, the flattened drapery folds and abbreviated rendering of facial features suggest a 10th-century date. RW, AF

59 Avalokiteśvara

From Cave 17, Dunhuang.
Late Tang or Five Dynasties, late 9th or early 10th century AD.

Ink and colours on paper. H. 46cm, W. 30.4cm.
OA 1919.1–1.0157* (Ch. 00387).

Stein, *Serindia* pp. 995–6; Waley (1931) cat. no. CLVII*; Whitfield, ACA vol. 2, pl. 54.

This figure of Avalokiteśvara was clearly painted by a child who perhaps shows himself as the small figure of a boy to the left of the Bodhisattva. Avalokiteśvara stands on a lotus-petal base above a pool of water and has been painted complete with all his accoutrements, including Amitābha in the headdress, a willow branch in one hand and a water-sprinkler in the other. The palms of Avalokiteśvara's hands have swastikas, one with forward-facing crampons and the other with backward-facing crampons. The young artist has paid relatively little attention to the portrayal of the form of the Bodhisattva's body with its diminutive limbs, but has instead lavishly decorated the figure with flowers and fluttering scarves. RW, AF

60 Sketch of a lion

From Cave 17, Dunhuang. Tang dynasty, late 9th century AD.

Ink on paper. H. 29.8cm, W. 42.8cm.
OA 1919.1–1.0169 (Ch. 00147).

Stein, *Serindia* pp. 891, 967, pl. XCVII; Waley (1931) cat. no. CLXIX; Whitfield, ACA vol. 2, pl. 55.

This masterly drawing may have been a preparatory study for a lion in a much larger painting, for example in the portrayal of Mañjuśrī's mount (*see* cat. nos. 5, 18). The rhythm of the outline does not suggest the use of a brush, since all the lines are short and even and do not show the parting of the brush hairs. The longer spirals of the mane appear to be made up of two or more arcs and semicircles. This solidity of line, also found in a sketch of a horse in the Pelliot collection in Paris (Jao Tsung-yi, 1978, Pelliot chinois

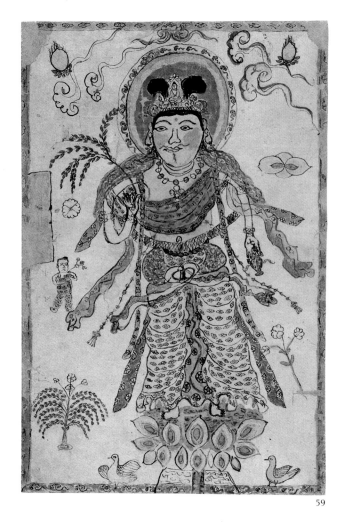

59

2951, pl. LII) and in some banner paintings in the British Museum (*see* cat. nos. 39–41), suggests that a pen made from wood or reed may have been used rather than a hair brush. The pens of this kind so far discovered appear to have been for the writing of scripts rather than for free pictorial representation. RW, AF

61 Tribute horse and camel

From Cave 17, Dunhuang. Tang dynasty, late 9th century AD.

Ink and colours on paper. H. 30.5cm, W. 84.5cm.
OA 1919.1–1.077 (Ch. 00207).

Stein, *Serindia* pp. 892, 976, pl. XCVI; Waley (1931) cat. no. LXXVII; Whitfield, ACA vol. 2, pl. 56.

The horse and camel seen here with their attendants are painted on two separate sheets of paper glued together. A third sheet of paper on the right, now detached, evidently portrayed a third animal: the whip of its groom is just visible on the right. This painting is simply a pictorial record, but in the Northern Song dynasty the great master of classical painting, Li Gonglin, was to transform a similar subject in his handscroll of 'Five Tribute Horses' (now lost).

60

61

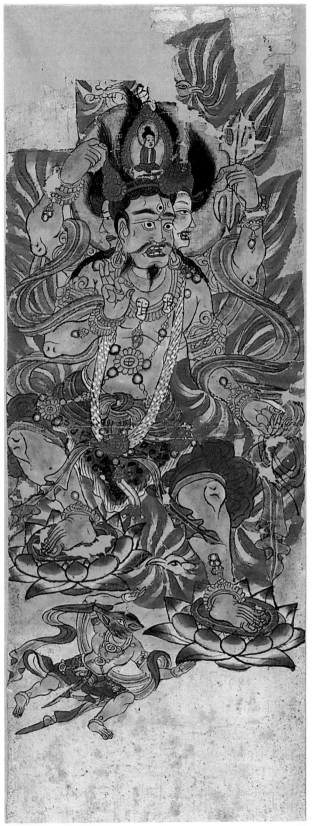

62

In the fourth year of Qiande (AD 966), the reverse of the drawing was used for a rough draft of an inscription relating to the repair of temples by Cao Yuanzhong, Imperial Commissioner at Dunhuang, who is named as donor on several of the woodblock prints from Cave 17 (*see* cat. nos. 83, 85). The scribe practised the date and a few other phrases by writing them over the paintings on the front of the paper. RW, AF

62 Ucchuṣma, Fiery-headed Vajra

From Cave 17, Dunhuang. Tang dynasty, late 9th century AD.

Ink and colours on paper. H. 80.7cm, W. 30.8cm.
OA 1919.1–1.040 (Ch. i. 0023).

Stein, *Serindia* pp. 876, 1012; Waley (1931) cat. no. XL; Whitfield, ACA vol. 2, pl. 57.

The Bodhisattva Ucchuṣma is one of the five divinities known as Vidyārājas or 'bright kings'. Sometimes identified with Vajra-*yakṣa* because of the thunderbolt he carries, he appears as an attendant upon the Thousand-armed Avalokiteśvara (*see* cat. no. 4). Like the other Vidyārājas, his role is to suppress evil powers. His name is translated into Chinese from Sanskrit as 'the Unclean' and in China he was invoked as the guardian of the cesspool. In this painting he is shown with three heads and four arms against a background of flames. In his crown is a figure of Amitābha Buddha. There is a swine-headed demon at the bottom of the picture. Stein found this painting with a wooden stick at the bottom and a bamboo stretcher at the top which indicates that it was at some time hung as a complete painting. However, a matching sketch in the Pelliot collection in Paris shows Hayagrīva, the horse-headed form of Avalokiteśvara (*Bannières*, No. 89). This suggests that these two drawings may have been sketches for two sides of a much larger composition as in the large silk painting of Thousand-armed Avalokiteśvara (*see* cat. no. 4), in which Ucchuṣma appears with the same black swine-headed attendant in the lower lefthand corner. RW, AF

63 Man and dragon

From Cave 17, Dunhuang. Tang dynasty, 9th century AD.

Ink and colours on paper. H. 45.5cm, W. 37cm.
OA 1919.1–1.0157 (Ch. 00150).

Stein, *Serindia* pp. 891, 967, pl. CI; Waley (1931) cat. no. CLVII; Whitfield, ACA vol. 2 , pl. 60.

When this painting was found, it was obscured by two woodblock prints of Avalokiteśvara (*see* cat. no. 82) which covered everything but the string of cash (Stein, op. cit., pl. CI). An official with a hoof-shaped foot stands in front of the kneeling dragon and writes on a tablet. The dragon is unusual in having horse's hooves, a voluminous mane and three prominent rock-like peaks on its back. This scene may represent the legendary ruler Fu Xi receiving the trigrams of the Book of Changes from a 'dragon-horse' that emerged from the Yellow River. In this context the string of cash may be auspicious money, known in the Song dynasty as

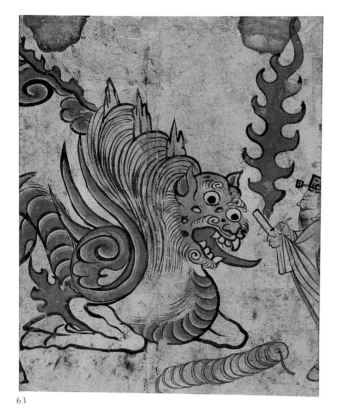

63

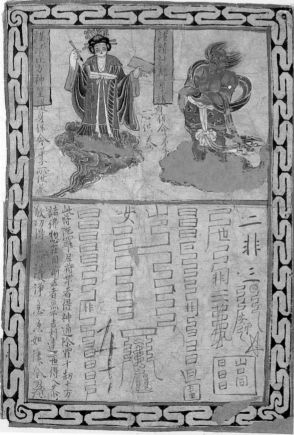

64

'dragon-horse money' and used here to refer to the Fu Xi legend. Alternatively the official's hoof-shaped foot may refer to the lameness of the great Yu, who quelled the waters of a great flood that inundated China in legendary times. He too received writings from a river deity, though from a tortoise rather than a dragon.

RW, AF

64 Talisman of the Pole Star

From Cave 17, Dunhuang. Five Dynasties, mid-10th century AD.

Ink and colours on paper. H. 42.7cm, W. 30cm.
OA 1919.1–1.0170 (Ch. lvi. 0033).

Stein, *Serindia* pp. 1080, 1214; Waley (1931) cat. no. CLXX; Whitfield, ACA vol. 2, pl. 61.

The purpose of this painting and the inscription below, which mixes Chinese script with talismanic formulae, is to place the donor under the protection of the two deities depicted. The righthand figure standing on what was a green cloud, now corroded away, represents the planet Ketu, and the female figure on the left is the spirit of the Pole Star. The inscription below promises that anyone wearing this talisman in his girdle '. . . will obtain magic power and will have his sins remitted during a thousand kalpas. And of the Ten Quarters all the Buddhas shall appear before his eyes. Abroad in the world he shall everywhere encounter good fortune and profit . . .' The actual power of the talisman resides in the calligraphic diagrams to the right of the inscription in Chinese. These are similar in form to those used up to recent times by Daoists. They employ elaborations and repetitions of characters in seal script in a style recalling that used on official seals.

RW, AF

65 Illustrations to the Ten Kings Sūtra

From Cave 17, Dunhuang.
Five Dynasties, late 9th or early 10th century AD.

Ink and colours on paper. H. 27.8cm, L. 239.9cm.
OA 1919.1–1.080 (Ch. cii. 001).

Stein, *Serindia* pp. 866, 1087, pls. XCIII, CIII; Waley (1931) cat. no. LXXX; Whitfield, ACA vol. 2, pl. 63.

This incomplete paper roll shows five of the Ten Kings of Hell, each of whom is attended by the Good and Bad Boys (recorders of the good and evil deeds of a person during life). The first king on the right sits at a table like a Chinese magistrate (65A). Two sinners with fetters on their hands and cangues around their necks are driven along by a bull-headed demon. A virtuous man and woman are shown carrying sūtra scrolls and a small image of Buddha respectively. Similar scenes portray the second, third and fourth kings (65B). After a break, the next king is evidently Kṣitigarbha, who decides which of the Six Gati or Ways of Rebirth are to be allotted to souls under judgement (65C). The Six Ways are shown as clouds trailing away from the place of judgement. Each cloud bears a symbolic figure. On the lowest, the Way of Demons is represented by a horned demon stirring a cauldron. Next a distraught figure in a

65B

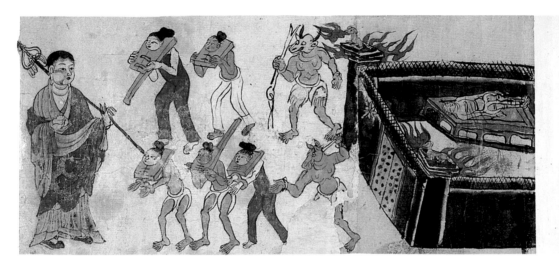

65D

loincloth stands for the Way of Pretas or hungry ghosts. A camel and horse represent the Way of the Animals and a man and woman dressed in 10th-century costume stand for the Way of Men. Immediately above them a haloed figure represents the Way of Asuras or titanic demons. Highest of all, a six-armed brahmā represents the Way of Divine Beings. After a further break in the scroll, there is part of one of the cities of Hell with flaming corner towers on which sit small dogs, one of which belches flames from its mouth (65D). Within the enclosure a tortured soul is bound on to a table or bed of some sort. Outside the city bull-headed demons threaten souls as they flee towards a large figure of Kṣitigarbha wearing monk's robes and carrying his staff and jewel. As Lord of the Six Ways he not only has the power to save souls from evil forms of rebirth, but also was regarded as the only Bodhisattva able to reclaim them from Hell.

RW, AF

66 Thousand-armed, Thousand-eyed Avalokiteśvara

From Cave 17, Dunhuang. Five Dynasties, mid-10th century AD.

Ink and colours on paper. H. 49.8cm, W. 29cm.
OA 1919.1–1.0159 (Ch. 00386).

Stein, *Serindia* p. 995; Waley (1931) cat. no. CLIX; Whitfield, ACA vol. 2, pl. 70.

This painting is a simple version of what can be a highly complex subject, the Thousand-armed, Thousand-eyed Avalokiteśvara (*see* cat. no. 4). Here only ten arms are shown in detail. Four arms have the attributes of discs for the sun and moon, a skull-headed mace and a trident. The remaining six hands are in the gestures of giving (*varada-mudrā*), of banishment of fear (*abhaya-mudrā*) and of offering (*anjali-mudrā*). The multitude of other hands with an eye in the palm of each are reduced to an aureole which reaches to the Bodhisattva's knees. This painting is similar to two pairs in the Pelliot collection in Paris (*Bannières*, Nos. 99, 100), suggesting that the three works may have been by the same artist or copied from the same source.

RW, AF

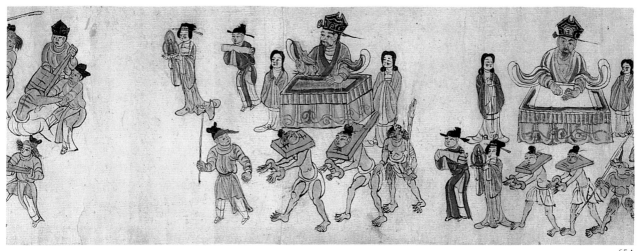

65A

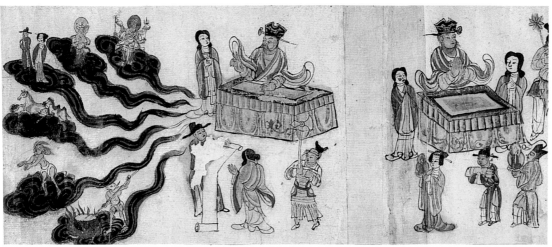

65C

67 Avalokiteśvara

From Cave 17, Dunhuang. Five Dynasties, mid-10th century AD.

Ink and colours on paper. H. 44.5cm, W. 31.2cm.
OA 1919.1–1.030* (Ch. liv. 0011).

Stein, *Serindia* p. 1399; Waley (1931) cat. no. XXX*; Whitfield, ACA vol. 2, pl. 72.

Avalokiteśvara, identified by the figure of Amitābha in his crown, is seated cross-legged on a lotus throne. Painted on a single sheet of the coarse paper used at Dunhuang, this is typical of paintings offered by the less wealthy devotees of Buddhism. The inscription on the left identifies the donor as a shoemaker: 'The Buddhist disciple of pure faith, the sewer of shoes and boots, the workman Suo Zhangsan dedicates with whole heart'. The family name Suo was common in the Dunhuang area during the Tang dynasty. RW, AF

68 Bhaiṣajyaguru with Cintāmaṇicakra and Vajragarbha

From Cave 17, Dunhuang. Five Dynasties, mid-10th century AD.

Ink and colours on paper. H. 84cm, W. 76.5cm.
OA 1919.1–1.071 (Ch. xxi. 0015).

Stein, *Serindia* p. 1021; Waley (1931) cat. no. LXXI; Whitfield, ACA vol. 2, pl. 74.

This double-sided painting was designed to be displayed on a window lattice, from which it appears to have been removed before being deposited in Cave 17. Paper has been pasted on to both sides of a sheet of coarse hemp cloth. On one side (68B) flowers are painted so as to appear in each square of the lattice. These would have been seen from outside through the lattice squares originally glued to the paper surface. The flowers resemble the artificial paper flowers displayed in this exhibition (*see* cat. no. 148) and recall other floral motifs of the Tang such as the flowers on the ceiling of the corridor leading to Princess Yongtai's burial chamber (*Tang Yongtai gongzhu mu bihua ji*, fig. 2).

The other side of the painting (68A), originally viewed

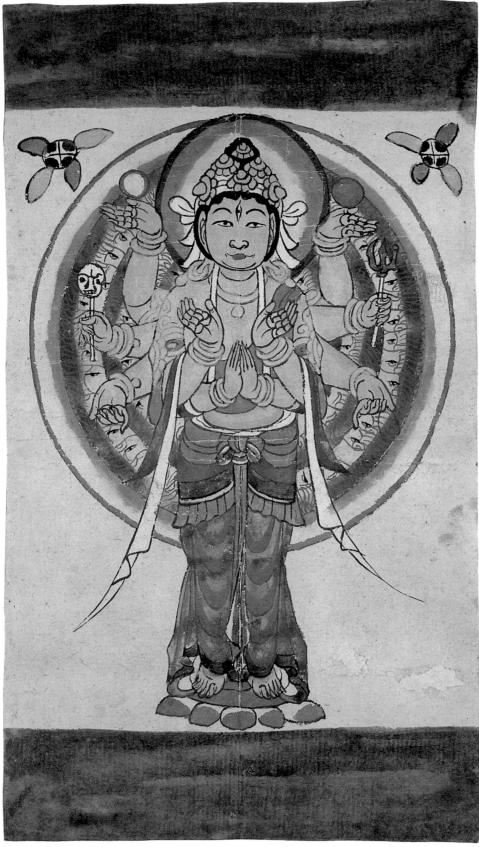

66

67

68B

from the inside, shows a Buddha flanked by two attendants. There is an inconsistency between the iconography of this group and the names actually given to the attendants in the inscription. The beggar's staff and bowl identify the central figure as Bhaiṣajyaguru, the Buddha of Healing, who is normally accompanied by the Bodhisattvas of the Sun and Moon (Sūryaprabha and Candraprabha). However, in this painting the figures have been labelled as Cintāmaṇicakra (on the Buddha's left) and Vajragarbha, two divinities of Esoteric Buddhism. It is possible that the artist was copying from an inappropriate model to fulfil a commission. RW, AF

69 Six female spirits to protect children

From Cave 17, Dunhuang. Tang dynasty, 9th century AD.

Ink and colours on paper. Each leaf: H. 33cm, W. 8cm.
OA 1919.1–1.0177 (1–3) (Ch. 00217 a–c).

Stein, *Serindia* pp. 978–9, pl. XCVI; Waley (1931) cat. no. CLXXVII; Whitfield, ACA vol. 2, pl. 75.

These three *pothī* leaves, each with a hole for stringing through its upper half, are painted on both sides with representations of spirits concerned with the welfare of small children. Each is accompanied by an explanatory inscription in Chinese and Khotanese which follows a more or less fixed pattern as in the one above the crow-headed spirit (69C): 'This female spirit's name is Shizhuning. If you dream of a crow and your small child has sharp pains in the stomach, then you may know that this spirit is the cause of the trouble. Sacrifice to it and all will be well.' An additional inscription on the face of the *pothī* showing the stag-headed spirit (69F) refers to 'sixteen female spirits protecting small

children' and suggests that the three leaves shown here were originally part of a set of eight painted on both sides.

RW, AF

70 Stencil for a five-figure Buddha group

From Cave 17, Dunhuang.
Five Dynasties or early Northern Song, mid-10th century AD.

Ink and pricked outlines on paper.
Whole stencil: H. 79cm, W. 141cm.
OA 1919.1–1.072 (Ch. 00159).

Stein, *Serindia* pp. 892, 969; Waley (1931) cat. no. LXXII; Whitfield, ACA vol. 2, pl. 78, fig. 138.

This is the largest and most impressive of the pricked paper stencils found at Dunhuang. It would have been used for producing multiple wall paintings and almost certainly for the central panel on the sloping faces of the cave ceiling, as in Cave 61 at Dunhuang, surrounded by smaller figures of the thousand Buddhas, also made with the aid of stencils. The stencil shows a complete group with a central Buddha, two Bodhisattvas and two monk disciples. To save time only the figures of the Buddha and the attendants on his left were drawn in ink. To ensure symmetry the sheet was then folded down the middle and holes were pricked through both layers of paper, following the ink outlines. To transfer the design to the wall, the stencil was laid out flat and a reddish powder, *tuhong* (earth red), was puffed or patted through the holes, leaving a dotted outline when the stencil was removed. Although this stencil bears traces of powder which show that it was actually used, it is not known whether any wall paintings based on it have survived in the Dunhuang caves. RW, AF

71 Buddha and stencil for a Buddha

From Cave 17, Dunhuang.
Five Dynasties or early Northern Song, mid-10th century AD.

Ink on paper, with pricked outlines from design on other side.
H. 32.5cm, W. 26.5cm. OA 1919.1–1.073(1) (Ch. xli. 002).

Stein, *Serindia* pp. 892, 1044; Waley (1931) cat. no. LXXIII; Whitfield, ACA vol. 2, pl. 79, fig. 139.

Both sides of the paper have been used. On one side is a drawing of a Buddha with his hands in the gesture of discussion (*vitarka-mudrā*) seated on a lotus base under a canopy. This drawing was not pricked for a stencil, possibly because the design was too large for the paper. The other side (not illustrated) was used as a stencil. It shows a similar but smaller design with a pricked outline which can be seen clearly from behind. The paper on the side used for a stencil is discoloured through repeated applications of the powder used to transfer the design to the wall. This stencil would have been used for the production of multiple Buddha images such as those in Cave 61 at Dunhuang. RW, AF

68A

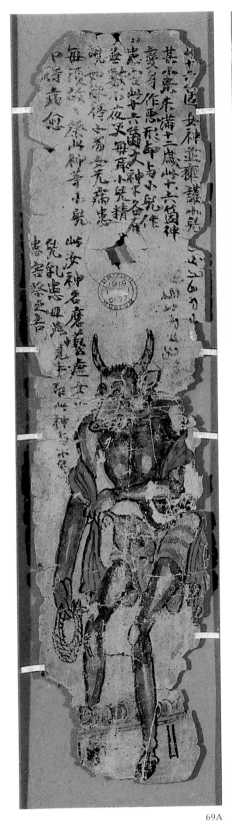

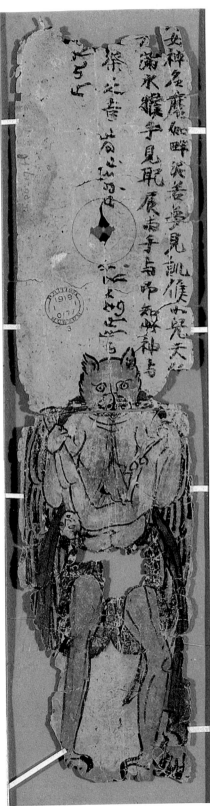

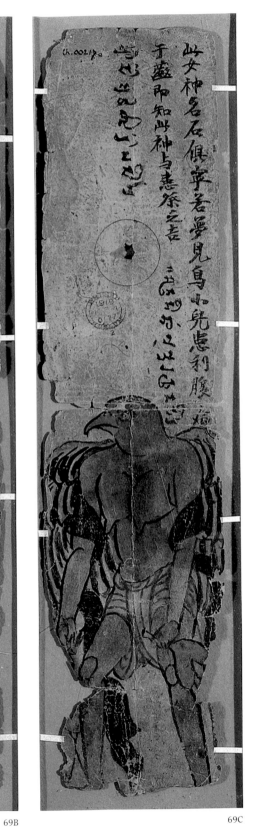

69A

69B

69C

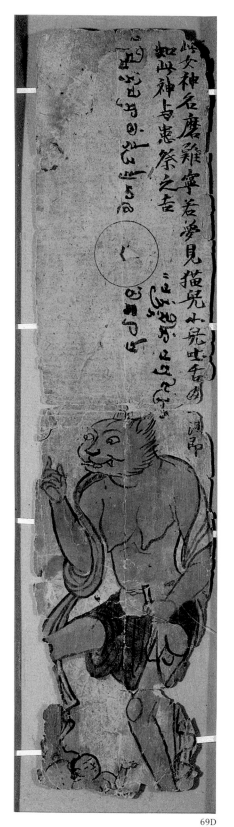

69D

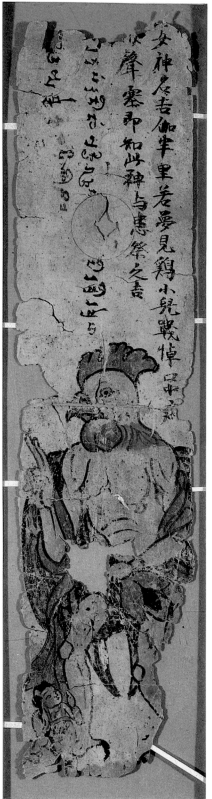

69E

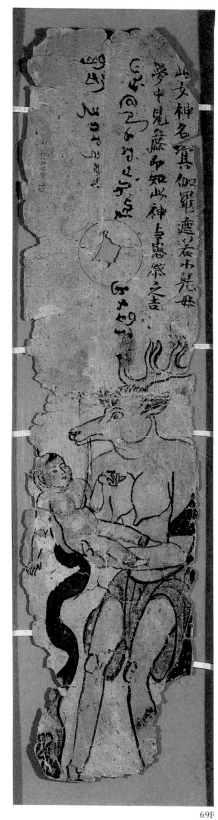

69F

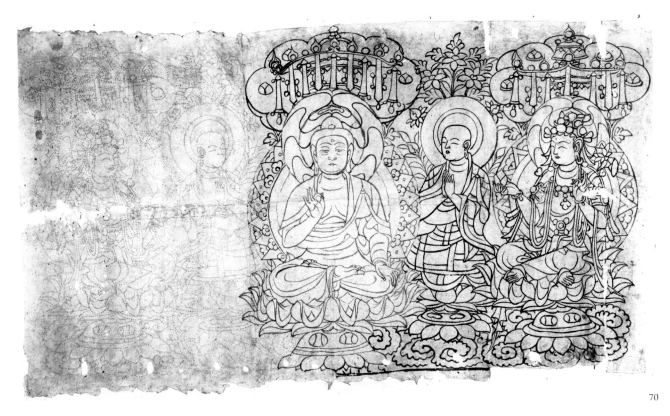

70

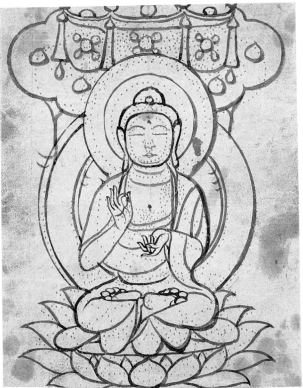

71

72 Sketches for illustrations to the Vimalakīrti-sūtra

From Cave 17, Dunhuang. Tang dynasty, 10th century AD.

Ink on paper. H. 31cm, W. 127cm. OA 1919.1–1.076 (Ch. 00144).

Stein, *Serindia* pp. 892, 966–7, pls. XCV, XCVII; Waley (1931) cat. no. LXXVI; Whitfield, ACA vol. 2, fig. 86.

This long strip was produced by pasting together three sheets of paper. Two of these were originally blank on both sides while the central piece bore a draft of a letter on one side, written in a year which corresponds either to AD 914 or to AD 974. In it an anxious mother writes to a priest, promising him 'a cotton shirt and a truss of hay' if he succeeds in procuring a young man to marry one of her daughters. One of the blank spaces flanking this letter has been used for a sketch of Vimalakīrti on his sick bed (72A). The other blank space on this side of the strip is filled with a number of small unrelated sketches. On the other side of the strip, which was completely blank, the procession of the Bodhisattva Mañjuśrī on his way to visit Vimalakīrti is depicted (72B). It is not possible to say whether these sketches were simply made for practice by an artist monk or whether they were studies for a full-scale work which has not been preserved. AF

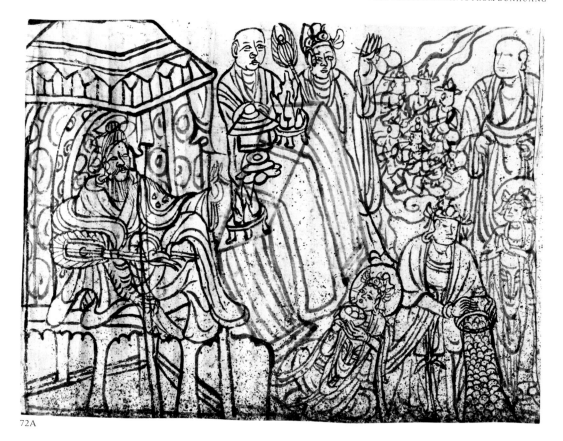

72A

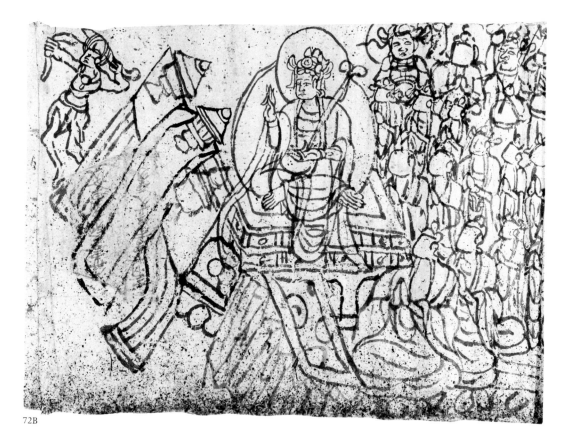

72B

73B

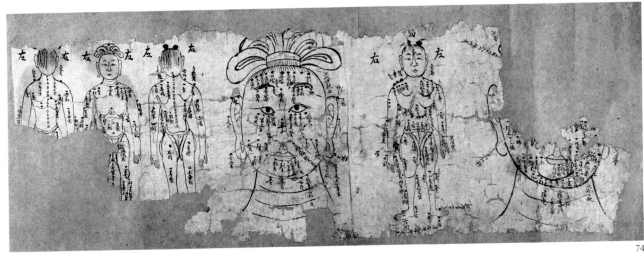
74

73 Sketches of mudrā

From Cave 17, Dunhuang. Tang dynasty, late 9th century AD.

Ink on paper. H. 15.4cm, W. 143.5cm.
OA 1919.1–1.083* (Ch. 00143).

Stein, *Serindia* pp. 892, 966, pl. XCVIII; Waley (1931) cat. no. LXXXIII*; Whitfield, ACA vol. 2, fig. 101.

This long roll of paper with ruled vertical columns and margins at top and bottom was originally intended for the copying of a sūtra text. Here it has been used for a set of drawings of nine standing figures, two seated figures, a single head, thirty-six pairs of hands and two single hands. The repertoire of *mudrā* shown in the hands and the attitudes of the Bodhisattva-like figures suggest that this document may be related to the Esoteric school of Buddhism introduced into China in the 8th century AD. This school aims to achieve the ecstatic union with the world-soul by means of mystic formulae (*tantra* or *dhāraṇī*) or spells (*mantra*) accompanied by music and manipulation of the hands. This particular scroll may have been intended as a visual aid for Esoteric worshippers. AF

74 Physiognomic diagrams

From Cave 17, Dunhuang. Tang dynasty, 9th century AD.

Ink on paper. H. 32cm, W. 90cm. OA 1919.1–1.042 (Ch. 00209).

Stein, *Serindia* pp. 892, 976, 1400, pl. XCVI; Waley (1931) cat. no. XLII; Whitfield, ACA vol. 2, fig. 103.

Physiognomical divination in China can be traced back into the first millennium BC, forming part of a complex of popular beliefs in fortune-telling. The diagrams on this roll are guides to gathering information from the body's appearance.

What remains of this roll shows front and back views of two figures, with their heads shown in larger size. They may be distinguished by the hairstyles: the hair of the female is gathered at the top of the head, while the male has the two topknots worn by young boys. The male head is at the far right; the female head is in the centre, flanked on either side by the front and back views of the male figure; finally, the front and back views of the female figure are at the far left.

The notes give the prognostications to be read from the presence of moles or other marks at particular points on the body or face. The notes for the female figure include references such as 'will respect her husband' and 'will bear honourable sons', as well as 'will marry three times and kill

73A

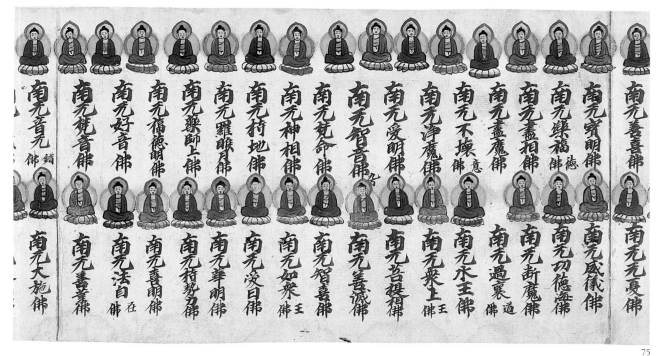

75

her husbands' and other warnings. Those for the male figure include references to 'wealth and honour', 'many wives', and 'fond of wine', while both have points signifying 'long life'. Thus the drawings provide a way of assessing prospective partners before marriage.

The existence of this and a similar work in the Pelliot collection in Paris (P. 3390; Hou Ching-lang, 1979) suggests that fortune-telling was probably one of the many services offered to pilgrims. RW, AF

75 Sūtra of Buddha names

From Cave 17, Dunhuang. Five Dynasties, early 10th century AD.

Ink and colours on paper. H. 28cm, L. (total) 274cm.
OA 1919.1–1.074 (Ch. 00188).

Stein, *Serindia* pp. 891, 974; Waley (1931) cat. no. LXXIV; Whitfield, ACA vol. 2, fig. 134.

A number of traditional Buddhist ceremonies mark the last day of the year according to the lunar calendar. These include, for instance, the ringing of a bell 108 times to symbolise release from the 108 kinds of sin. This scroll was designed for use in another part of that day's ceremonies in which the Buddha was invoked under a long series of different names. Each name is headed by a small Buddha figure under which is an inscription of the form *Nanwu X Fo* ('Praise to the Buddha X'). At one point the series of names is interrupted by a short prose text describing the descent of the Bodhisattva Baoda to Hell, where he witnessed the tortures of the damned souls. AF

95

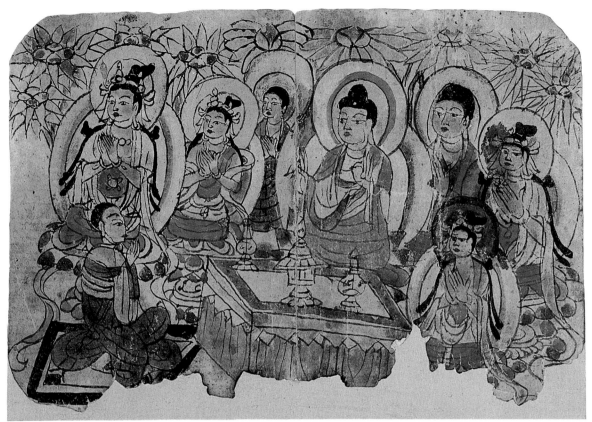

76A

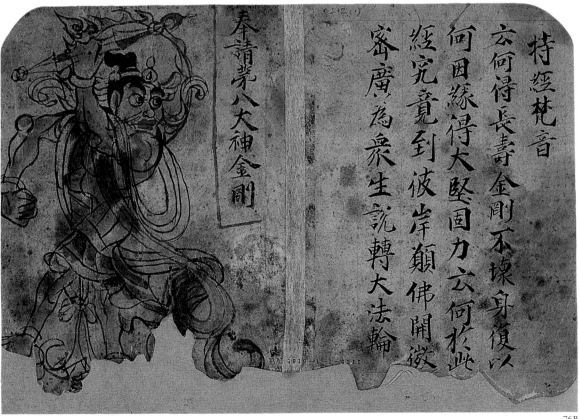

持經梵音
云何得長壽金剛不壞身復以
何因緣得大堅固力云何於此
經究竟到彼岸願佛開微
密廣為眾生說轉大法輪

奉請第八大神金剛

76B

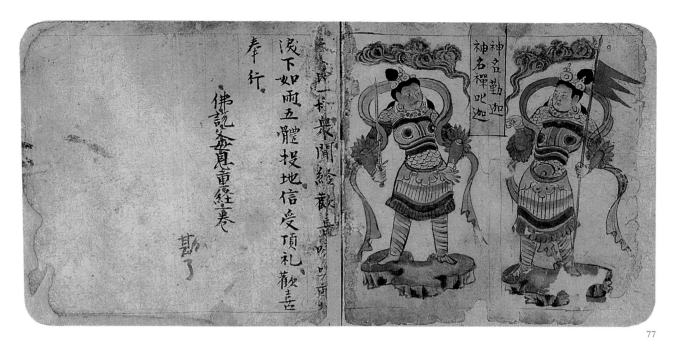

77

76 Buddha preaching the Law (frontispiece to the Diamond Sūtra); Vajrapāṇi (reverse)

From Cave 17, Dunhuang. Five Dynasties, early 10th century AD.

Ink and colours on paper. H. 14.2cm, W. 21cm.
OA 1919.1–1.0212 (Ch. xi. 001–2).

Stein, *Serindia* pp. 891, 1015, pl. XCII; Waley (1931) cat. no. CCXII; Whitfield, ACA vol. 2, pl. 67, fig. 98.

The painting (76A) was the frontispiece of a booklet containing the *Jingang panruo poluoni jing* ('Diamond Sūtra'). The monk kneeling in front of the Buddha and his retinue of attendants must be Subhūti, one of the ten chief disciples of the Buddha and the principal interlocutor in the sūtra. The composition is essentially the same as that of the famous printed frontispiece to the scroll in the British Library of the Diamond Sūtra dated AD 868. From a similar booklet in the Pelliot collection in Paris (P.4096, Jao Tsung-yi, 1978, pls. XLVI, XLVII), there is evidence that this frontispiece did not come at the very beginning, but followed depictions of eight Vajra kings. The British Museum leaf is an isolated one, but on the back (76B) is the last of these Vajra kings with the inscription, 'The eighth great spiritual Vajra who receives requests' (Whitfield, op. cit., fig. 98). None of the booklets from Dunhuang is dated before AD 868, and this one appears from its style to be early 10th century in date. RW, AF

77 Booklet with sūtra text

From Cave 17, Dunhuang. Tang dynasty, 9th century AD.

Ink and colours on paper. Each half folio: H. 13.5cm, W. 14.5cm.
OA 1919.1–1.0208 (Ch. xxii. 0026).

Stein, *Serindia* p. 1026, pl. XCII; Waley (1931) cat. no. CCVIII; Whitfield, ACA vol. 2, pl. 69, fig. 96.

This booklet once had a cover of purple fabric but very little of it now remains. The first two pages (Whitfield, op. cit., fig. 96, folios lv–2r) show two Devarājas or Heavenly Kings on the righthand folio, and the sūtra title *Foshuo huixianglun jing* on the lefthand folio. The sūtra text follows on pages 5–19, written by the monk Yinian whose signature appears in red on the last page. The second two pages (folios 2v–3r) show two other Devarājas and the last three lines of a second sūtra entitled *Fumu enzhong jing*. The title of another very popular sūtra at Dunhuang, the *Wu chang jing*, appears on the last page after the monk's signature. The booklet seems to have originally contained the text of three sūtras although the beginning and end of the book are now missing. RW, AF

78 Mārīcī and attendants, with donors, and cover of booklet

From Cave 17, Dunhuang.
Late Tang or early Five Dynasties, late 9th–early 10th century AD.

Ink and colours on paper. Painting: H. 14.3cm, W. 10cm.
OA 1919.1–1.0207 (Ch. 00211).

Stein, *Serindia* pp. 865, 976–7; Waley (1931) cat. no. CCVII; Whitfield, ACA vol. 2, pl. 68.

Only the cover and one loose page of this booklet remain. The cover is of finely woven purple cotton in a diaper pattern. Inside the cover a sheet of paper was pasted in, but the left half has been torn away. The right half shows the remains of the edge of a painting with streamers and scarves and the four characters *ba jingang ming* ('names of the eight Vajras'). Since the eight Vajra kings also appear at the beginning of a booklet of the Diamond Sūtra now in the Pelliot collection in Paris (P.4096, Jao Tsung-yi, 1978, pls. XLVI, XLVII), it seems likely that this booklet also originally contained a copy of the Diamond Sūtra. Its only

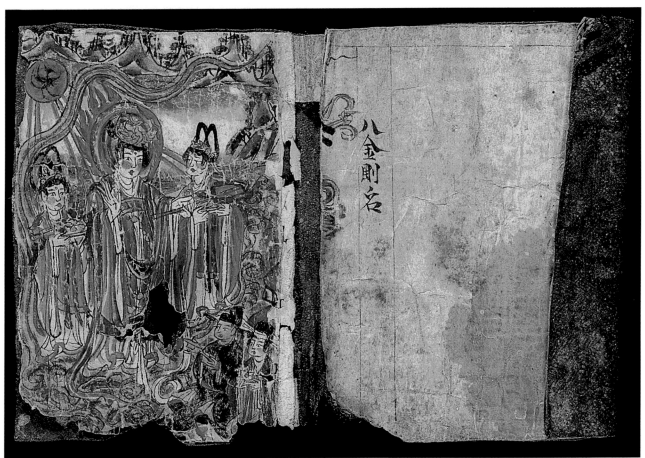

78

79

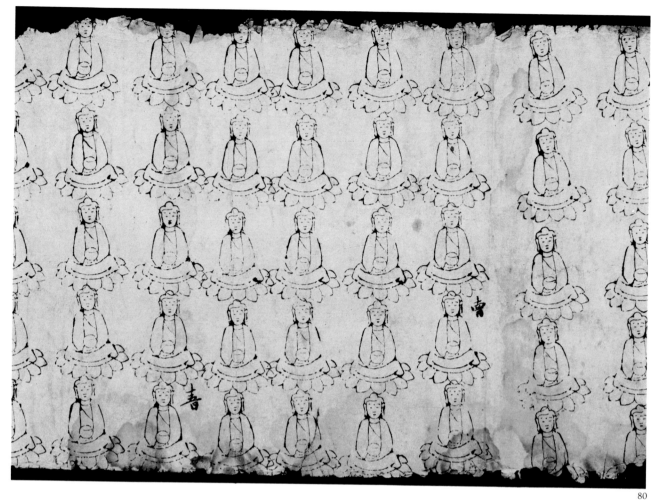

80

content now is a single finely executed painting of the divinity Mārīcī, Goddess of Light, holding a fan and descending with attendants on a purple cloud. On the right a pair of donor figures are shown. The scene is set over a sea with a landscape at the top and a sun disc with radiating sunlight. The iconography of Mārīcī and the headdresses of the attendants seem to reflect early 9th-century conventions, although the kneeling donors suggest a later date.

RW, AF

79 Miniature booklet containing the sūtra Foshuo xuming jing

From Cave 17, Dunhuang.
Tang dynasty or early Five Dynasties, late 9th–early 10th century AD.

Ink on paper. H. 6.4cm, W. (two pages) 13cm.
OA 1919.1–1.0209 (Ch. 00213).

Stein, *Serindia* p. 977; Whitfield, *ACA* vol. 2, fig. 99.

This small booklet contains the texts of the Prolongation of Life Sūtra. The crudely brushed calligraphy and illustration suggest that this was the work of a child. This impression is strengthened by the fact that the hair of the worshipper

shown in the frontispiece seems to be in the two tufts characteristic of young boys.

AF

80 Roll of repeated impressions of a seated Buddha

From Cave 17, Dunhuang. Tang dynasty, 8th–9th century AD.

Woodblock print, ink on paper. H. approx. 30cm.
OA 1919.1–1.0256 (Ch. 00417. a, b, c).

Stein, *Serindia* p. 999; Whitfield, *ACA* vol. 2, fig. 156.

This roll of good-quality paper bears a large number of simple images of a seated Buddha with alms bowl. These have been produced by printing repeated impressions from a single woodblock. The motive was to gain merit by multiplying images of the Buddha. An interesting feature of this scroll is that the dates written after every twenty-one impressions reveal that printing was carried out on the fast days of the Buddhist calendar, the eighth, fourteenth, fifteenth, twenty-third, twenty-ninth and thirtieth days of the month. It is impossible to tell whether the owner of this paper roll used their own woodblock or whether it was brought to a temple for printing.

AF

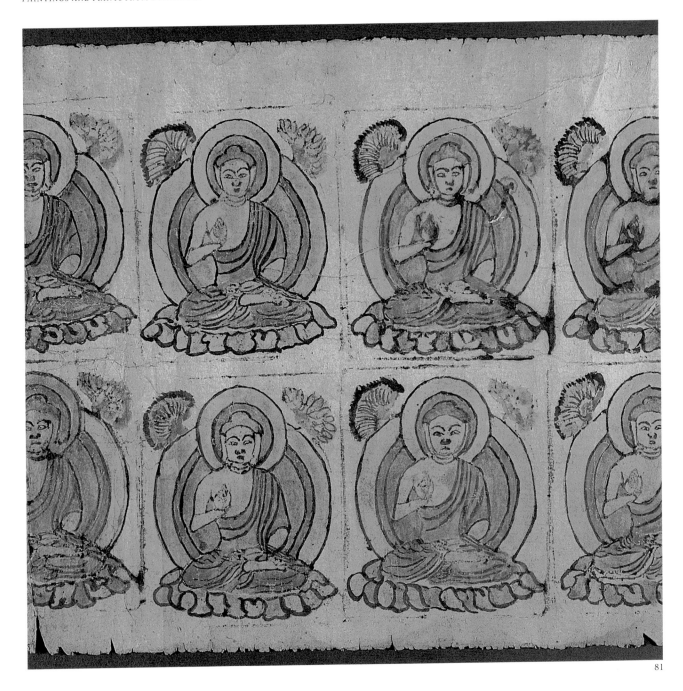

81

81 Roll of repeated impressions of a seated Buddha

From Cave 17, Dunhuang. Tang dynasty, 9th century AD.

Woodblock print, ink and added colour on paper.
Each impression: H. 10.7cm, W. 9.3cm.
OA 1919.1–1.0254 (Ch. 00421).

Stein, *Serindia* p. 999; Whitfield, ACA vol. 2, pl. 82.

This paper roll is a further example of printing multiple images for devotional purposes. In this case the woodblock print which was used was relatively sophisticated and colour was added to the image after the outline had been printed on the paper. RW, AF

82 Avalokiteśvara

From Cave 17, Dunhuang. Five Dynasties, 10th century AD.

Woodblock print, ink on paper with hand-colouring and blue paper borders.
H. 39.9cm, W. 17cm. OA 1919.1–1.0234 (Ch. 00150. a).

Stein, *Serindia* p. 968, pl. CI; identical to Waley (1931) cat. no. CCXXXIII; Whitfield, ACA vol. 2, pl. 81.

The figure of Avalokiteśvara, backed by an aureole and nimbus, is seated on a lotus within a circle and holds a half-open lotus. There are two cartouches on lotus bases; the one on the right names the Bodhisattva, the one on the left contains a dedication. The text below contains a prayer. This print was one of a number of impressions from the same block discovered in Cave 17. Unlike the others, this one has been finely hand-coloured with stencil-printed blue paper borders added to the top and bottom. This and another impression (Ch. 00150. b) were found pasted over a painting of an official standing in front of a horse-dragon with a large string of cash (*see* cat. no. 63).

This print exemplifies the usual format for votive woodcuts in which a picture of the deity occupies the upper section with the text of prayers or dedication below. This format is known as *shangtu xiawen* ('illustration above and text below') and was to become the dominant layout for illustrated books of all kinds from the Song dynasty to the 16th century. Another feature of this print which passed into use in printed books was the lotus-based cartouche bearing an inscription. This became the standard method for giving details of the printing establishment at the end of a book.

RW, AF

83 Avalokiteśvara

From Cave 17, Dunhuang. Five Dynasties, dated AD 947.

Woodblock print, ink on paper.
Printed area: H. 31.7cm, W. 20.0cm.
OA 1919.1–1.0242 (Ch. 185. d).

Stein, *Serindia* p. 974; identical to Waley (1931) cat. no. CCXLI; Whitfield, ACA vol. 2, fig. 155(b).

The figure of Avalokiteśvara stands on a lotus pedestal beneath a canopy with his left hand in the gesture of discussion (*vitarka-mudrā*) and the right hand hanging by his side holding a flask. The cartouche on the left names the Bodhisattva and the one on the right states that Cao Yuanzhong, the Imperial Commissioner at Dunhuang from AD 946 to 975, commissioned the print. The main inscription was printed from a separate woodblock, as can be seen from the misalignment of the two blocks on a duplicate impression in the British Museum. The text of the inscription describes how the print came to be commissioned and ends: 'The disciple, Military Controller of the Guiyi Army, Inspector of Guazhou, Shazhou and other districts, Commissioner for the distribution of military land allotments within the sphere of his jurisdiction and for the suppression of Tibetan tribes, specially promoted additional Grand Preceptor, inaugural Baron of the prefecture of Qiao, Cao Yuan-

82

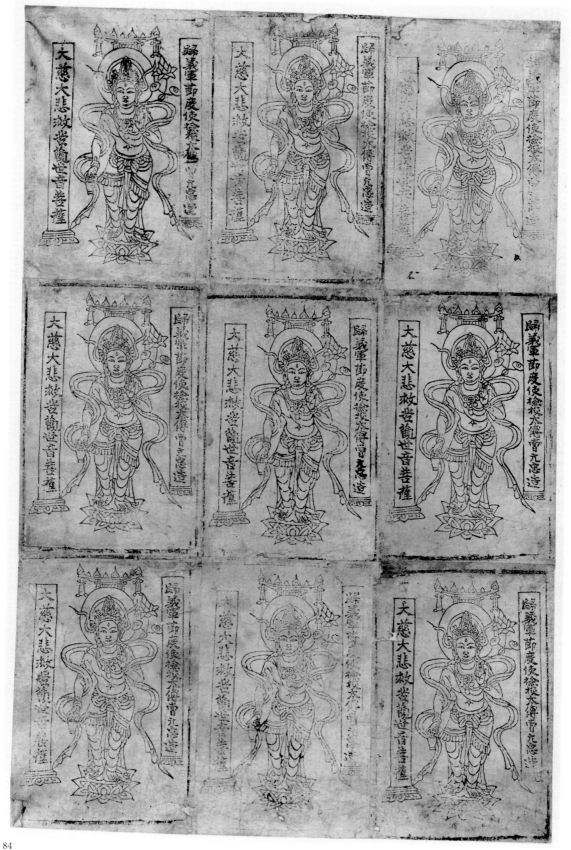

84

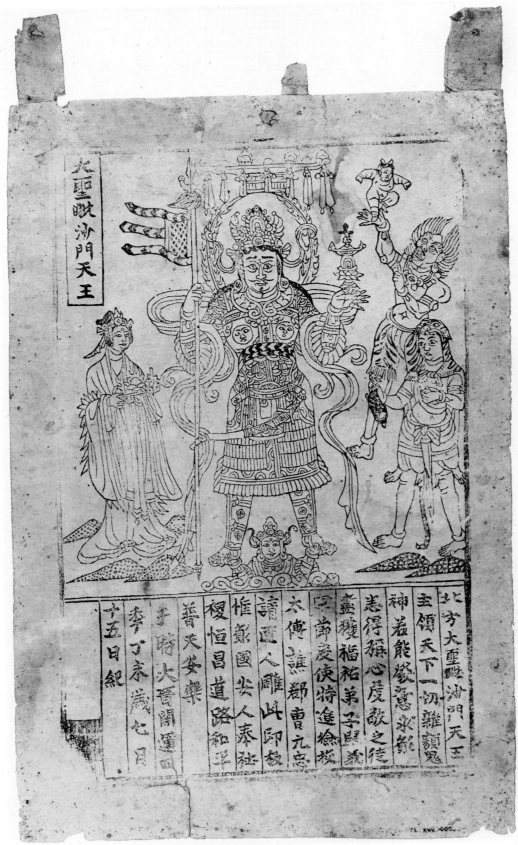

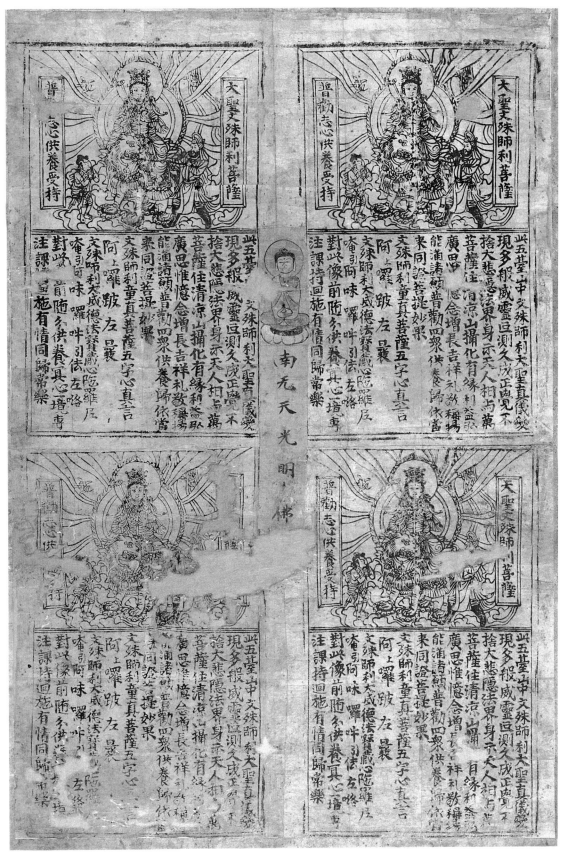

zhong carved [had carved] this printing block and offered it on behalf of the municipal shrines of the city, that they may know no troubles; on behalf of the whole prefecture, that they may be intact and peaceful . . . The time being the fourth year of Kaiyun, the year *dingwei*, the seventh month, the fifteenth day [this was] inscribed. [Cut by] the workman Lei Yanmei (?)' (based on Waley, 1931, pp. 199–200). ᴀꜰ

84 Avalokiteśvara

From Cave 17, Dunhuang. Five Dynasties, dated AD 947.

Woodblock print, ink on paper.
Each image (printed area): H. *c*.20.4cm, W. *c*.15.4cm.
Composite image: H. 63cm; W. 41.9cm.
OA 1919.1–1.0244 (Ch. lvi. 0026).

Stein, *Serindia* p. 1079; for individual impressions see Waley (1931) cat. no. CCXLI; Whitfield, ACA vol. 2, fig. 155(a), (c).

This composite work showing nine identical images of Avalokiteśvara uses prints made from the upper block of the woodcut shown in the previous entry. Each print has been cut out close to the border surrounding the image and the prints have been assembled in three rows of three. ᴀꜰ

85 Vaiśravaṇa with attendants

From Cave 17, Dunhuang. Five Dynasties, dated AD 947.

Woodblock print, ink on paper. Printed area: H. 40cm, W. 26.5cm.
Paper (including loops): H. 51cm, W. 32cm.
OA 1919.1–1.0245 (Ch. xxx. 002).

Stein, *Serindia* p. 1037; Waley (1931) cat. no. CCXLV; Whitfield, ACA vol. 2, fig. 153.

This woodblock print shows Vaiśravaṇa, Guardian of the North (other prints from the same block are in the Pelliot collection in the Bibliothèque Nationale in Paris). He stands under a canopy and on the hands of a small figure of the earth goddess. He has a stūpa containing a seated Buddha on his left palm to symbolise his role as one of the four guardians of the Buddhist universe, and in his right hand is a halberd. On his left are two large figures. The lower one is a *gandharva*, who wears a leopard-head helmet and skin and in one hand holds a mongoose which is symbolic of Vaiśravaṇa's original identity as Kuvera, the Indian god of wealth; in the other hand, the *gandharva* holds a flaming pearl. The upper figure is a *yakṣa* with a naked child standing in its upheld hand. Both the *yakṣa* and the earth goddess have strong associations with Khotan, where Vaiśravaṇa is said to have granted a son, nurtured by the earth goddess (again through the intercession of Vaiśravaṇa), to the childless king of Khotan (Beal, 1906, vol. 2, p. 311). On Vaiśravaṇa's right is the figure of his sister Śrī Devī holding a dish of fruit.

Cao Yuanzhong, the Imperial Commissioner at Dunhuang, is named in the inscription as having commissioned this print (*see* cat. no. 83). This woodcut is printed from a single block. Along the top border of the print are two paper loops and remnants of a third which would have been used for hanging it. ᴀꜰ

86 Four impressions of Mañjuśrī mounted on one sheet with a painting of Amitābha Buddha between them

From Cave 17, Dunhuang. Five Dynasties, mid-10th century AD.

Woodblock print, ink on paper, with the Buddha coloured by hand.
H. 63cm, W. 46cm. OA 1919.1–1.0239 (Ch. 00204).

Stein, *Serindia* p. 976; for individual Mañjuśrī prints see Waley (1931) cat. no. CCXXXV; Whitfield, ACA vol. 2, fig. 147.

This sheet of paper bears four impressions of a votive print showing Mañjuśrī, the Bodhisattva of Wisdom. In the central column, originally blank, there has been added a painting of the Buddha Amitābha. The Mañjuśrī print follows a standard form used in prints from Dunhuang. The upper register is occupied by a central figure with an identifying inscription on one side and a record of the pious intent behind the print on the other. Beneath are instructions for veneration of the image and prayers to be recited. ᴀꜰ

87 Ritual print with Mahāpratisarā surrounded by a dhāraṇī in Sanskrit

From Cave 17, Dunhuang.
Northern Song dynasty, dated fifth year of Taipingxingguo (AD 980).

Woodblock print, ink on paper with Sanskrit letters overprinted on the lotus medallions.
Printed area: H. 41.7cm, W. 30.3cm.
OA 1919.1–1.0249 (Ch. xliii. 004).

Stein, *Serindia* pp. 893–4, 1044–5, 1399, pl. CII; Waley (1931) cat. no. CCXLIX; Whitfield, ACA vol. 2, fig. 151.

The disc within the frame of this print is filled by a Sanskrit inscription written around the contour of the circle. At its centre is the eight-armed Bodhisattva Mahāpratisarā, 'the great accorder of what is sought', who is an incarnation of Avalokiteśvara. On the two inner sides of the frame, Chinese inscriptions followed by transliterations of Sanskrit name the eight attributes held by the Bodhisattva's hands. These were interpreted by Waley as the pestle, axe, lasso, knife, jewel, wheel, lance and book. Above the central disc to the left the name of the cutter of the woodblock is given as Wang Wenzhao. On the right the donor is named as Li Zhishun. The *dhāraṇī* or mystic formula in the centre talks of the great benefits to be derived from making a copy of it, which shows clearly the motivation for multiple printing. The large cartouche at the bottom of the print contains the Chinese text of the *dhāraṇī* entitled *Da sui qiu tuoluoni*. At the end of the cartouche the date is given as '. . . Taipingxingguo fifth year, sixth month, tenth day [equivalent to 24 July AD 980]'. ᴀꜰ

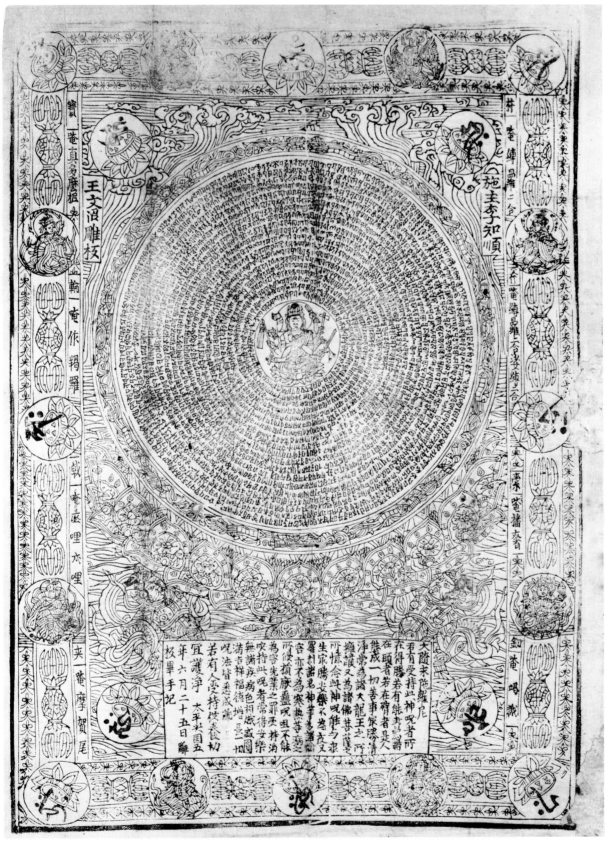

87

Textiles from Dunhuang

The 8th- and 9th-century silk banners, temple articles and fragments which Stein collected from the Caves of the Thousand Buddhas (Qianfodong) are now divided between three museums: the National Museum in New Delhi, and the Victoria and Albert Museum and the British Museum in London. The British Museum is fortunate in having major complete articles such as the *kaṣāya* patchwork (cat. no. 89), the sūtra wrapper (cat. no. 91), the altar valance (cat. no. 90) and the Vulture Peak embroidery (cat. no. 88). Stein's French contemporary Paul Pelliot collected a number of silk fragments now in the Musée Guimet in Paris, and the German Le Coq presented a group of small pieces to the Berlin Museum.

These collections were all acquired during the early 20th century from Central Asia. In the Tang dynasty, however, textiles were also exported eastwards from China, and some have survived to the present day. In 8th-century Japan, for instance, textiles were among the royal possessions placed in the Shōsō-in repository of the Tōdai-ji temple at Nara along with inventories recording the dates of the gifts. Since then, the Shōsō-in has been added to on only a handful of occasions, and its contents are in an excellent state of preservation. They include, in addition to the textiles, Tang dynasty silver, ceramics, glass and musical instruments. The repository is not only valuable for the extremely high quality of the items it contains, but also for the way its contents help to date artefacts from China.

Textiles have been unearthed increasingly since the 1960s, most notably at Astāna, Fufeng Famensi and Jiangling Mashan. These excavations have added much to our understanding of the silks in collections around the world.

Silk in early China

Silk was produced in China at least six or seven thousand years ago. Neolithic stone ornaments carved in the shape of silkworms have been found at Shaguotun, in Liaoning province in north-east China, while in the central province of Shanxi, excavations at the neolithic site of Xiaxian Xiyincun have revealed a silkworm cocoon cut in two. Further south at Wuxingxian in Zhejiang province, an area identified with modern silk production, a bamboo box 4,700 years old containing a piece of woven silk has been found. It

is the earliest example of silk fabric and probably survived due to damp conditions underground. Most early textile evidence takes the form of imprints left by fabrics which have long since disintegrated. Two examples may be seen on a jade halberd in the Palace Museum, Beijing, and on a bronze ritual execution axe unearthed in the city of Anyang in Henan province. Silkworms appear amongst the motifs on magnificent bronze ritual vessels cast in Anyang during the latter part of the Shang dynasty (c.1700–1027 BC). The ideogram for silkworm appears quite frequently in oracular inscriptions carved on animal bone and tortoise-shell, and it seems there was even an office of 'Nü Cang' or 'Mistress of the silkworm'. It is quite clear from these various sources that silk was sought after and the silkworm revered from the earliest periods of Chinese history.

In the Western Zhou period (1027–771 BC) which followed the Shang, the palace department of *fu gong* ('women's skill') included a silk supervisor, a hemp supervisor, dyers, weavers and others. The allotting of particular tasks established a system of production and made technical progress more rapid. Even the price of silk is recorded; at one point in the Western Zhou dynasty, one horse and one bolt of silk could be exchanged for five slaves. Only the emperor and women of the nobility used silk, although it was frequently exchanged amongst princes. Silk brocade is mentioned frequently in the *Shi Jing* (Book of Songs), the classical anthology of poems gathered from all over China between the 9th and 5th centuries BC. The disintegration of the Western Zhou empire into numerous smaller states meant an increase in the number of kings, princelings and nobles who demanded silk. During the Eastern Zhou (770–256 BC), burial regulations required that the coffins of feudal lords be covered with a silk embroidery. An embroidered silk saddle-cloth in Tomb 5 at Pazyryk in southern Siberia demonstrates that silk items were already being exported from China in the 4th to 3rd centuries BC. Early examples are only partly embroidered, for embroidery grew out of the practice of painting designs on silk cloth which had first been coloured with vegetable dyes. Parts of the design were embroidered and part only painted until later in the Eastern Zhou, when entirely embroidered examples appear.

Map of modern China showing ancient textile sites

Silk in the Han dynasty

During the course of the Han dynasty (206 BC–AD 220), embroidery became widespread. Even bureaucrats and merchants used embroidery and silk for clothes, wall hangings and horse trappings. The main areas of production were along the reaches of the Yellow River in central north China, particularly in the prefecture of Qi, roughly equivalent to present-day Shandong province. Qi was renowned for its textiles, and almost every household was involved in their production. In his famous discourse the *Lunheng*, Wang Chong (AD 27–97) remarked: 'In the state of Qi, as for embroidering, there is not a woman who does not know how to'. Some of the textiles were exported to other regions, others offered to the palace as imperial tribute. In fact, the imperial weaving workshops were also situated in Qi. The *sanfuguan* (three costume office), established during the first part of the Han dynasty, was so called because it produced silks for the three seasons of spring, summer and autumn. Such was the imperial expenditure on fine silks that in 44 BC, the fifth year of his reign, the Emperor Yuan felt compelled to issue an edict closing the *sanfuguan*; however, other records show that imperial silk workshops did survive in the area until the end of the Han dynasty.

A large industry also existed in the western Chinese state of Shu, in present-day Sichuan. Here and in other provinces local embroidery stitches developed, creating distinct regional styles. Imperial workshops existed in the capital Chang'an until AD 23, and in the capital at Luoyang from AD 25 until the end of the dynasty. The eastern states of Wu and Yue also offered silk as imperial tribute.

The role of silk as a prestigious offering was not confined to China proper, but played an important part in the country's international relations. A large number of bolts was presented annually to the chief of the Xiongnu barbarians on the north-western border in an attempt to unite the peoples. The Xiongnu were an aggressive nomadic people on whom the Han relied for horse stock, and on whose co-operation their prosperity depended. The borders of North China were particularly important to the Han economy, for it was across those desert regions that great quantities of silk were exported as far west as the Mediterranean, along the famous 'Silk Route' (*see p. 10*). A sea route from China's south coast was also used to export silk to Japan, South Asia and some parts of the Middle East.

The highly organised silk industry of the Han dynasty developed a great variety of specialised weaving implements which made many different weaves possible. The first Chinese character dictionary *Shuo wen jie zi*, partly compiled during the Han, lists almost twenty types of silk fabric, most of which do not have Western counterparts and so cannot be accurately described in English. A type of thin satin called *juan* is recorded in *Xijing zaji* ('Miscellanies from the Western capital'), where we learn that it took sixty days to weave one bolt. Satins were by no means the most complex weaves of the period. Brocades are highly complicated. Chinese etymologists have suggested that the character *jin*, which means brocade, includes the graph for gold instead of silk because the values of gold and brocade were comparable. The best-quality brocade cost 20,000 cash per bolt, medium quality 10,000 and lower quality 5,000. This compares with plain silk at 400 cash per bolt, a fifteenth of the price of good brocade.

Han styles and patterns

The patterns of Han dynasty brocades relate closely to the contemporary style of painting on lacquer, with paired dragons, winged birds, interlacing borders and cloud scrolls (*see* cat. no. 93). The motifs are strictly Chinese but the overall design on some cloths shows Middle Eastern influence, as in the medallion and square lozenge arrangement on the group of nine fragments (cat. no. 92). Auspicious Chinese characters with meanings such as 'long life' or 'happiness' often appear woven into Han silk fabrics. They are either interspersed amongst animal motifs or repeated in columns as a major feature of the design (cat. no. 94).

The Han dynasty collapsed in AD 220, and throughout the succeeding periods of the Three Kingdoms (220–65) and the Two Jin (265–420) the textile industry of Sichuan province emerged to lead the country in silk production. The introduction of the 'horse-bit' loom made possible a variety of new designs, and for the first time gold was added to brocade cloths. The silks of Sichuan were transported right across China to the north and east.

During the period of the Northern and Southern dynasties (AD 420–589) a most important technical development occurred. Han dynasty silks and the later products from Sichuan, however fine, were always patterned in the warp, but during the 5th century, weft-patterned silks appeared for the first time. Patterning the weft allows far more complex designs and a wider cloth than is possible in a warp-patterned fabric. The technique had been used for wool-weaving amongst the north-western border peoples since the Eastern Han dynasty, but the central Chinese tradition had remained firmly warp-patterned for a further two centuries.

Influences from the West

Renewed contact with western Asia may have encouraged the adoption of the weft-patterned technique in the Chinese silk industry. The effects of a newly re-opened Central Asia are certainly evident in decorative motifs on silks and other media for more than a century before the Tang dynasty (AD 618–906). The most prominent of these is the pearl roundel seen on several textiles in the exhibition (cat. nos. 96, 97, 104). The pearl roundel consists of a circle of bead shapes surrounding a pictorial motif, and occurs widely on Sassanian architectural stucco and metalwork. In China its earliest appearance is on sandstone carvings at the Buddhist cave site of Datong in Shanxi province, which date from the 5th century AD. The influence of these foreign designs is evident on several of the silk fragments collected by Stein.

The stiff outlines of the pearls and the deer in cat. nos. 96 and 97 are partly explained by the technical necessity to 'step' the outline of a pattern thread by thread when changing colour, but still these pieces contrast strongly with the printed fragment (cat. no. 105). In these pieces, the roundel is composed of encircled flowers rather than plain spots, providing a fitting enclosure for the more ornate design of typically Tang birds and foliage. The lavish lozenges between the roundels equal the roundels in size, a balance which contrasts with the earlier examples (cat. nos. 96 and 97) where the small lozenges, themselves enclosing confronting ducks, merely fill the spaces between the much larger roundels. In cat. no. 104 the scheme of the Sassanian roundel is revived, but with a naturalism which betrays its late 8th- to 9th-century date. In the 9th century and later, the pearl roundels are replaced by designs of plaited rope circles.

New decorative motifs are one aspect of contact with western Asia, but the major vehicle for all such influences was the Buddhist religion. Buddhism manifested itself in the silk industry in the form of embroidered images (see cat. nos. 88, 99). The earliest known of these is a fragment discovered in 1965 at Dunhuang, in a crack between the walls of caves 125 and 126. It depicts a seated Buddha with a Bodhisattva on his right, and below him an inscription and a group of named donor figures in Tartar dress. It is dated to AD 487. Buddhist embroidery was widespread in the Tang dynasty. In the late 7th century the Empress Wu Zetian ordered the imperial embroidery workshop to produce 400 paradise pictures. The famous Tang poet Bai Juyi frequently mentions silks in his poems – for example, 'A guest comes from the Northwest, he offers me kingfisher silk' – and sometimes praises the needlework of his sister-in-law Du. She was married to Bai Juyi's younger brother, the writer of fiction Bai Xingjian, and one of her Buddhist embroideries was at least half the size of the Vulture Peak embroidery exhibited here (cat. no. 88).

Silk in the Tang dynasty

Not only embroidery but all types of silks flourished during the Tang dynasty (AD 618–906). Throughout the 7th century trade along the Silk Route had increased greatly. By the 8th century, the Tang capital Chang'an (present-day Xi'an) was the most cosmopolitan city in Asia and had a substantial foreign population. The reign of the Emperor Minghuang, which lasted from AD 712 until the disastrous rebellion of An Lushan (AD 755–63), was one of the most glorious in Chinese history, and much of the achievement of the period was founded in the prosperous trade China enjoyed with her westerly neighbours. The historian Du Huan, who was in the Middle East from 751 to 762, records that in the city which is today Najaf in Iraq, markets and bazaars were full of Chinese brocade and embroidery.

By this time silk had been joined by other materials, notably ceramics and silver, as acceptable imperial tribute, but its role as an export commodity was greater than ever before. The textiles from Qianfodong exhibited here are one example of Chinese silks being used in Central Asia, but entire bolts travelled to markets much further west to be sold and resold.

The techniques invented during the Han dynasty and in the centuries after its collapse became widespread during the Tang dynasty but were also developed and varied. The most important production centres were under the supervision of government-appointed officials, where silk production was of high quality. Feudal lords frequently had manor workshops, and there were specialist ones in the towns. There were even village workshops, such as that of the Yuan family from Dingzhou in Hebei province, who had 500 looms. Each area produced its own particular figured silk, such as Youzhou sun-pattern silk, Huazhou geometric-pattern silk and Qingzhou immortal-pattern silk. The gazetteer section of the *Xin Tangshu* (New History of the Tang dynasty) records that in the eastern provinces of present day Jiangsu and Zhejiang, every prefecture had its own variety of water-pattern, fish-mouth-pattern and at least ten other types of silk. These local products would have been patterned in the warp and were probably single-colour figured silks, such as can be seen on the *kaṣāya* (cat. no. 89) and the altar valance (cat. no. 90).

The majority of small fragments from Qianfodong are either figured weaves and gauzes or polychrome silk, where

the design is woven in several colours to give a rich and sumptuous effect. Most types of figured weaves can be seen on the altar valance (cat. no. 90). Apart from elaborately patterned silks decorated by patterning the weft as mentioned earlier, silks were also decorated by printing and dyeing or enriched with embroidery and gilding.

Silk printed with flowers in three colours has been found at a Han dynasty site in Gansu, but it was during the Northern Dynasties period (5th–6th centuries AD) that the technique known as *jia xie* was invented. This involves cutting the pattern into two boards, originally of wood, and sandwiching the silk fabric tightly between them. Small holes in the boards are then plugged or opened to allow a succession of dyes to colour different parts of the pattern. A large area of fabric could be dyed at once using this technique by folding the silk before placing it between the boards. On some pieces such as the banner with horses (cat. no. 110) the folding is evident.

Embroideries are of two types: the Buddhist images discussed above, where the figures are built up in satin or chain stitch; and the silks, which are decorated with embroidered designs often related to other materials. Examples of the second type are the cover (cat. no. 98) decorated with flowers and ducks, and the large fragment with the deer's head (cat. no. 100). Embroideries such as this are often embellished with an outline of gold-leafed or silver-leafed thread placed on the silk and held down with small couching stitches.

Such silks are rich indeed, but the most sumptuous of Tang textiles are the small pieces of *kesi* tapestry weave. The technique of handweaving a pattern using several colours, doubling back with each thread when the colour changes so that there are open slits in the fabric, appears amongst Egyptian Coptic woollen textiles and woollen fragments of Han and later date unearthed in Xinjiang. It was first used in silk, however, in the Tang dynasty, when it was woven in narrow strips of up to 2cm in width. It was used for banner suspension loops (cat. no. 112) and to embellish larger objects such as the *sūtra* wrapper (cat. no. 91) in this exhibition. One of the most extensive and finest examples preserved appears on cat. no. 111, where strips of *kesi* compose a complete border to the banner heading. These small fine pieces represent the first of what would become the most prized of all China's silks. SJV

88 Śākyamuni preaching on the Vulture Peak

From Cave 17, Dunhuang. Tang dynasty, 8th century AD.
Silk embroidery on hemp cloth faced with silk.
H. 241cm, W. 159.5cm. OA (Ch. 00260).
Stein, *Serindia* pp. 983–4, pl. CIV; Whitfield, ACA vol. 3, pls. 1, 1–1–1–7, figs. 1, 2.

This magnificent embroidery is one of the largest Chinese examples known, and its theme and composition compare more closely with the big paradise paintings than with the other Dunhuang textiles. The subject is Śākyamuni preaching the Lotus Sūtra at Rājagṛha on Mt Gṛdhrakūṭa (the Vulture Peak) which is represented by the rocks surrounding the Buddha. His posture is the usual one for depictions of this event, with the right hand extended straight down and the left grasping the hem of his robe. The Buddha is attended by two disciples and two Bodhisattvas, probably Avalokiteśvara and Mahāsthāmaprāpta. The background is scattered throughout with leaves and flowers. At the top of the hanging are two *apsarasas* flanking a jewelled canopy and at the bottom are two groups of donor figures and a central inscription panel. There are eight narrower cartouches for dedicatory inscriptions, of which only two contain characters, and these are no longer legible.

Stein records that the embroidery was stored in Cave 17 with the disciple figures along the lines of the folds, which explains the heavy damage to them. Apart from the partial obliteration of these figures, the hanging is in remarkably

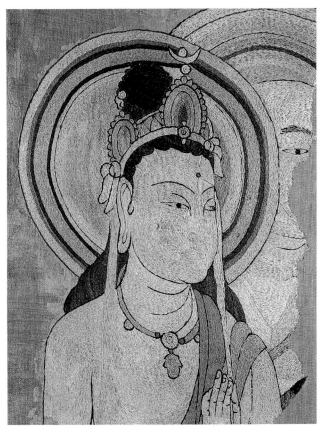

88B (detail)

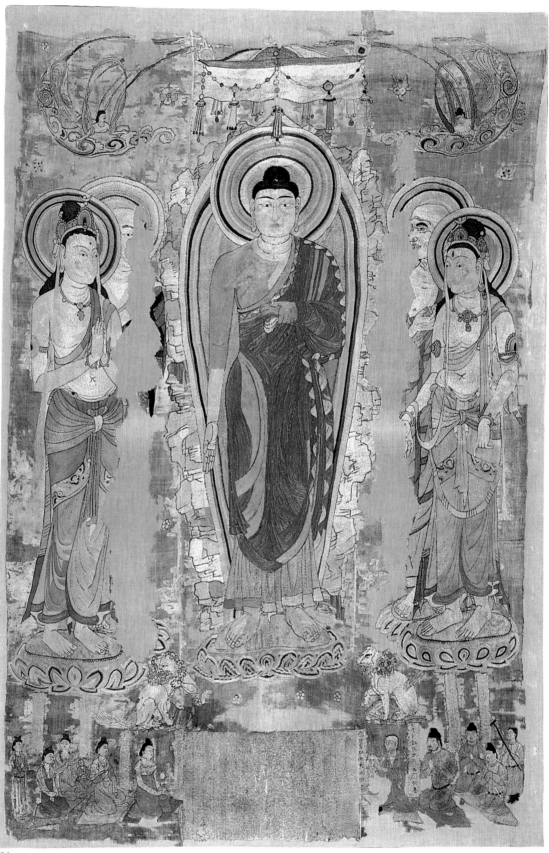

88A

88C (detail)

good condition with the embroidery intact and the colours vivid. Large areas of the thin silk beneath the embroidery have worn away, leaving the hemp backing visible. sjv

89 Patchwork, probably a kaṣāya

From Cave 17, Dunhuang. Tang dynasty, 8th–9th century AD.

Silk. H. 107cm, W. 149cm. OA MAS 856 (Ch. lv. 0028).

Stein, *Serindia* pp. 1069–70, pls. CVII, CXXII; Whitfield, ACA vol. 3, pls. 9, 9–1–9–7, fig. 8.

Stein suggested that this large patchwork was an altar-cloth but Whitfield has identified it as a *kaṣāya* or Buddhist monastic robe. Buddhist robes were made of patches of cloth as a sign of humility. The magnificent array of printed, embroidered and polychrome silks which compose this robe show that it must have belonged to a priest of high rank. The border consists of fine plain silk printed with an exuberant foliating scroll in blue. Along the top edge below the border is a wide band of much coarser silk printed in brown with floral medallions (89C). The same design appears on an adjoining patch where, in contrast, the medallions are woven in several colours (89B). The central area of the patchwork is broadly symmetrical with patches of identical or matching silks arranged on each side of a vertical axis. The most arresting of these are the two white panels embroidered with flowers, probably peonies. Each panel has the same floral design but the colours are different. The lefthand flower has small pink buds whereas on the righthand flower they are partly blue and partly unworked.

In common with all the embroidered patches of the *kaṣāya* and fragments elsewhere in the exhibition, these two panels have been stitched on gauze which has mostly disintegrated to expose a plain silk backing. The silk embroidery which must have dominated the patchwork has largely deteriorated. The white blossoms embroidered on a scarlet ground in the centre of the cloth appear in four other worn patches at the top and bottom of the second column from both left and right. On the lower left the patch includes two blue birds in addition to the blossoms. The same blossoms overlie brown, red, blue and yellow patches of plain and figured silk covering a large rectangular area in the centre of the patchwork. The plain patches beneath must have been included for strengthening. The coarse scarlet strengthening patch also runs under two lower patches. sjv

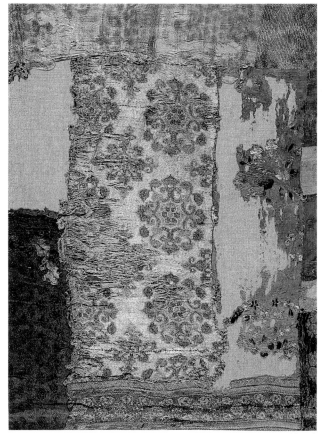

89B (detail)

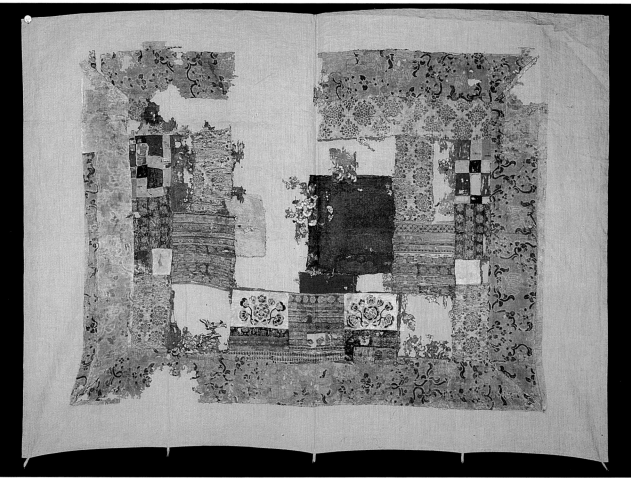

89A

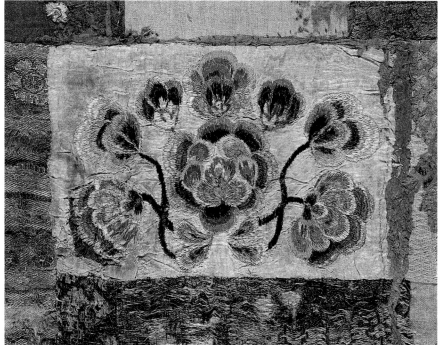

89C (detail)

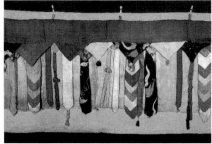

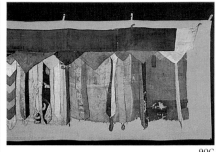

90A 90B 90C

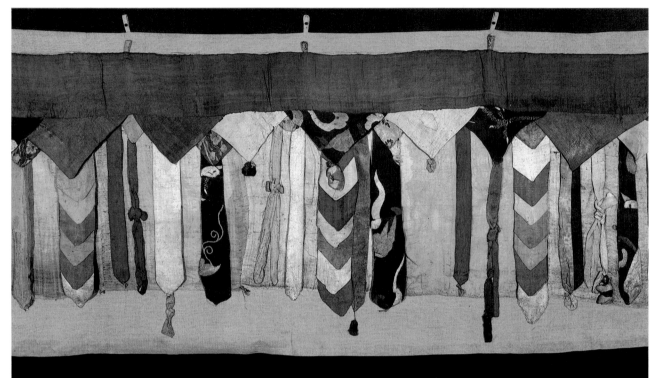

90B

90 Altar valance

From Cave 17, Dunhuang. Tang dynasty, 8th–9th century AD.

Silk. H. 46cm, W. 282cm. OA MAS 855 (Ch. 00279).

Stein, *Serindia* p. 985, pl. CX; Whitfield, ACA vol. 3, pl. 8, figs. 4, 5.

Altar valances like this one were once commonplace in Buddhist temples yet very few have survived. Stein presented two others to New Delhi but this is the most complete of the three, missing only a few streamers at the righthand end. The valance includes sixteen varieties of plain or figured silk, three different embroideries and one type of printed silk. It is composed of fragments stitched together, the largest of them being the red silk band along the top. The silk curtain behind the streamers is composed of ten panels of white, yellow and green, plain and figured silks. The triangles below the top band are of seven different colours of plain silk, one type of polychrome silk and two varieties of embroidery. The most striking of these is the dark brown silk with a large design of flowers and bird's feet with long

talons. The same embroidery is used for three of the streamers.

Three smaller triangles are of much finer embroidery with flowers outlined in a couched thread which was formerly wrapped with silver. The third embroidery, of flowers on a red ground, is used for two of the streamers. Like the bird-embroidered brown silk, the stitching is coarse, but the two types are interesting for being the only examples of embroidered silk in the collection whose gauze backing has not disintegrated. Seven of the streamers, including a green and a white streamer, are knotted in the middle and have been knotted together. Eleven others have pads or panels attached at the bottom; from three of the streamers hang small stuffed silk figures. Stein suggests (op. cit., p. 900) that the figures had previously been used as votive offerings by people hoping to have children. SJV

116

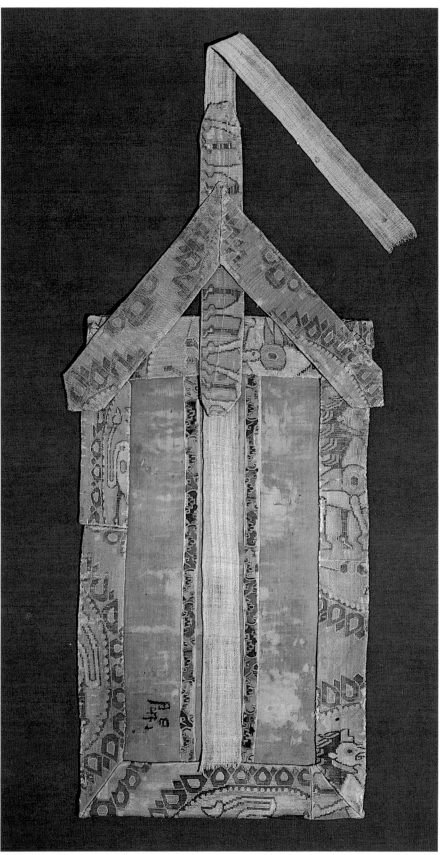

91

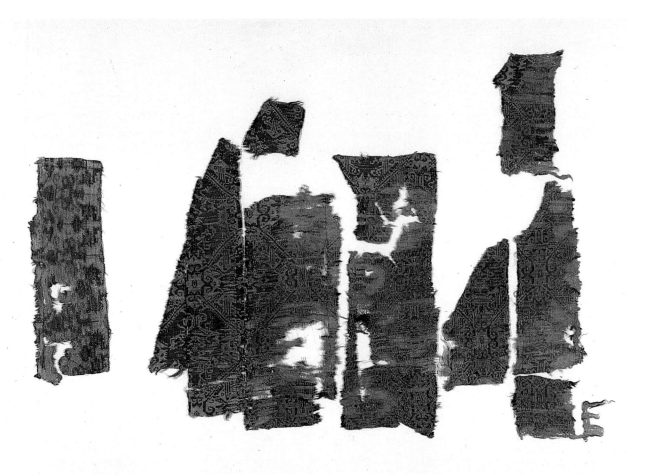

92

91 Sūtra wrapper

From Cave 17, Dunhuang. Tang dynasty, 8th century AD.

Silk. H. 30.6cm, W. 78.6cm. OA MAS 858 (Ch. xlviii. 001).

Stein, *Serindia* pp. 1049–50, pls. CVI, CXI, CXVI; Whitfield, ACA vol. 3, pl. 6, figs. 6, 7.

A long sūtra might consist of several scrolls which would be kept in a wrapper for storage. This wrapper is made from a plain woven silk with edging and decoration of much finer silk fabrics. Two strips of *kesi* tapestry weave run down the centre. The edges and endpiece are made from a thick woven silk patterned with a bold design of confronting lions within roundels. The weave and the design compare with three fragments in the exhibition (*see* cat. nos. 96, 97). An examination of the dyes and colour schemes of these pieces shows that they are related to a group of silks in Europe which may be attributed to the textile centre of Zandane near Bokhara in Sogdiana, southern Russia, and date to the 7th century (Shepherd, 1959, pp. 15–40, fig. 10). In one corner of the wrapper is painted the character *kai* (open). Characters served to index sūtra wrappers, probably according to the order of the 1,000 characters in the *Qianziwen* (Thousand Character Classic). SJV

92 Group of nine fragments

From a watch-tower on the Dunhuang *Limes*.
Han dynasty, 206 BC–AD 220.

Silk.
From left: H. 15cm, W. 5cm; H. 19cm, W. 6.6cm; H. 3.5cm, W. 3.9cm; H. 15.6cm, W. 6.5cm; H. 19cm, W. 7.2cm; H. 9.6cm, W. 4.6cm; H. 8.1cm, W. 4.2cm; H. 12.8cm, W. 4.9cm; H. 4.2cm, W. 6cm.

OA MAS 820 (T. xxii. c. 0010. a.).

Stein, *Serindia* pp. 720, 785–6, pls. LV, CXVIII; Whitfield, ACA vol. 3, pl. 38.

West of Dunhuang and slightly to the north is the series of military forts which Stein named the Dunhuang *Limes*. It was there that Stein discovered this group of fragments together with stable refuse, records on pieces of wood and a number of silk, wool and cotton fragments. The nine fragments, shown separately here, are illustrated in *Serindia* stitched together to form one large piece, as Stein must have found them. All but one of the fragments have been cut from the same cloth. The design of stylised dragons and phoenixes, framed in a squared scrollwork to form an overall design of medallions and squared lozenges, is of purely Chinese origin. In the centre of each medallion is an eight-pointed star-shape which can also be seen on a fragment in

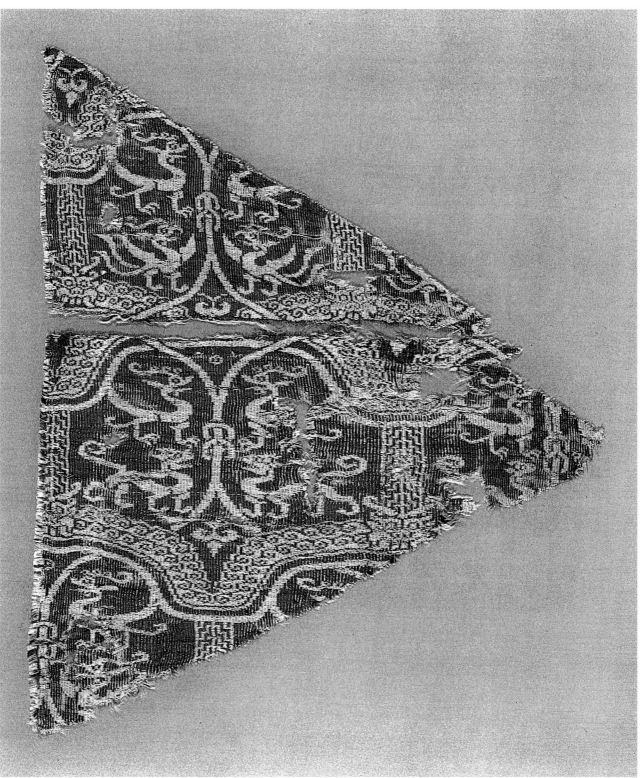

93

the Pelliot collection in Paris. The fragment on the left is of a different, less highly stylised design. The warp threads are the same in all nine pieces but in the case of eight of them, the wefts are of a coarser dark thread. Stein records that one of the documents that came from the watch-tower where this group was discovered is marked with a date corresponding to 98 BC.

<div align="right">SJV</div>

93 Pair of fragments

From Cave 17, Dunhuang. 3rd–5th century AD.

Silk. From left: H. (max.) 20.5cm; 15.8cm.
OA MAS 926 a, b (Ch. 00118).

Stein, *Serindia* pp. 963–4, pl. CXI; *Burlington Magazine* August 1920; Whitfield, ACA vol. 3, pl. 37, fig. 12.

Like those in the previous example, these pieces are of a tightly woven double cloth. When Stein discovered the fragments they were stitched together to form a larger triangle backed with plain buff silk and bordered with dark red tape. Such an arrangement almost certainly constituted a banner headpiece. The paired dragons and winged birds among interlacing borders, and the stepped border design itself, are all uncommon on textiles. The arched border and double cloud scroll appear in large format on another small fragment in the British Museum (OA MAS 803), but these seem to be the only such examples from Cave 17. A similar fragment was unearthed in 1968 at Astāna.

<div align="right">SJV</div>

94 Two fragments

From the Dunhuang *Limes*. Eastern Han dynasty, AD 25–220.

Silk. From left: H. 6.7cm, W. 4.2cm; H. 4cm, W. 4.3cm.
OA MAS 793 a, b (T. XV. a. 002).

Stein, *Serindia* p. 781, pl. LV.

These fragments come from a large cloth woven with rows of auspicious characters (*see p.110*). A large fragment unearthed at Loulan in 1980 and now in the collection of the Xinjiang Autonomous Region Academy of Social Sciences Archaeological Research Institute appears to belong to the same cloth or to an identical one. The Xinjiang fragment does not include the rectangles in the design but is clearly woven with the character *xu* (continuous or successive) replacing a pair of dots in the wavy line, and it is repeated down the cloth to form a column of *xu* characters. The wavy lines to the right is another column composed of the character *shi* (generation). It is thought that the design was originally completed with the character *jin* (brocade) so that the piece read 'brocade of successive generations'. It is described as having a density of 56 warp threads and 36 weft threads per centimetre (*Zhongguo meishu quanji* vol. 6, p. 39). Even on this small fragment the fineness of the weave is evident. Stein writes that fragments similar to this one appear among silk fabrics excavated from Loulan in 1914 and now in New Delhi (L.C. ii. 05. a, L.C. 031 b). The first of these has a selvedge from which the piece has been identified as warp-patterned. Another fragment unearthed from Loulan in 1980

bears the same design of small squares and wavy lines as these pieces, but is executed in brown and beige (*Zhongguo meishu quanji* vol. 6, pl. 92).

<div align="right">SJV</div>

95 Rug fragment

From Loulan. Late 3rd–early 4th century AD.

Wool. H. (max.) 22.5cm, W. (max.) 21.5cm.
OA MAS 693 (L.A. VI. ii. 0046).

Stein, *Serindia* p. 438, pl. XXXVII; Whitfield, ACA vol. 3, pl. 50.

The site from which this rug fragment was recovered was a rubbish pit where inscribed bamboo slips dated between AD 264 and 270 were also found. The thickness of the warps and wefts of the rug fragment differ greatly; the warp is of a dark brown stringy wool of approximately 1mm thick while the weft is as thick as 7mm. There is a large knot every 2 to 3cm along the reverse, which Stein suggests was included to prevent the rug from slipping. The knotted pile includes five different colours. The fragment appears to come from the edge of the whole piece, for there are seven border stripes on the left. The pattern to the right is quite complicated but the fragment is too small to reveal what the whole design may have been. A similar fragment was unearthed in 1959 from a Han tomb at Minfeng Dasha in Xinjiang province.

<div align="right">SJV</div>

96 Two fragments

From Cave 17, Dunhuang. 7th–8th century AD.

Polychrome silk.
From left: L. 27cm; H. 21.7cm, W. 8cm.
From left: OA MAS 862a (Ch. 009); OA MAS 862b (Ch. 00359. a).

Stein, *Serindia* pp. 939, 991–2, pls. CXI, CXV; Whitfield, ACA vol. 3, pls. 40–1, 40–2, fig. 14.

These fragments belonged to separate items. Stein describes the larger triangular piece as a banner headpiece with borders, though these no longer remain. It was originally attached to a 9th-century banner (Ch. 009) now in New Delhi. The smaller fragment was stitched to the following example to form another triangular banner heading. The five colours of silk are all woven together, making the cloth thick and heavy. This technique compares with the lion roundel edges on the sūtra wrapper (*see* cat. no. 91), although in this case the outlines of the design are much smoother. The design and weave of these fragments is similar to a complete width of silk in the Collegiate Church at Notre Dame at Huy in Belgium (Shepherd, 1959). The Huy silk has a Sogdian inscription on the reverse, dating it to the 7th century.

<div align="right">SJV</div>

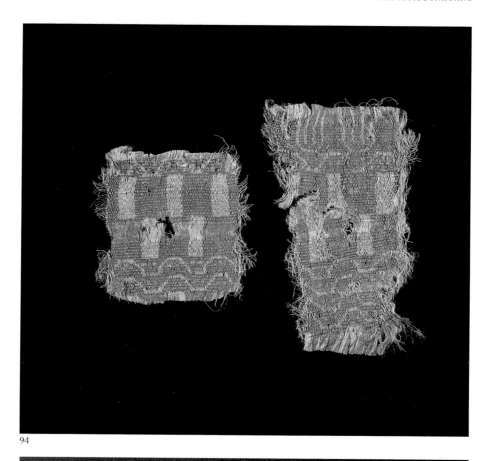

94

95

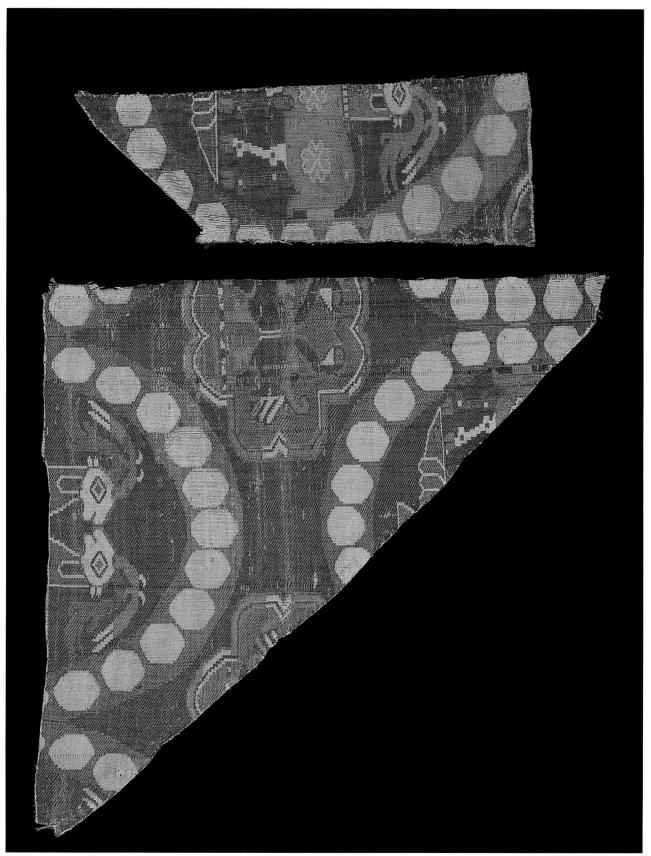

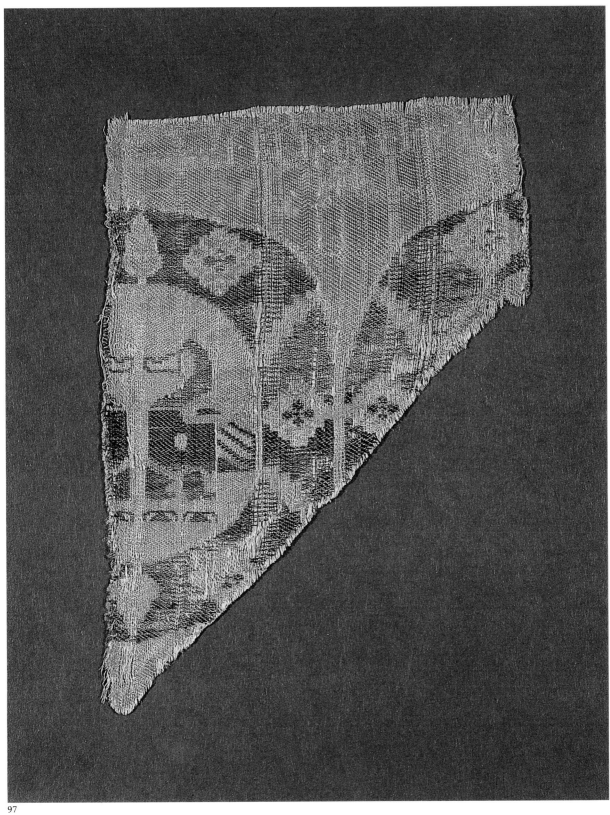

97

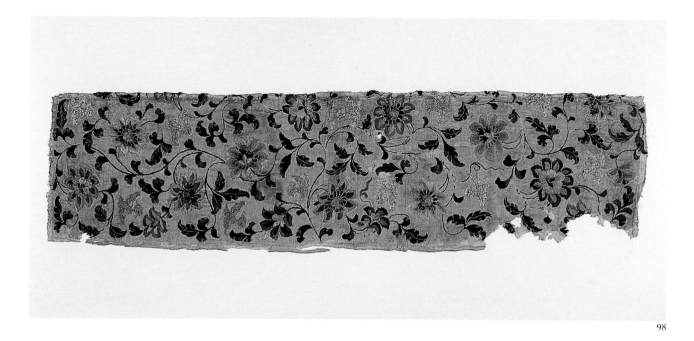

98

97 Fragment

From Cave 17, Dunhuang. 7th–8th century AD.

Polychrome silk. H. 15.7cm, W. 11.5cm.
OA MAS 863 (Ch. 00359. b).

Stein, *Serindia* p. 991, pl. CXV; Whitfield, ACA vol. 3, pl. 40–3.

This fragment was originally stitched to the smaller fragment in the previous example to form a banner headpiece. The former seams show as brighter strips on both edges of the fragment. Stein and Xia Nai (*Kaoguxue he kejishi*, 1979, pp. 96–7) describe this type of fabric as weft-faced which is usual for Tang polychrome silks. However, Whitfield calls this example warp-faced and suggests a connection with products from the textile centre of Zandane near Bokhara in Sogdiana, southern Russia (*see* cat. no. 91). SJV

98 Panel with flowers and ducks

From Cave 17, Dunhuang. Tang dynasty, 9th–10th century AD.

Silk embroidery. H. 23.4cm, W. 91.7cm.
OA MAS 857 (Ch. xxii. 0019).

Stein, *Serindia* p. 1024, pl. CVI; Whitfield, ACA vol. 3, pl. 3, fig. 3.

When discovered by Stein, this large piece of embroidery was folded over and sewn into a bag-shaped cover. The long selvedge and the two short edges are the proper ends of the cloth, but the abrupt ending of the embroidery on the other long edge shows that the cloth was cut. The exuberant scroll of leaves and flowers is executed in silk thread on a ground of cream silk twill which is itself figured with a scroll design. Behind the figured silk is a piece of plain woven cream silk which acts as a backing, and the embroidery is stitched through the two layers using a long satin stitch. The ducks are embroidered only on the beak, eye and upper wing section. The remainder of each bird is formed by laying

down a thick thread covered in gold and couching it with small stitches. The petals and leaves are similarly outlined with a single couched thread covered in silver, which survives as dark grey oxidised stretches. The gold and silver thread and the bright-coloured silk threads are better preserved at one end of the piece. At the other end, areas of blue silk have worn away to expose the original ink outline for the design. A third of the way along, the small birds change direction. The overall design of a meandering scroll with flowers and birds is a concept which survived for many centuries in the Chinese decorative repertoire. SJV

99 Standing Buddha holding an alms bowl

From Cave 17, Dunhuang. Tang dynasty, 7th–8th century AD.

Silk embroidery and gilded leather. H. 11cm, W. 6.7cm.
OA MAS 911 (Ch. iv. 002).

Stein, *Serindia* p. 1014, pl. CVI; Whitfield, ACA vol. 3, pl. 2.

The small Buddha holds an alms bowl in his right hand, while the left hand gathers his robe in exactly the same gesture Śākyamuni displays in the Vulture Peak embroidery (*see* cat. no. 88). The regularity of the mandorla flames and the rigid rectangular design on the Buddha's robes contrast with the more fluid style of the Vulture Peak. The image of the small Buddha is embroidered in chain stitch through two layers of supporting silk, though the stitching is so dense that almost none of the background silk is visible. The immediate layer is of a dark red ribbed woven silk similar to that supporting a small chain-stitched fragment also in the British Museum (OA MAS 788). The ribbed silk of this piece is itself backed with a plain woven silk of the same dark red colour. The thread in which this Buddha is embroidered is noticeably finer than that used for the satin stitch of the slightly later Tang floral embroideries in the collection.

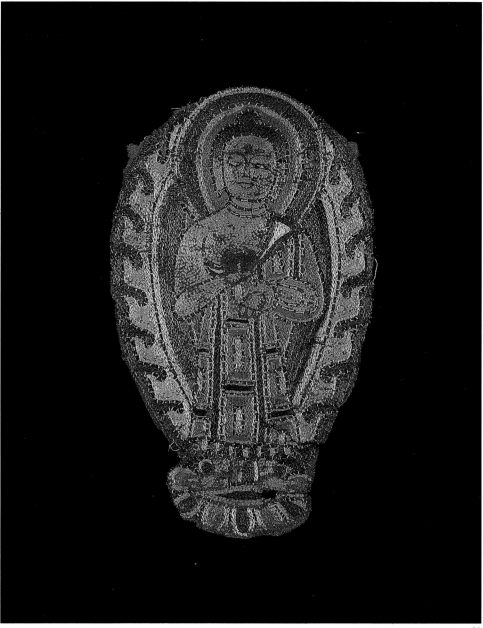

99

The outlines of the figure, the mandorla and the lotus pedestal were all originally depicted in gilded leather. Most of this has disintegrated but the yellow couching stitches which held the strips in place remain. In the few places where the leather does survive, there are only a very few traces of gilding. A hanging composed of some eighty small embroidered Buddha images is illustrated by Stein (Ch. 00100, Stein, op. cit., pl. CV). Another small embroidered Buddha, from Toyok in the Turfan area on the northern Silk Route and dated 8th–9th century AD, is in the West Berlin State Museum (*Along the Ancient Silk Routes*, no. 144). Whitfield suggests that this piece and the one in Berlin might have been small figures in the halo of a larger Buddha. SJV

100 Fragment

From Cave 17, Dunhuang. Tang dynasty, 8th–9th century AD.
Silk embroidery. H. 29cm, W. 8cm. OA MAS 912 (Ch. xxvi. 003).
Stein, *Serindia* p. 1030, pl. CVI; Whitfield, ACA vol. 3, pl. 4.

The tail of an unidentified beast at the top of the fragment, seen together with the deer's head and antlers below, indicate that this piece must have been part of a considerably larger embroidery. The use of ten different colours in the largest flower shows how lavish the embroidery was. The design is executed in satin stitch through two layers of silk, the upper one of gauze and the lower of plain woven silk. Gauze was used for most embroideries in the Tang dynasty because its open weave eliminated the risk of cut-

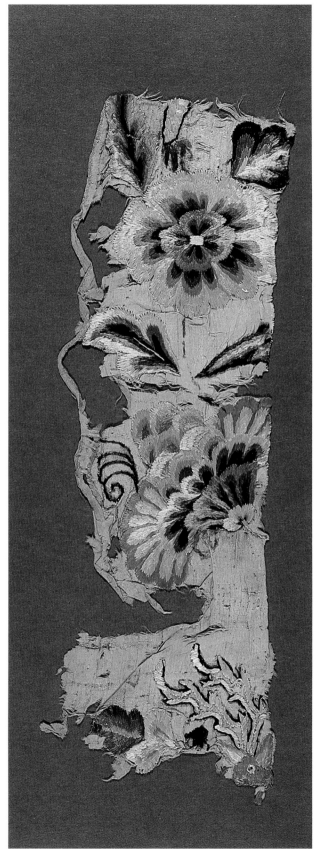

100

ting individual threads during close working. The gauze on this fragment only remains beneath the embroidery itself, the rest appearing to have worn away. The reverse of the fragment shows that the supporting plain silk was originally pink. Most of the silk has faded, but the embroidered areas retain a strong pink colour. Below the antlers of the deer is an area where the dark blue threads have disintegrated, exposing the gauze and some ink outline drawing.

SJV

101 Fragment

From Cave 17, Dunhuang. Tang dynasty, 8th–9th century AD.

Silk, paper, gold and silver. H. 6.3cm, W. 14cm.
OA MAS 915 (Ch. 00347).

Stein, *Serindia* p. 989, pl. CX; Whitfield, ACA vol. 3, pl. 4.

This embroidery was probably produced as a border for a banner heading or other larger item. Stein comments that this fragment was 'apparently cut from a band $1\frac{3}{4}$ inches wide, for which [the] embroidery was designed'. It is clear that the piece was intentionally narrow, for the half-flowers are properly finished off either with a folded edge or a strip of gilded paper. The gold bordering the blue and green petals is applied to thin paper strips. Like the gilded threads in the panel with flowers and ducks (*see* cat. no. 98) and the leather in the standing Buddha (*see* cat. no. 99), the paper is held down by couching stitches. The petals of the red flower are outlined with silver using the same technique, though the silver appears black after oxidisation. The satin stitch embroidery is executed on a single thickness of black silk which is quite thick. The latter has been glazed and is figured with a design of small concentric lozenges. SJV

102 Fragment

From Cave 17, Dunhuang. Tang dynasty, 8th–9th century AD.

Silk embroidery. H. 7.3cm, W. 4.2cm. OA MAS 955 (Ch. 00445).

Stein, *Serindia* p. 1000; Whitfield, ACA vol. 3, pl. 25.

This is one of a group of banner streamer fragments stamped with a leaf design, of which some were embroidered in green. That pieces with a stamped design must have been awaiting embroidery is indicated by the fact that other embroideries whose stitching has worn away leave exposed areas of ink outline. Several other examples exist of gauze banner streamers from Cave 17. SJV

103 Fragment from the border of a painting

From Cave 17, Dunhuang.
Tang dynasty, probably 9th century AD.

Silk embroidery. H. 31cm, W. 17.5cm.
OA 1919.1–1.05, 1919.1–1.052* (Ch. 00167).

Stein, *Serindia* pp. 970–1, pl. LXI (for further references see cat. no. 21); Whitfield, ACA vol. 2, pl. 26; vol. 3, pl. 5.

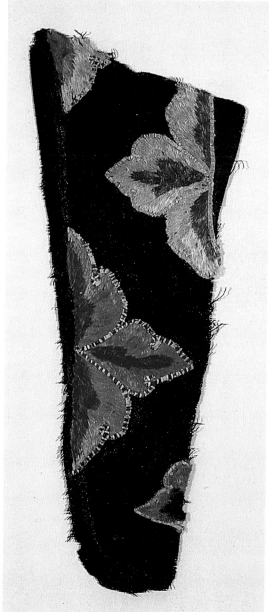

101

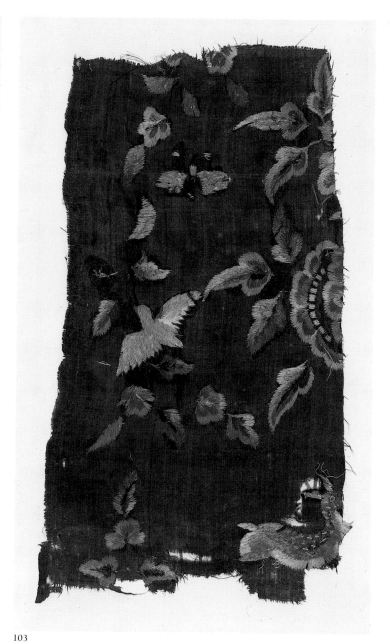

103

102

This fragment of embroidery once filled a gap in the border of a painting in the exhibition (*see* cat. no. 21). Remaining patches of dark green gauze show that the embroidery was originally densely patterned and must have appeared similar to the embroidered cover (*see* cat. no. 98). The effect was undoubtedly lavish, yet a number of details show this piece to be less fine than some of the other embroideries in the exhibition. For example, only six colours are used in the largest flower compared to ten in another fragment (*see* cat. no. 100), and the motifs are not outlined in silver and gold. The bird is outlined but in a single line of pink stitching which matches its beak and the upper edges of its wings. The dense design of birds with outspread wings amid flowers and foliage compares with Tang mirrors inlaid with mother-of-pearl. An embroidery in the Pelliot collection in Paris (EO. 1191/B) appears to be another fragment from the same piece. SJV

104 Three banner fragments

From Cave 17, Dunhuang. Tang dynasty, 9th century AD.

Printed silk.
From left: H. 29cm, W. 11cm; H. 30.3cm, W. 17cm; H. 28.5cm, W. 28.2cm.
From left: OA MAS 874b (Ch. 00291); OA MAS 874a (Ch. 00291); OA MAS 875 (Ch. 00292).
Stein, *Serindia* p. 986, pls. CXIII, CXVI.A; Whitfield, ACA vol. 3, pl. 13, fig. 9.

These three pieces come from two separate banners. Stein records that the two rectangular fragments on the left were combined with two fragments of plain silk, whose whereabouts are unknown, to make a banner of four sections stiffened with bamboo at the joins. The square piece was folded diagonally to form a headpiece for another banner. At 55cm in diameter the design would have occupied the whole width of an average silk bolt 59 to 60cm wide. It is based on the Sassanian motif of a pair of confronting animals within a pearl roundel. Pearl roundels on early textiles were often interspaced with lozenges or floral medallions, and a motif of this type is evident on the square fragment. However, the naturalistic style of the deer, the tree dividing them and the small floral designs both on the background and within the spots of the roundel are Chinese adaptations of the Sassanian motif and indicate a later date. A fragment found by a Japanese archaeological expedition to Dunhuang bears the same design, with the addition of four characters meaning 'flowering tree, paired deer' between the animals. The whole design originally belonged to woven textiles on a smaller scale. A grey penumbra around the blue areas is possibly a technical fault which may account for the cutting up of what must have been in its entirety a large and bold design. SJV

105 Two banner headings

From Cave 17, Dunhuang. Tang dynasty, 8th–9th century AD.
Printed silk.
From left: H. 23.8cm, W. 23.8cm; H. 26.3cm, W. 26cm.
From left: OA MAS 876 (Ch. 00304.a); OA MAS 877 (Ch. 00304. b).
Stein, *Serindia* p. 987, pl. CXIII; Whitfield, ACA vol. 3, pl. 18, fig. 10.

These two pieces are cut from the same fine plain silk which must have been printed with circular medallions of more than 50cm diameter. The idea of a roundel with lozenges interspersed derives ultimately from Sassanian art, but the dense foliage and other motifs on this piece are a typical Tang design. The naturalistic pairs of birds appear on Tang lacquerware, silver and ceramics. In particular, their positioning at the outer edge of the central decoration is similar to the designs on the circular *sancai* three-colour ceramic trays (*see* cat. no. 106). As in the three fragments in the previous entry, the outer border of the circle is a sinicised version of the pearl roundel motif. SJV

106 Streamer

From Cave 17, Dunhuang. Tang dynasty, 8th–9th century AD.
Silk. H. 34.4cm, W. 11cm. OA MAS 884 (Ch. xxiv. 009).
Stein, *Serindia* p. 1029, pl. CXIII; Whitfield, ACA vol. 3, pl. 21.

The comparatively short length of this streamer suggests that it originally belonged to an altar valance rather than a banner. The edges have been rolled and sewn with red silk thread to protect them from fraying. The floral design is printed on gauze and outlined in ink by hand. The colours have faded considerably but must once have been bright yellow on a bright salmon ground. The combination of motifs of flying ducks with foliage, also shown in the previous entry, appears regularly on flat dishes of Tang three-colour ceramic ware. The arrangement of the design with alternating half-motifs is similar to that of many narrow strips of *kesi* tapestry. SJV

107 Fragment

From Cave 17, Dunhuang. Tang dynasty, 8th century AD.
Printed silk. H. 11.5cm, W. 25cm. OA MAS 931 (Ch. 00309. a).
Stein, *Serindia* p. 988; Whitfield, ACA vol. 3, pl. 20–1.

Stein found this piece together with some smaller fragments which formed the border of a banner headpiece with a white silk centre. He describes it as part of the body of a banner. A banner headpiece of white silk with a complete border in this print is in the Pelliot collection in Paris (EO. 1192/C–2, Mission Pelliot XIII p. 265). The silk is a soft fine plain weave and has been rolled over and stitched along one edge. The lozenge-shaped floral spot repeat pattern has been printed lightly, and does not penetrate to the lower threads in the weave. SJV

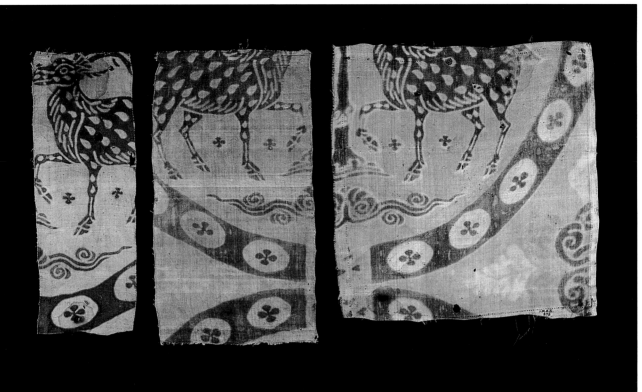

104

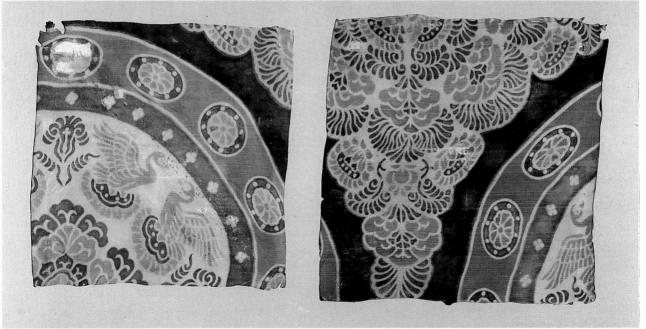

105

129

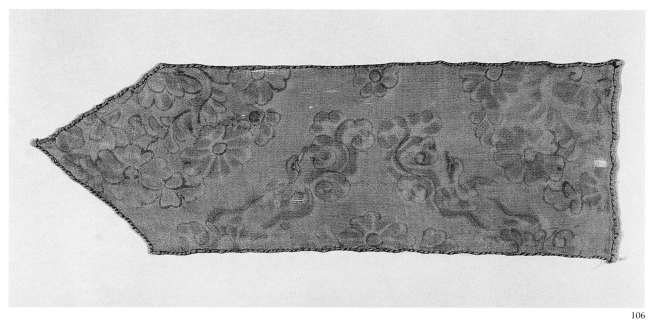

106

107

109

108 Two fragments

From Cave 17, Dunhuang. Tang dynasty, 8th–9th century AD.

Printed silk. From left: H. 17cm, W. 8cm; H. 17cm, W. 6.5cm. OA MAS 878a, b (Ch. 00305).

Stein, *Serindia* p. 987, pl. CXIII; Whitfield, ACA vol. 3, pl. 17.

The silk here is a tightly woven plain weave. The smaller of the fragments shows clearly where the fabric was folded so that two layers or more could be printed together. The green flowers have been dyed twice, with blue and yellow, just as the purplish brown areas have been dyed both scarlet and blue. SJV

109 Fragment

From Cave 17, Dunhuang. Tang dynasty, 8th–9th century AD.

Printed silk. H. 5.8cm, W. 16.5cm. OA MAS 932 (Ch. 00510. a).

Stein, *Serindia* p. 1007; Whitfield, ACA vol. 3, pl. 20–2.

This small fragment is a banner suspension loop which has been opened out. As in the previous item, the decoration was produced by folding the material both horizontally and vertically, and then diagonally, to obtain mirror images of the design on either side of each fold. RW, SJV

108

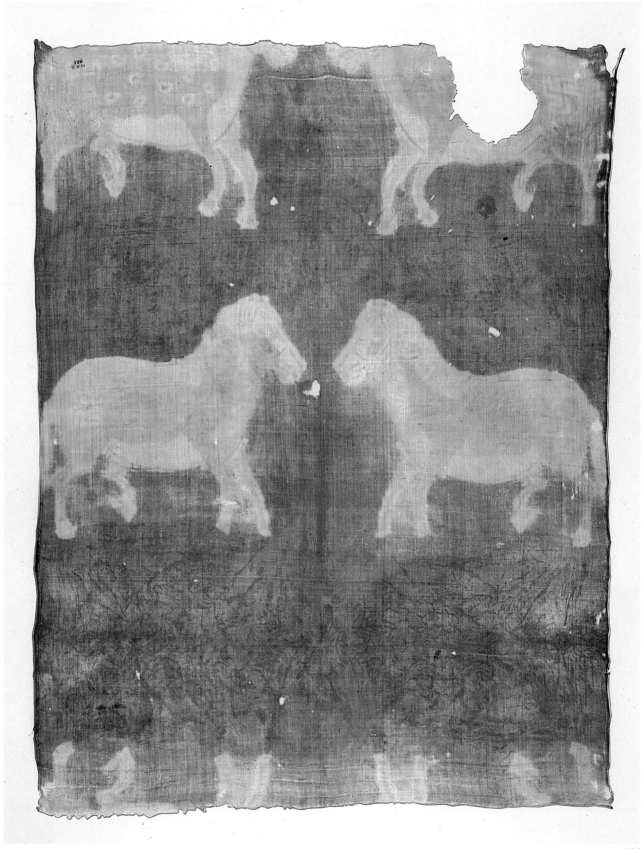

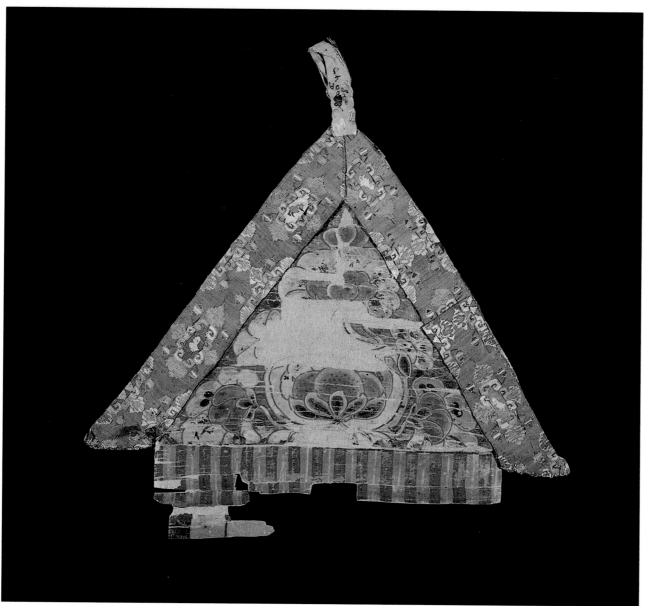

110 Banner

From Cave 17, Dunhuang. Tang dynasty, 8th–9th century AD.
Printed silk. H. 134.6cm, W. 53cm. OA MAS 885 (Ch.00357).
Stein, *Serindia* p. 991, pl. CXVI.A; Whitfield, ACA vol. 3, pl. 15.

In its complete form this banner would probably have been longer, with at least one more pair of horses below the present lower edge. At the upper edge the tops of the horses' heads are obscured by the pink banner heading sewn above. The uppermost horses are the more elaborate, with white spotted markings as well as a swastika on the hindquarters. The eight paired markings at the base are the mirror image of the legs of the horses above. The repeat pattern was produced by folding the silk before printing (*see p.112*), which in this case is clearly visible. Since the design is also symmetrical on a vertical axis, the silk must have been folded in four before being printed. The pairing of the animals derives from early Sassanian textile motifs and the stocky horse resembles the Przewalski breed of the Mongolian steppes. SJV

111 Banner headpiece

From Cave 17, Dunhuang. Tang dynasty, 8th century AD.
Painted and *kesi* silks. H. 22.5cm, W. 23cm.
OA MAS 905 (Ch. 0058).
Stein, *Serindia* pp. 950–51; Whitfield, ACA vol. 3, pl. 43.

This sumptuous banner headpiece is composed of painted plain silk bordered with strips of *kesi* silk tapestry. The painting consists of a large flower surrounded by three smaller ones and is bordered along the lower edge with a valance of stripes painted in orange and red. *Kesi* tapestry is the most opulent form of Tang silk textile. It is woven in narrow strips and used as borders or as additional adornment on the highest quality items. The border here represents the full width of the tapestry. The arrangement of the decoration, where one complete motif alternates with two joining half-motifs, is typical.

Stein describes the motif as a duck-pond surrounded by plants. The colouring of the four leaves and the four buds alternates according to whether the motif is a whole or a half. The ducks and their ground change not only in colour but also in design. This difference in design from motif to motif is only possible in *kesi*, where a narrow piece of tapestry is produced by hand, and cannot occur in ordinary weaving. The duck on this *kesi* is the sinicised version of the Indian goose which symbolises the enlightened pupil. The centre of the petals and the edges of the buds are decorated with gold-leafed paper or leather. Another banner headpiece bordered with the same *kesi* tapestry is published by Stein (Ch.lv. 0034, op. cit., pls. LXXX and CV). SJV

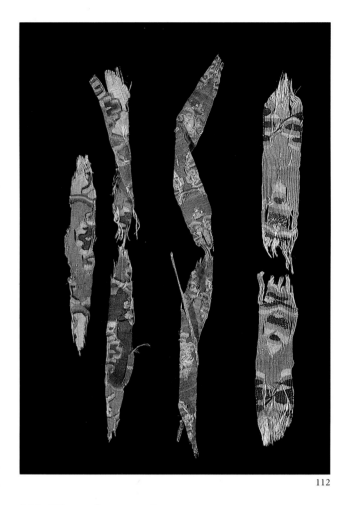

112

112 Three fragments

From Cave 17, Dunhuang. Tang dynasty, 8th century AD.
Kesi tapestry-woven silk.
From left: L.16.5cm, W.1.5cm; L.9.0cm, W.1.2cm; L.18.8cm, W.1.4cm; L.8cm, W.1.7cm; L.8.5cm, W.1.8cm.
From left: OA MAS 906a,b (Ch. 00166); OA MAS 907 (Ch. 00300); OA MAS 908a,b (Ch. 00301).
Stein, *Serindia* pp. 970, 987, pls. CVI, CXII; Whitfield, ACA vol. 3, pl. 44.

Kesi was a precious type of textile used only in small quantities. In the Tang dynasty, *kesi* tapestry-woven silks were only produced in narrow strips, as can be seen from these fragments. The fragments represent the full width of the tapestry and clearly display the characteristic vertical split at the point where the colour changes. The white areas of coarser thread were originally gilded, though this is almost entirely worn away. The damage at the centre of each strip indicates that the pieces were used as suspension loops for banners and, in the case of the two on the far right, the loop has worn through completely. SJV

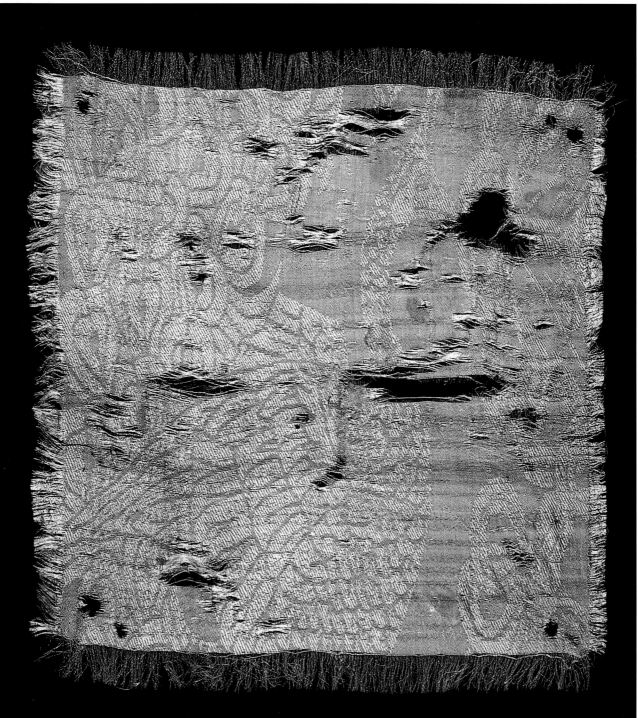

113

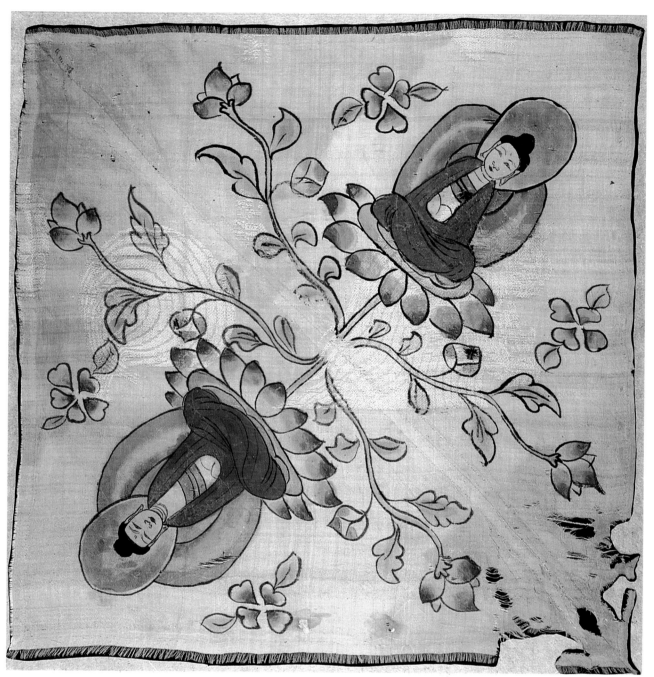

114

Relics of the Silk Route

The Buddhist paintings and manuscripts from the Caves of the Thousand Buddhas at Dunhuang are today the most famous of all the finds made by Sir Aurel Stein. However, for Stein himself, his surveys and excavations at many other sites in what is now the Chinese province of Xinjiang occupied proportionately far more of his time and attention. Stein's imagination was fired and his own efforts sustained by his interest in three great figures: Alexander the Great; the Chinese monk and pilgrim Xuanzang, who travelled along the routes between the great Buddhist monasteries in the Tarim Basin to India in the 7th century AD; and Marco Polo.

The campaigns of Alexander the Great, which took him as far as the banks of the Indus, brought Greek settlement into what are today the lands of Afghanistan and Pakistan. The Kushans ruled this area, known as Gandhara, in the first centuries AD, and the early Buddhist sculptures they carved show the influence of Classical art from the Mediterranean. Stein was to track these similarities in both figure styles and architectural ornament across the wastes of Central Asia as far east as Loulan. In the bitterly cold and windy winter conditions of the Tarim Basin, on the edge of the relentless Taklamakan Desert, he exclaimed time and again at the Classical features that had reached this remote corner of East Asia by way of India:

When I came to clear the clay sealings on the documents which I had carried away to my tent carefully wrapped up, I discovered that almost all remained as fresh as when first impressed, and that most of them were from intaglios of classical workmanship representing Pallas Promachos, Heracles with club and lion-skin, Zeus, and helmeted busts.

Stein, *Ruins of Desert Cathay*

Balancing his interest in Classical antiquity was his own identification with the pilgrim Xuanzang, whose account of his travels across Central Asia provided Stein with invaluable information on the cities and sites of the 7th century AD and enabled him to recognise places by their earlier Chinese names. Stein also made extensive use of those sections of the Han (206 BC–AD 220) and Tang (AD 618–906) dynastic histories dealing with the area. Indeed, even today an understanding of the very complex history of the area is dependent on the Chinese histories and to a lesser extent on late Classical and Byzantine accounts. Stein discovered few traces of the period of Marco Polo, but he was nonetheless conscious throughout his expeditions of following in the tracks of that famous European.

Sites represented by objects in the exhibition

Although there are no contemporary written accounts of the early development of the cities of Central Asia, Stein's numerous finds of early texts in Sanskrit, Kharoṣṭhī (the early written language employed in the north-west of the Indian sub-continent) and Brāhmī illustrate the pervasive influence of a ruling class or classes with strong ties to India. Indian and Iranian coins or copies of them were also found in great numbers. These finds were particularly welcome to Stein and are recorded in great detail, as they confirmed his understanding of the history of the area.

As Stein made his visits to the Tarim Basin from his base in Kashmir, his journeys inevitably were from west to east. In addition, while expeditions led by German scholars concentrated on the northern Silk Route, he worked mainly along the southern route (*see p.140*). Discussion of the sites, therefore, here follows the southern Silk Route from west to east before mentioning the sites on the northern Silk Route.

Khotan

Khotan, with its capital at the site of Yotkan, was one of the most important kingdoms in the Tarim Basin. Chinese accounts of Khotan, known by the name of Yutian, start in the Western Han period around the 2nd to 1st century BC. Legend has it that a son and ministers of the great Indian king Aśoka established a colony in Khotan during the 3rd century BC, and this story is included in the monk Xuanzang's description of his pilgrimage route. Whatever its origins, Khotan became a formidable power. When China reasserted its authority in the Tarim Basin during the 7th century AD, Khotan was chosen as the seat of one of the Four Garrisons. Although Chinese control waned during the 8th century, later Chinese dynastic histories mention embassies from Khotan in the 11th century. In the 13th century Khotan was described by Marco Polo, and the area appears again in the Ming histories as sending further embassies to China.

Clay impressions of Classical seals on Kharoṣṭhī documents. Found at Niya (Stein, *Ruins of Desert Cathay*, fig. 95)

Map of Central Asia showing the principal archaeological sites

1 Karasai
2 Yotkan
3 Rawak
4 Dandān-oilik
5 Farhād-bēg-yailaki
6 Khādalik
7 Darabzan-dong
8 Kara-yantak

archaeological sites

500 kilometres

Stein visited Khotan on all three of his expeditions. No structures remained above ground at Yotkan, but Stein recovered many small terracottas and some ceramic vessels (cat. nos. 137, 138, 139). Many of the small terracottas were pieces of larger objects, sometimes vessels and probably occasionally larger items. The depiction of faces, often framed by beaded roundels, is Classical in style, probably adopted from Iran. The beading in particular is found in Sassanian work and before that on Roman silver. The highly decorated ceramic vessels with appliqué designs were to stimulate striking Chinese copies in high-fired glazed ceramic.

Buddhist sites north of Khotan and in the Domoko area

On all his expeditions Stein investigated Buddhist sites north of the Khotan oasis and also visited sites near the oasis of Domoko, slightly further east. From both the documents found there and the features of the sculptures and wall paintings, Stein dated the main occupancy of these sites to the pre-Tang period (before 618 AD).

At Karasai, north-west of Khotan, Stein investigated remains which he believed belonged to two small shrines, from which came small reliefs of Buddhist figures (cat. no. 129). The dating of these figures to the 6th century AD is based on stylistic evidence.

A much larger and more impressive group of shrines was found at Rawak, north-east of Khotan. In a courtyard enclosing a stūpa Stein discovered massive sculptures whose clinging drapery reveals the sculptors' skill in rendering the human form. These impressive figures were surrounded by smaller sculptures. On the evidence of Chinese coins, Stein dated some of the structures to the period between the 4th and 7th centuries AD.

The fort at Mazār-Tāgh was rather different, being a slightly later military rather than religious building. It was situated about 150km from Khotan, on a range of hills extending north-west. In refuse heaps Stein found weapons and documents in Tibetan and from these he concluded that the fort may have become important from the 8th century when the Tibetans overran the Tarim.

Of the sites near Domoko, the next oasis, the most extensive finds preserved in the British Museum were made at Dandān-oilik. The main investigation of several small shrines took place during Stein's first expedition (1900–01). Many stucco fragments of religious sculptures were found. The most exciting discovery, however, was a group of painted wooden panels (cat. nos. 131, 132) found leaning

against a base within one of the shrines. Stein concluded that they were votive offerings. A number of documents also came to light, some religious and others secular in content, including a petition for the return of a donkey. The dates given in the latter were all of the 8th century AD.

Much nearer Domoko were the sites of Farhād-bēg-yailaki, Khādalik and Darabzan-dong. Farhād-bēg-yailaki was excavated in 1907 during Stein's second expedition. He took the remains to be part of a monastery that had been abandoned in the second half of the 8th century. He found early tablets written in Brāhmī, a small stūpa similar in plan to the one at Rawak, and painted panels he thought would have been used as votive offerings. In the most important shrine were the remains of colossal statues, some wall paintings, a Sanskrit text and documents fastened with clay sealings.

The shrines at Khādalik were, on the basis of coin evidence, taken to be of similar date. In the principal room were a large central image and the remains of wall paintings which had belonged to double walls enclosing the square room (cat. no. 126). Many small stuccos and the moulds used in making them were also retrieved and are now in the British Museum (cat. nos. 162, 163).

The third site represented here, Darabzan-dong, revealed the remains of a Buddhist temple, likewise abandoned at the end of the 8th century. Stein believed that these buildings had all been abandoned as the Tarim became desiccated.

The Kingdom of Shanshan

To the east of the Buddhist sites just described lay Niya, a major city and indeed probably the capital of the kingdom known as Shanshan. Loulan, at the eastern edge of the salt lake Lop Nor, marked its eastern extremity. All three of Stein's expeditions took him to these two major sites as well as others belonging to this kingdom. From his many finds of early documents in Kharoṣṭhī, Stein concluded that the peoples of this state were of Indian origin.

Unlike the many mud-brick buildings found at the sites discussed above, at these two sites Stein excavated numerous wooden buildings, often elaborately carved. He concluded that they were dwellings as opposed to religious structures, and even identified remains at Niya and at Loulan as parts of official quarters. Stumps of fruit trees preserved in the sand appeared to be traces of ancient orchards.

In great excitement, Stein discovered at Niya a large cache of official documents. A date equivalent to AD 269 on one of the few Chinese documents in this cache led Stein to argue that the whole find was of this date. He was also very

intrigued by labels in Chinese among the finds, which he believed had been attached to gifts between members of a ruling family.

Loulan, at the extreme eastern edge of Shanshan, produced many similar discoveries. In addition there was evidence of its use as a Chinese military post during the Han period (206 BC–AD 220); a small garrison was retained there into the 3rd century AD. Dates on documents confirm that the site was occupied until the 4th century.

Among the most spectacular finds from Niya and Loulan are the large fragments of wooden architecture. The carved decoration illustrates very clearly that the dominant stylistic influences in the area came from the west and not from China. No remains were found of the typical bracketing system by which the beams of Chinese roofs were supported on wooden columns. Structure and decoration reflecting provincial forms of Western Classical architecture which flourished in both Iran and the north-west corner of the Indian sub-continent were prevalent. For example, several buildings were supported on columns with decorated capitals. Cat. no. 115 is of Corinthian type and is paralleled further west in Gandhara, Parthia and the Hellenistic world. Cat. no. 119 approximates to the form of an Ionic capital; intermediaries are found in scrolled capitals at Persepolis. In

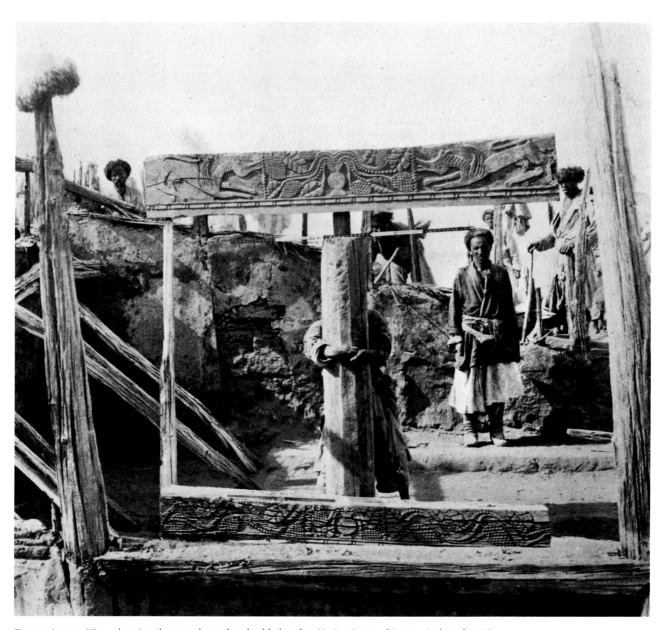

Excavations at Niya, showing decorated wooden double bracket (Stein, *Ruins of Desert Cathay*, fig. 98)

finds that resembled cat. no. 121 (from Khādalik), Stein identified the combination of decorative mouldings as Iranian in origin.

Likewise, architectural ornaments on wooden beams have Classical parallels. These include half-palmette scrolls (cat. no. 117), rosettes (cat. no. 116), and wreath patterns that look like bands of overlapping scales (cat. no. 117). The origins of these motifs are found in the architecture of the Hellenistic Mediterranean, and intermediaries are evident in the decoration of buildings in Parthian Iran and Gandhara.

Buddhist sites along the southern periphery of the Shanshan kingdom were investigated at Mirān and Chark-

lik, especially during Stein's second expedition (1906–09). The Buddhist remains at Mirān in particular provided striking evidence of the influence of Western painting and sculptural styles at the eastern end of the Tarim Basin. Famous wall paintings depicting heavenly beings with wings reflect Iranian and Western Asian traditions of representing deities. The colossal head of a Buddha (cat. no. 125) shows the influence of the massive statues of the Hellenistic and Roman world, and of their Parthian competitors, on Eastern Asia. Similarly huge sculptures were to be employed in China at the great cave-temples at Yungang in Shanxi province.

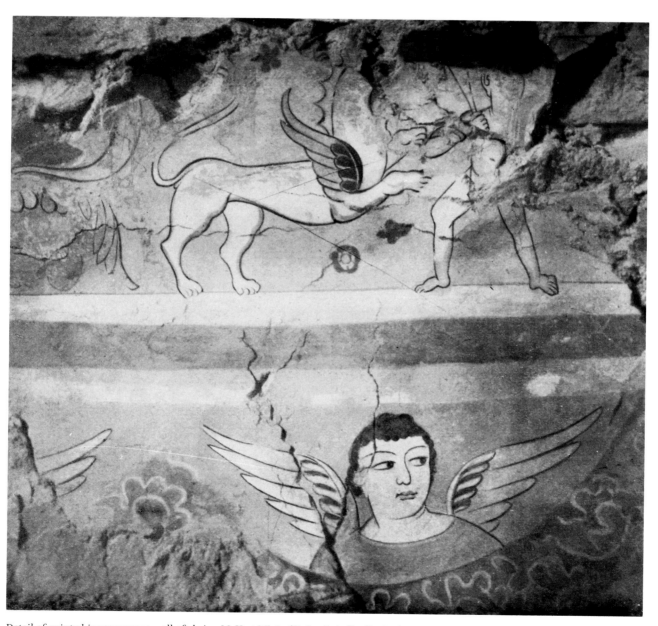

Detail of painted inner passage wall of shrine M. V at Mirān (Stein, *Serindia*, fig. 133)

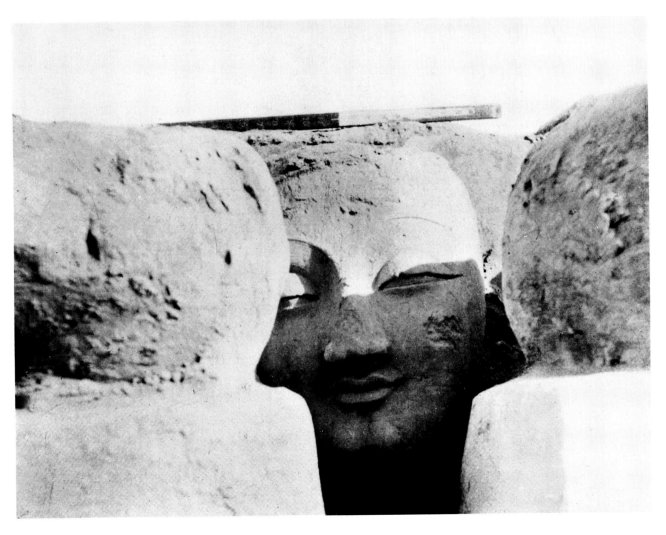

Stucco head of a colossal Buddha from the ruined shrine M. II at Mirān (Stein, *Serindia*, fig. 122)

The Northern Silk Route

The investigations made by Stein along the northern edge of the Taklamakan Desert were much more limited than his work in the south. Although he makes few mentions of the German expeditions to this area, it seems likely that Stein deliberately kept away from sites at Kucha and Turfan where Alfred Grünwedel and Albert von Le Coq were working on behalf of the Berlin Museum of Indian Art. Stein therefore visited only briefly sites near Kucha, the centre of a small kingdom of Indian or Iranian origin.

He did excavate, however, at the next settlement to the east, at Karashar, Khōra and at shrines near Shorchuk, which he designated Ming-oi. The term Ming-oi is Turkish for 'the thousand houses' and is used for cave-temples and remains of buildings in Central Asia. Here Stein explored many small shrines which seemed to have been in use up to and including the 8th century AD, as indicated by Chinese coins. Stein was evidently concerned that the many stucco figures he discovered, including the figure of a warrior (cat. no. 150), appeared on stylistic grounds to be older than the 8th-century date he postulated. Indeed, many fragments resembled what he believed to be the early terracottas from Yotkan. Stein therefore suggested that older moulds had survived and been reused, but it is more likely that the remains he discovered belonged to a wider range of dates than he supposed.

Away from the Tarim Basin and lying at the foot of the Tianshan mountains is the great oasis of Turfan, sunk in a depression more than 100m below sea level. Remains of two major cities, Gaochang and Yarkhoto, still survive today with massive mud-brick structures above ground. Gaochang, also known as Koco and Karakhoja, was the site of a Chinese walled city founded in the 5th century AD. Nearby lies the cemetery of Astāna, in which corpses have been

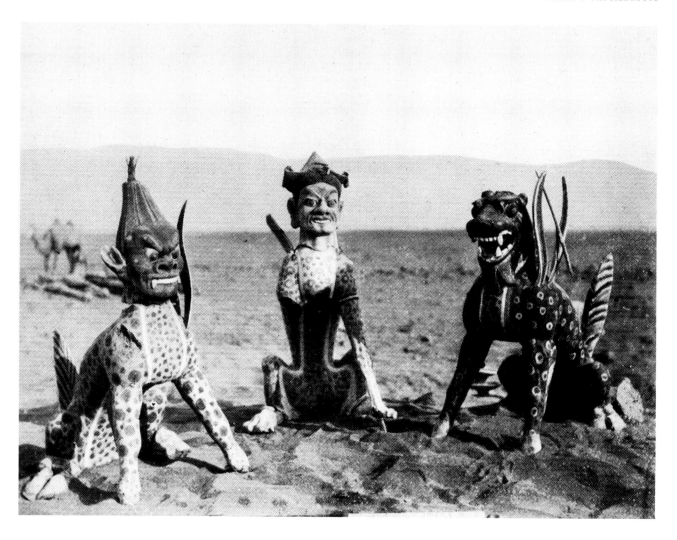

Painted stucco figures of monsters from tomb Ast. iii. 2 in the Astāna cemetery (Stein, *Innermost Asia*, fig. 325)

preserved by the extraordinary dryness of the area. The bodies were often wrapped in fine figured silks, following a practice also used in China; coins, many of them local copies of Sassanian and Byzantine coins, were placed in their mouths. Burial goods from these tombs, such as the large figure of a horse (cat. no. 144), were local variants on those used in Tang tombs near the capital of Chang'an.

Yarkhoto, the other major city site, was occupied until at least the 8th century. Here, as at Gaochang, massive remains of temples still stand, among them remains of the shrines of the Manichaeans, an Iranian sect that flourished in this remote oasis.

Further east at Dunhuang, where the paintings in the first section were recovered, Stein investigated the fortifications built for defence of the Chinese borders. These watch-towers he christened the '*Limes*', from the Latin *līmes*

(boundary), again reflecting Western Classical models. In the rubbish heaps at these towers Stein found Chinese documents on wooden slips, some dated to the 1st century AD. There was a mixture of other débris including gaming pieces, tally sticks and combs. The pegs painted with faces (cat. no. 147) came from one of these sites.

Rarely since the expeditions of Stein, Grünwedel and Le Coq, the French scholar Pelliot and of the Japanese, has the area been studied in the depth or breadth brought to their work by these formidable explorers and scholars, although in recent decades the glories of the cave-temples have been carefully recorded. Stein and the others are often criticised for having removed precious archaeological finds from their homelands, but without their endeavours very little indeed would be known about this remote and still treacherous landscape, in its time a pivot of the Buddhist world. JR

115

116

117

115 Fragment of carved capital

From Loulan. *c.*3rd century AD.

Wood. H. 18.1cm. OA MAS 699 (L.B. 0014).

Stein, *Serindia* pp. xxiii, 48n., 398, 440, pl. XXXII.

This fragment of a capital was ranked by Stein as one of the most interesting pieces of woodcarving from a Buddhist temple excavated at Loulan. The carved decoration of acanthus leaves and volutes is of the Indo-Corinthian type and the general make-up of the object has characteristics found in Byzantine capitals. AF

116 Carved beam

From Loulan. *c.*3rd century AD.

Wood. L. 109cm. W. 19.3cm. OA MAS 704 (L.B. II. 0015.a).

Stein, *Serindia* pp. 397, 442; Whitfield, ACA vol. 3, fig. 31.

This wooden beam comes from the same shrine as one of the balustrade sections (*see* cat. no. 118B) and the model wooden stūpa (*see* cat. no. 120) found at Loulan. The chief feature of the ornamentation is a series of hanging circles linked by straight cinctures, each containing an eight-petalled lotus flower. This type of ornament corresponds closely to that found by Stein in 1901 painted around the walls of a main hall at Niya. AF

117 Carved beam

From Loulan. *c.*3rd century AD.

Wood. L. 168.7cm. OA MAS 707 (L.B. II. 0037).

Stein, *Serindia* pp. 396, 397, 443; Whitfield, ACA vol. 3, fig. 33.

Stein suggests that this fine mitred end beam originally formed a lintel over one of the doorways of a Loulan shrine.

He points out the resemblance of the scroll decoration to early Christian Coptic decorative carvings, and notes the Hellenistic form of the triple leaves in the hollows of the winding stems and the six-petalled rosettes. Such triple leaves are also found in the decoration of Gandharan relievi. AF

118 Balustrades

From Loulan. *c.*3rd century AD.

Wood. H. 52cm, L. 64.7cm.
A: OA MAS 729 (L.B. V. 0014–0018).
B: OA MAS 708 (L.B. II. 0047).

A: Stein, *Serindia* pp. 404, 449, pl. XXXIII; Whitfield, ACA vol. 3, fig. 27.
B: Stein, *Serindia* pp. 396, 442sq., 449, pl. XXXIII; Whitfield, ACA vol. 3, fig. 28.

This pair of similar balustrade fragments comes from the remains of two separate shrines at the Loulan site. AF

119 Carved double-bracket capital

From Loulan. *c.*3rd century AD.

Wood. L. 82.2cm. OA 1928.10–22.11 (L.K. i. 03).

Stein, *Innermost Asia* pp. 187, 192, 194, pl. XV.

This carved wooden double-bracket capital was found in the ruins of living quarters of the ancient fort designated by Stein as L.K. With its two scroll-shaped brackets recalling the volutes of Ionic Greek capitals, it has close affinities to wooden double brackets found at the Loulan site L.A., and to those in stucco found at the shrine M. II at Mirān, about 110km southwest of Loulan. More distant geographical connections may be drawn with the capitals represented in Gandharan relievi and their Persepolitan models. AF

147

118A

118B

119

120

120 Model stūpa finial

From Loulan. *c.*3rd century AD.

Wood. H. 51.5cm. OA MAS 706 (L.B. II. 0033).

Stein, *Serindia* pp. 396, 443, pl. XXXII; Whitfield, ACA vol. 3, fig. 36.

This carved wooden finial representing a stūpa is one of two similar carvings recovered by Stein in December 1906 from the Buddhist shrine L.B. II, discovered by Sven Hedin in 1900. The square-cut base of the model stūpa is surmounted by a drum-shaped cylinder with a ring at the centre. Above this is a small rectangular platform and five 'umbrellas' similar to those found in Indian stūpas, and a ball top. There is a mortice in the base which suggests that this stūpa and the similar one found with it were used as part of the architectural framework of the shrine, serving as finials. Many other examples of architectural woodwork were found at this site including balusters and beams with decorative carving. AF

121 Carved double bracket with upper part of pillar shaft

From Khādalik. *c.*6th century AD.

Wood. H. 53.8cm, L. 80.6cm. OA MAS 435 (Kha. v. 003a).

Stein, *Serindia* pp. 160, 191, 491, 1248n.; Whitfield, ACA vol. 3, fig. 66.

This double bracket comes from the verandah of what may have been a small monastic dwelling adjoining a shrine at Khādalik. The unusual volutes with almost upturned ends on either side of the base resemble examples found at Mirān and Niya. Stein identifies this feature as having an Indo-Persian origin. AF

122 Fragment of carved frieze

From Khādalik. *c.*6th century AD.

Wood. L. 48.2cm. OA MAS 391 (Kha. i. E. 044).

Stein, *Serindia* pp. 160, 180, pl. XVII.

This architectural fragment, possibly from a cornice, comes from one of the Khādalik shrines. Below the plain rectangular moulding a convex moulding is carved with relief lozenges. This fragment of the frieze shows traces of elaborate painted decoration in red, blue, white and red-brown. AF

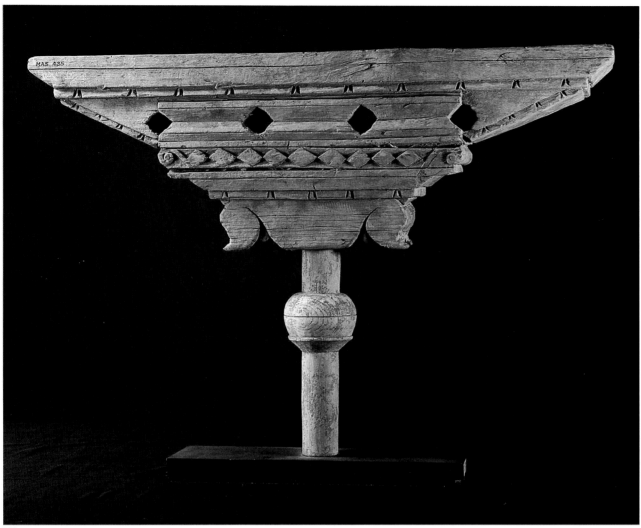

121

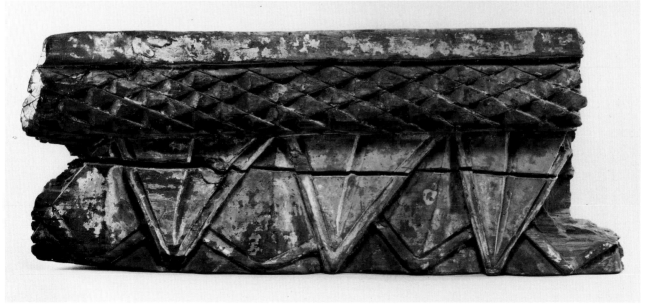

122

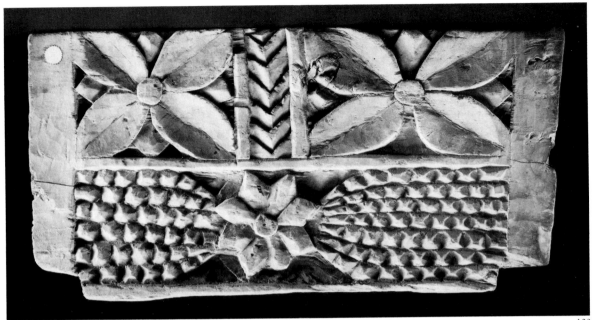

123

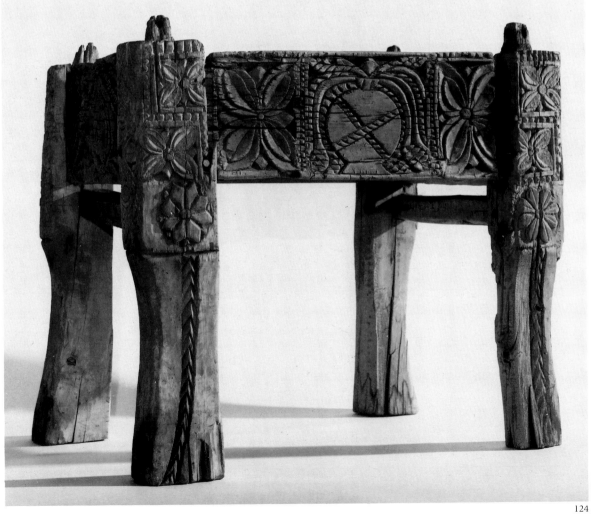

124

123 Carved panel

From Niya. c.3rd century AD.

Wood. L. 38.7cm. OA MAS 535 (N. xiii. v. 1).

Stein, *Serindia* pp. 48n., 217, 249, pl. XIX.

This boldly carved wooden panel was found at Niya in a small room adjacent to what seems to have been the office of a petty official. It was with an assortment of household débris including a bootlast, a weaver's comb, baskets, pottery fragments and an object identified as a mousetrap. This panel may have originally formed part of a chair or other item of furniture. Its style of decoration, particularly the two flowers in their square frames, are very similar to that of the following example of a table-like object from Niya. AF

124 Carved table or altar frame

From Niya. 1st–4th century AD.

Poplar wood. H. 60cm, L. 67.8cm, D. 45cm.
OA 1907.11–11.85 (N. vii. 4).

Stein, *Ancient Khotan* pp. 334, 397, pl. LXVIII; Whitfield, ACA vol. 3, pl. 60.

The wooden furniture and remains of architectural decoration found by Stein at Niya on his first Central Asian expedition (1900–01) closely resembled the items discovered on his second Central Asian expedition (1906–9) at Loulan near Lop Nor. This piece of carved poplar was found disjointed and lying face down in the remains of the substantial dwelling N. III at Niya, about 3km south of the stūpa. Stein identified it as a chair but Whitfield suggests that it is more likely to have been a small table or an altar. The eight-petalled lotuses which appear on the legs, and the object resembling a Buddhist stūpa garlanded and bedecked with streamers in the middle of the front panel, both suggest that this object is of Buddhist origin. The four-petalled flowers within square frames are identical to those seen in painted wall decoration at Dunhuang and elsewhere. Paper flowers of this type have also been found (*see* cat. no. 148). The tenons at the top of each leg would have secured a flat top, which is missing together with the back panel. All the panels are morticed into the legs and supported with dowels; there is an additional stretcher below each of the end panels. RW, AF

125 Colossal head of the Buddha

From Mirān. 5th century AD.

Stucco with traces of pigment. H. 54cm. OA MAS 627 (M. II. 007).

Stein, *Serindia* pp. 487–9, 539, pl. XLVI; Whitfield, ACA vol. 3, pl. 48.

Only the front part of this head remains. It may be identified as that of a Buddha from the tight curls on the head, which bear traces of black paint. Although patches of the top coating of white slip still remain on the face, most of the original surface has disappeared to reveal the stucco,

composed of large amounts of hair mixed with clay. This head comes from the third of five colossal seated figures of the Buddha discovered in the Mirān *vihāra* (chapel intended to house a sacred Buddhist image) M. II. The *vihāra* consisted of a two-storied mound made of sun-dried bricks. A passage enclosed the central portion of the shrine and the colossal seated figures were lined along the outer wall. Each measured over 2m across the knees and all were in the gesture of meditation (*dhyāna-mudrā*). A 5th-century date for these huge figures is suggested by various kinds of evidence found by Stein at the site. The drapery folds over the knees of the figures resembled the style of the 5th-century Gandharan sculptures; there were traces of red pigment similar to the statues from Rawak and Indo-Persian-style stucco pilasters around the base of a shrine. Finally, Stein found a palm leaf *pothī* in the shrine written in Sanskrit, using Brāhmī characters of an early Gupta type which cannot be later than the 5th century AD. RW, AF

126 Fragments of wall painting

From Khādalik. c.6th century AD.

Ink and colour on plaster.
From top left: H. 16.8cm, W. 16cm; H. 11.5cm, W. 10cm; H. 15cm, W. 10cm.
From top left: OA 1919.1–1.0268 (Kha. i. C. 0095); OA 1919.1–1.0275 (Kha. i. E. 0065); OA 1919.1–1.0261 (Kha. 0026).

Stein, *Serindia* pp. 177, pl. XI; 182; 168; pl. XI; Whitfield, ACA vol. 3, pl. 53–2, 3, 4.

The two fragments on the left are from a large square shrine at Khādalik from which Stein recovered many fragments of manuscript and wall painting. A large section of wall painting measuring 2.75 × 1.5m with rows of stencilled Buddhas was found in a passage of this shrine, whose fresco pattern was identical to one found at Dandān-oilik. The lower fragment shows Gaṇeśa, the elephant god of wealth, who is the eldest son of Śiva, depicted with an elephant's head and a man's torso. Around his neck is a rope of pearls and in his three visible hands are a basket containing what appear to be fruit or cakes, a radish, and an ankus or elephant goad. He is wearing a red-brown dhoti and a grey stole. The top fragment shows the head of a Buddha with downcast eyes, blue hair and a white fillet around the *uṣṇīṣa*, tied in a knot at each side with ends hanging at the back. The head stands within a halo edged with blue. The fragment on the right shows the right hand of a figure of the Cosmic Buddha Vairocana with a sun disc on his shoulder and a *vajra* or thunderbolt on the forearm. The very clear webbing, here seen between the thumb and first finger, is one of the thirty-two *mahāpuruṣalakṣaṇas* or marks of a ruling king or a future Buddha. The little finger is missing and an extra finger appears to have been inserted behind the index finger. In the palm can be seen the sacred mark of a ring surrounded by small circles, representing the *cakra* or wheel of the Law. RW, AF

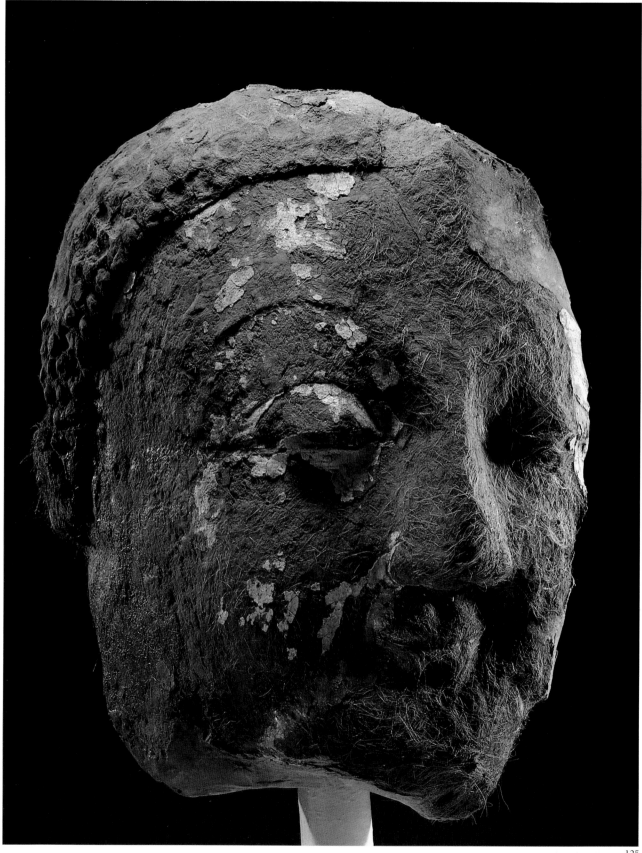

125

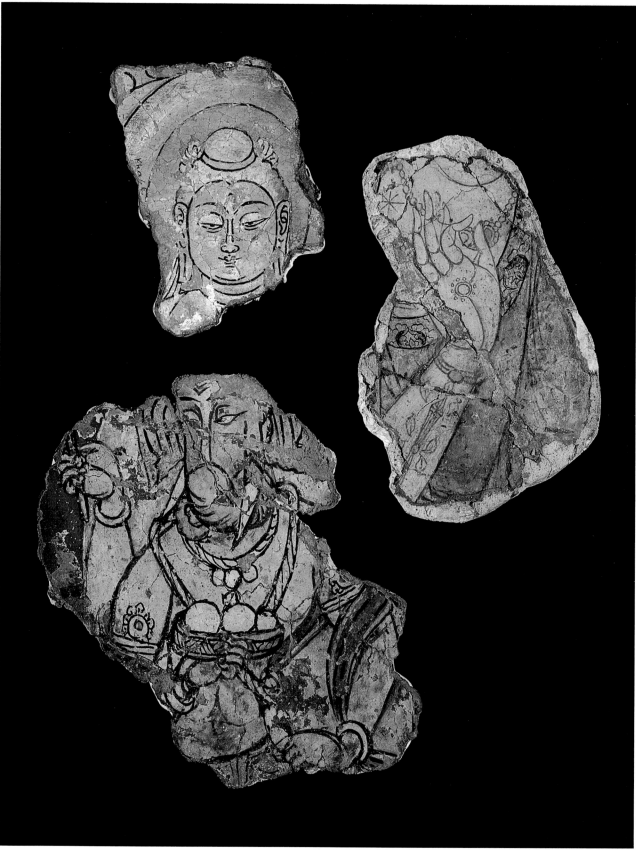

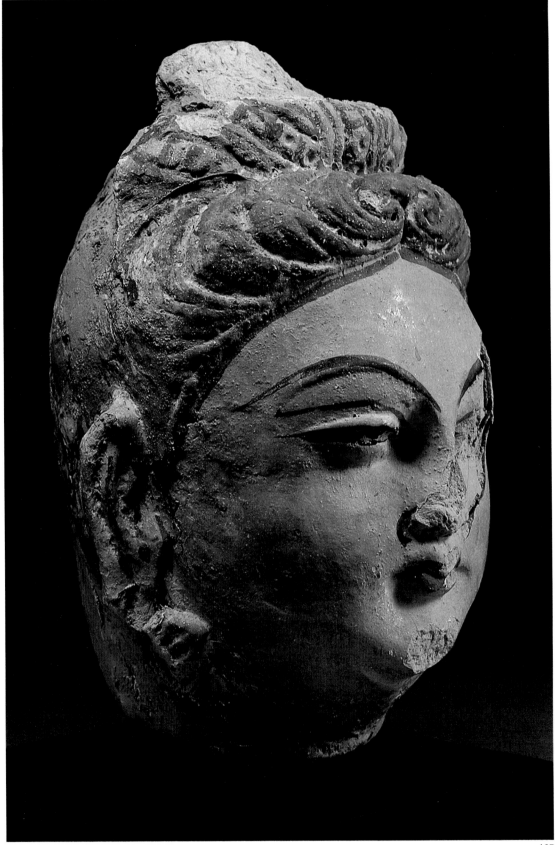

127

127 Head of a Buddha

From Darabzan-dong, near Domoko.
Tang dynasty, 7th–8th century AD.

Painted stucco. H. 21cm. OA MAS 452 (Dar. 008).

Stein, *Serindia* p. 201, pl. CXXXVIII; Whitfield, ACA vol. 3, pl. 56.

The ruined site of Darabzan-dong, first investigated by Stein
in autumn 1906, was under irrigation two years later so that
his finds are the only record of it. He found fragments of wall
painting with cursive Brāhmī script and two stucco heads in
high relief, of which this is one. The head was modelled on a
clay and fibre backing and is hollow, having originally been
set on a wooden core. The Darabzan-dong heads are similar
to those from the shrines at Khādalik, 4km to the north. Stein
concluded that the Darabzan-dong shrines, like those at
Khādalik and Dandān-oilik, must have been abandoned
towards the end of the 8th century. RW, AF

128 Painted panel: Buddha

From Khādalik. *c.*6th century AD.

Painted wood. H. 17.8cm, W. 10.0cm.
OA MAS 419 (Kha. ii. E. 0013).

Stein, *Serindia* pp. 165, 189, pl. XIV; Whitfield, ACA vol. 3, fig. 49.

This fragment of a painted wooden panel showing part of a
standing Buddha is one of numerous painted panels found at
Khādalik which had probably once served as votive gifts.
Stein records that many of the examples found at Khādalik
were very badly faded, probably due to moisture damage or
exposure to the air. To accommodate a standing figure the
present panel would originally have been close to 40cm long
and 20cm wide. AF

129 Standing figures of the Buddha

From Karasai. 5th century AD.

Stucco. **A:** H. 20cm. **B:** H. 15cm, W. 9cm.
A: OA MAS 340 (K.S. 001). **B:** OA MAS 344 (K.S. 007).

Stein, *Serindia* pp. 1273, 1280, pl. X; Whitfield, ACA vol. 3, pls. 61,
62.

Both these figures come from the Buddhist shrines of Karasai
in the north-west of the Khotan district, abandoned about
the 6th century AD. The figures are in the banishment of fear
gesture (*abhaya-mudrā*) with flames issuing behind the
shoulders and edging the nimbus and mandorla. These small
figures would originally have been placed within the vesica
of a larger statue (*see* cat. no. 136). Parts of the background to
which they were attached can still be seen, and there is a pad
of stucco which served to fasten them to it. The background
material included abundant traces of straw used to bind it
together, but the figures themselves are finely made. The
investigations made for Stein by Sir Arthur Church (*Serindia*
vol. III, Appendix D) show that the figures were moulded,
lightly fired, then coated with a thin layer of white gypsum
to give them a porcelain-like colour and finish. Although the
modelling of these figures is closely related to Gandharan

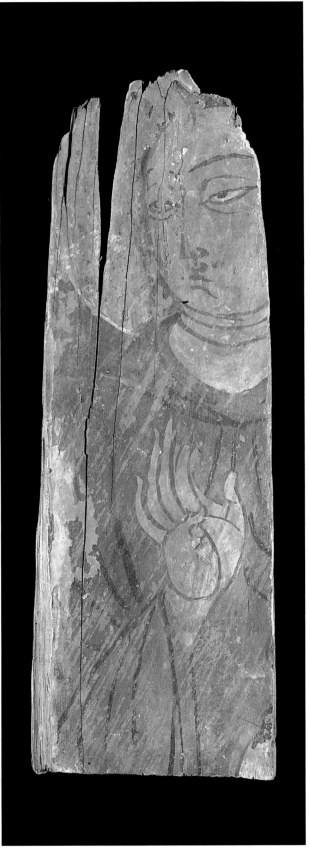

128

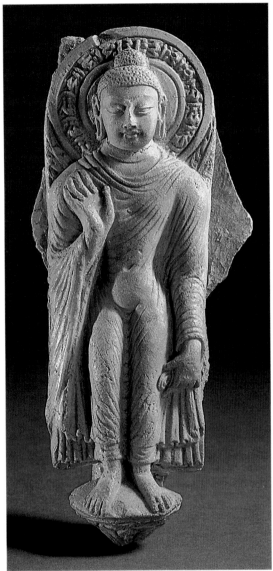

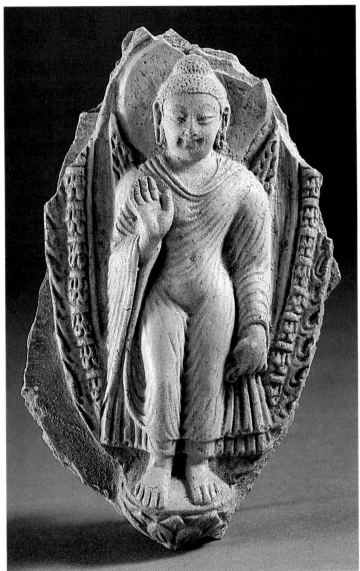

129A 129B

stone sculpture, a comparison shows these to have a flatten-
ing of such details as drapery folds and flames. RW, AF

130 Painted panel: Cosmic Vairocana

From Farhād-bēg-yailaki. *c.*6th century AD.

Painted wood. H. 37.8cm, W. 18.5cm. OA MAS 459 (F. II. iii. 2).

Stein, *Serindia* pp. 1248, 1258, pl. CXXV; Whitfield, ACA vol. 3, pl.
72.

This painted panel was found at a site due north of Domoko
in an area of the building F. II which Stein believed to have
been part of the living quarters of a small monastery. The
panel was one of the two discovered behind the square base
of an image in a large temple-cella surrounded on three sides
by a circumambulatory passage. Along the base of an
adjoining cella wall five more panels were found. Stein

remarks that they 'lay obviously in the place where they had
been deposited as votive offerings by the last worshippers'.
The present panel has a pointed top edge and a figure of
Buddha with both nimbus and mandorla. The Buddha is
Vairocana, the supreme Buddha, recognisable by the two
seated Buddhas on his torso, the symbols of the sun and
moon on his right and left shoulder, the pairs of long
rectangles on each upper arm and the bird on each forearm,
in addition to many circles (*see* the lower Buddha image in
cat. no. 2). The long rectangles are generally taken to
represent the scriptures in the form of *pothī* (*see* cat.
no. 69). RW, AF

158

130

131

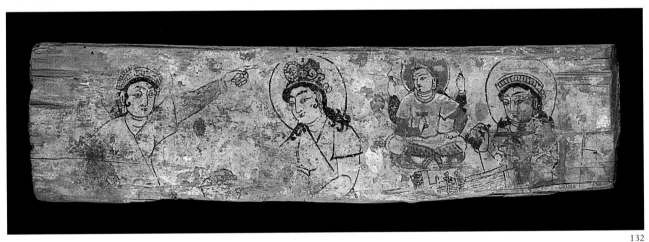

132

131 Painted panel with Indra, Maya-Śri and Brahmā (?)

From Dandān-oilik. c.6th century AD.

Painted wood. H. 10.6cm, W. 25.8cm. OA 1907.11–11.72 (D. X. 3).

Stein, *Ancient Khotan* pp. 260, 299–300, pl. LXIV; Whitfield, ACA vol. 3, pl. 67, fig. 97.

This is one of several finely preserved panels found at Dandān-oilik whose intact state is due to the fact that they were placed above floor level. The figure on the left has been identified as Indra, god of the atmosphere, holding his symbol the *vajra* or thunderbolt. The figure on the right may be Brahmā, the father of all living beings, with three (out of four) heads and a third eye in each, holding a bow and arrows and a drinking bowl. The central figure holds a sun and moon in addition to another unidentified object and may be a goddess of abundance, which would suggest that the entire group might refer to an event such as a Buddha's birth. On the other side (not illustrated here) two Buddhas are seated facing each other. The figure on the extreme left is possibly a Bodhisattva; the corresponding figure on the right is almost completely effaced. RW, AF

132 Painted panel: story of the Silk Princess

From Dandān-oilik. c.6th century AD.

Painted wood. H. 12.0cm, W. 46.0cm. OA 1907.11–11.73 (D. X. 4).

Stein, *Ancient Khotan* pp. 230, 251n., 259–60, 300, 377; Whitfield, ACA vol. 3, pl. 66.

This panel was found standing against the octagonal base originally belonging to a stucco image in the small cella D. X. at Dandān-oilik with wall paintings of small Buddha images, nothing of which remains. The main features of the figures

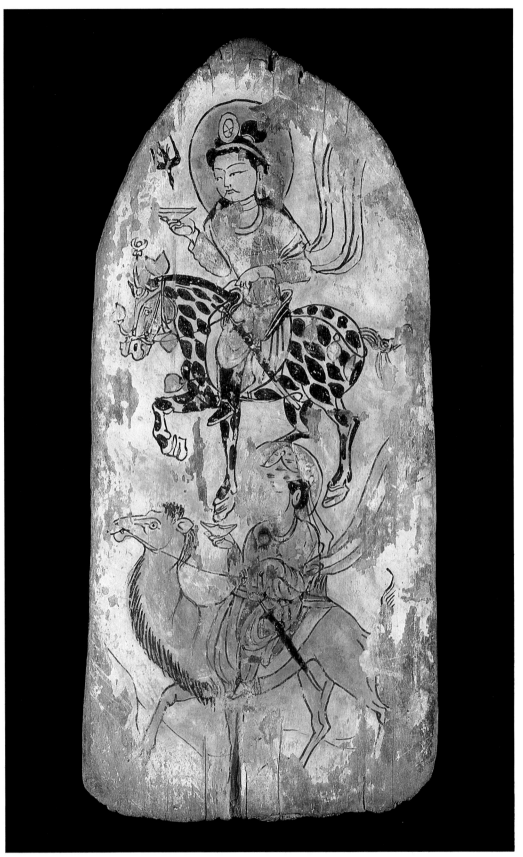

133

here are outlined in red with the upper eyelids and eyebrows in black. Stein has identified the panel as illustrating the legend of the introduction of sericulture to Khotan. The second figure from the left is the Chinese princess who was warned that neither silkworms nor mulberry leaves could be raised in Khotan (Xuanzang, *Da Tang Xiyuji*, Ch. 12). The princess then hid mulberry seeds and eggs of the silk moth in her headdress and smuggled them through a border-post into Khotan. The basket is full of cocoons, showing the success of the mission. The figure on the extreme left is an attendant pointing to the hidden items in the princess's headdress. At the far right a figure holds a beating comb in her hand (*see* cat. no. 146); there is a loom in front of her and an object behind which may be a reel for thread. The next figure is a four-armed deity who may be the patron of weaving associated with the silk legend. Stein remarked upon the petal-shaped spots of dark pink around the figures and compared them to the auspicious sandal-ointment marks used by Hindus. Stein recovered another panel showing a different version of this legend, which is now in New Delhi (D. II. 010; Stein, op. cit. pl. LXVII). RW, AF

133 Votive panel: riders with bowls

From Dandān-oilik. *c.*6th century AD.

Painted wood. H. 38.5cm, W. 18.0cm. OA 1907.11–11.70 (D. VII. 5).

Stein, *Ancient Khotan* pp. 248, 253, 261, 275, 277–8, 298, pl. LIX; Whitfield, ACA vol. 3, pl. 69.

This panel was one of three found in the loose sand in the south-east corner of a dwelling at Dandān-oilik. The reverse side of the panel is unpainted and the remains of dowels in five places suggest that it was originally hung on the wall. The aristocratic rider holding a bowl or wine cup into which a bird appears to be diving is a theme frequently found near Khotan. A similar horse and rider, originally one of a series of mounted figures, appears in a wall painting of the Sudhana *jātaka* which Stein photographed in Shrine II at Dandān-oilik. The theme of this painting may be explained through its association with Vaiśravaṇa: a scene painted on a wooden panel in the British Museum (OA 1925.6–19.25) shows a rider accompanied by two black birds approaching Vaiśravaṇa, the guardian of Khotan. The riders with birds may represent Khotan's Turkish neighbours; in this panel, therefore, the figures would represent tributaries to Khotan. RW, AF

134 Votive panel: Maheśvara (obverse) and the God of Silk (reverse)

From Dandān-oilik. *c.*6th century AD.

Painted wood. H. 33cm, W. 20.2cm. OA 1907.11–11.71 (D. VIII. 6).

Stein, *Ancient Khotan* pp. 260, 261, 275, 277–9, 278n., 298, pls. LX, LXI; Whitfield, ACA vol. 3, pl. 70.

This was one of three panels found together, including the previous example. Stein suggests that it was probably

intended to stand upright on a shelf or in a stand, and since it was painted on both sides it could not be doweled from the back for hanging. The triple-headed deity on this panel (134A), with a fierce head and a benign head, holds a sun and moon, a *vajra* or thunderbolt and another object. He has been identified as Maheśvara, the name by which the Hindu god Śiva appears in Khotanese texts (Williams, 1973, pp. 142–5). Two white bulls appear beneath the deity. These may be identified as the bull Nandin, Śiva's mount. The representation of Śiva is also found at Yungang (Cave 8, late 5th century AD) and at Dunhuang (Cave 285, early 6th century) and shows the influence of Tantric Buddhism and Śaivism from India.

The image on the reverse side of the panel (134B) shows strong Iranian influence: the bearded deity is dressed in princely costume; he wears a golden crown, green flowered tunic, flowered undergarment and trousers and long black boots, and a dagger lies in his lap. The objects he carries are the same as carried by the four-armed figure in the panel showing the legend of the Silk Princess (*see* cat. no. 132). It has been suggested that they represent a goblet, a weaver's comb and a shuttle (Williams, 1973, pp. 147–50).

RW, AF

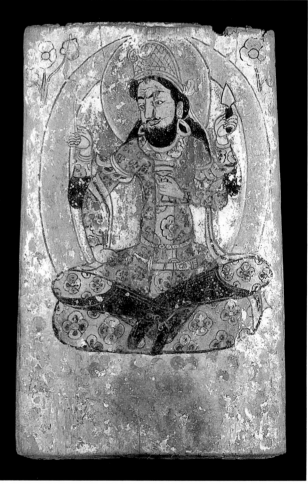

134B

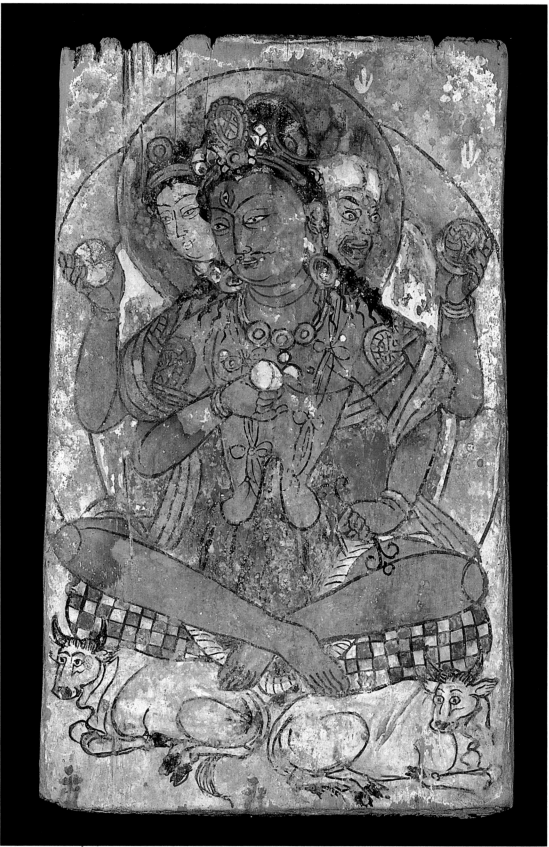

134A

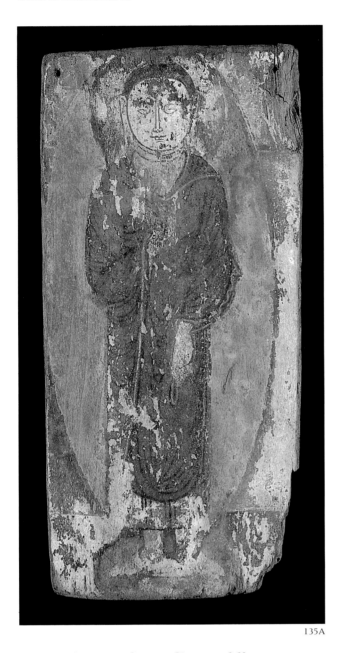

135A

135B

135 Votive panel: standing Buddha

From Dandān-oilik. *c.*6th century AD.

Painted wood. H. 26.4cm, W. 13.0cm. OA 1907.11–11.67 (D. IV. 4).

Stein, *Ancient Khotan* pp. 264, 265, 296, pl. LXV; Whitfield, *ACA* vol. 3, pl. 71, fig. 95.

This is one of two painted panels which Stein found at the west side of the temple-cella D. IV at Dandān-oilik. Both sides show a standing Buddha with the right hand in the gesture of the banishment of fear (*abhaya-mudrā*). On one side (135A) the Buddha in a red robe is within an oval vesica which has lost all pigment. The facial features are outlined in red and the drapery folds are in ink. On the other side (135B) the Buddha wears nothing but a loin cloth. Although much of the pigment has been lost, the figure can be identified as

Vairocana, the Cosmic Buddha, from details such as the *vajra* or thunderbolt on the forearm and the double rings on the upper legs. The style of these two figures shows little Chinese influence. The robed figure has draperies which still follow Gandharan style fairly closely, with the left hand holding a loop of robe. The figure of Vairocana may be contrasted with a more developed version with ample robes in Cave 428 at Dunhuang of the Northern Zhou (AD 557–81). This suggests that the painted panel dates from the 6th century AD at the latest. RW, AF

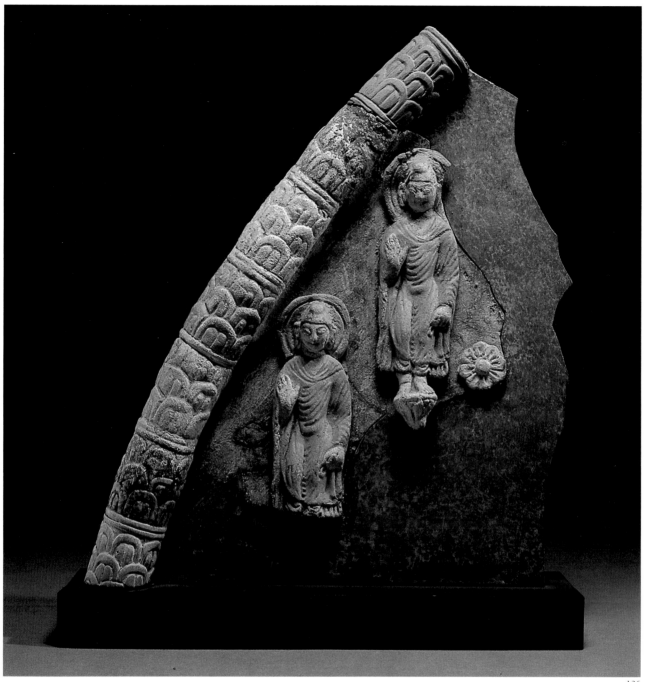

136

136 Fragment of a vesica

From Dandān-oilik. 6th–7th century AD.

Painted stucco. H. 34.7cm, W. 28.5cm.
OA 1907.11–11.62 (D. II. 34).

Stein, *Ancient Khotan* pp. 245, 250, 292, pl. LIV; Whitfield, ACA vol. 3, pl. 73.

This fragment comes from the smaller of the two cellas of Shrine II at Dandān-oilik, which Stein excavated in 1900–01. It shows the way in which many of the moulded figures

Stein recovered during his Central Asian excavations (*see* cat. no. 129) were originally set up. The individual Buddhas standing with the right hand making the banishment of fear gesture (*abhaya-mudrā*) were first moulded and then attached to the background by a pad of clay. Painted lotuses are still faintly visible on the vesica. The Buddhas are painted in red with green aureoles and white faces, hands and feet. The moulded leaf border was painted in alternating dark grey, red, green and white. RW, AF

165

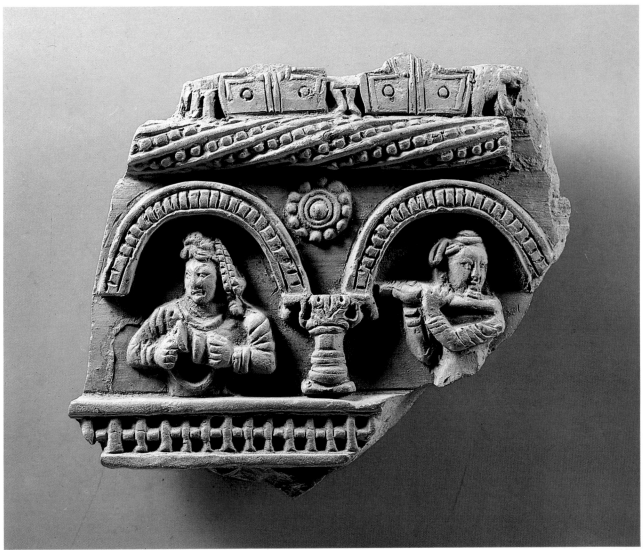

137A

137 Sculptural fragment

From Yotkan. 4th–5th century AD.

Terracotta. H. 12cm, W. 13.5cm. OA MAS 5 (Yo. 02).

Stein, *Serindia* pp. xxii, 98sq., 103, 115, 1211sq., 1467sq., pl. I; Whitfield, *ACA* vol. 3, pl. 74, fig. 99.

One side of this fragment (137A) shows two musicians under the arches of part of an elaborate arcade; a strong Gandharan influence is evident. The upper border of the reverse (137B) bears a row of rosettes above a simple moulded strip. The nature of the object from which this fragment comes has been the subject of some discussion. Stein thought that it might have been part of an exceptionally large vase, but on the basis of related objects Whitfield has argued that it may be a fragment of a model shrine, possibly consisting of a walled enclosure surrounding a central stūpa. RW, AF

137B

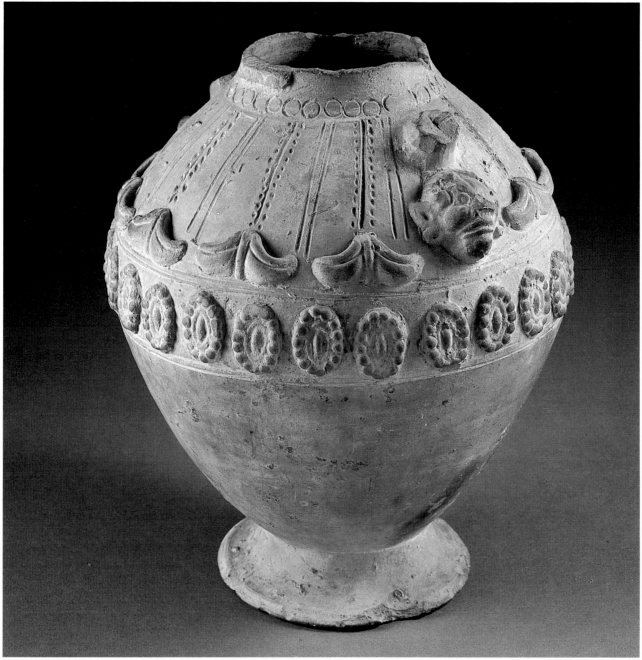

138

138 Vase

From Yotkan. 1st–3rd century AD.

Pottery with appliqué decoration. H. 20cm, D. of body 17.5cm.
OA MAS 4 (Yo. 01. a).

Stein, *Serindia* pp. 98, 102, pl. IV; Whitfield, ACA vol. 3, pl. 79.

This is a rare example from Yotkan of a nearly complete vase. It was made on the wheel and has incised, punched and appliqué decoration. A band of oval jewels with beaded rims has been applied between the incised lines around the widest part of the vase. Pairs of swags and two human heads have been added to the shoulder. Both the neck and the two handles were broken off and ground down in antiquity so that the vase might continue to be of some use. The handles would probably have been surmounted by animal bodies with the front legs of the animal merged into one and joined to the neck of the vessel beneath the rim. The rim would have been flat and the animal head raised above the rim so that it faced its opposite across the mouth of the vessel. Many examples of such handles exist in the British Museum and other Central Asian collections. RW, AF

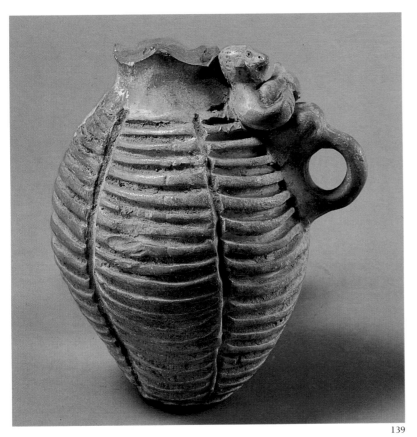

139

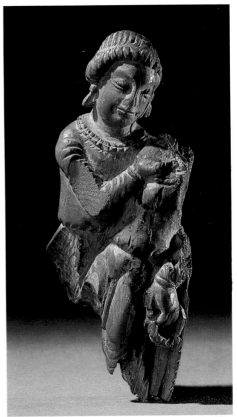

140A

139 Small jug or ampulla

Acquired at Yotkan. 1st–4th century AD.

Pottery with appliqué decoration. H. 10.6cm, W. 9cm.
OA 1907.11–11.39 (Y. 0228).

Stein, *Ancient Khotan* pp. 207, 217, pl. XLIII; Whitfield, ACA vol. 3, pl. 81.

Stein acquired this piece during his first Central Asian expedition (1900–01). The body of the jug is decorated with horizontal ridges with deep grooves pressed into the clay and is divided into six vertical segments. The appliqué figure of the monkey playing a lute, which forms part of the handle, occurs frequently among other figurines from Yotkan. The shape of the jug is similar to glass vessels from Bactria, dating from the 1st to the 3rd century AD, in which decoration is applied by trailing glass of a different colour around the vessel over vertical divisions of trailed glass.

RW, AF

140B

141

140 Mithuna figure

From north-west India; found at Khotan.
Post-Gandhara period, 6th–7th century AD.

Ivory. H. 7.5cm. OA 1907.11–11.49 (Kh. 008).

Stein, *Ancient Khotan* pp. 209, 222, pl. XLVIII; Whitfield, ACA vol. 3, pl. 82.

This type of ivory representing a husband and wife is known as *mithuna* or *dampati*. Here the head and torso of the young man survives intact, and he has one arm around his wife's shoulders (140B). She has lost her head and left arm; her left hand holds a small floral wreath (140A). The lower part of both figures is missing. Although Stein believed this piece to be from Khotan, it has since been compared with Gandharan art and may have been produced in north-west India in the 6th or 7th century AD. Such a small carving could easily have been brought from India and shows one of the material ways in which new styles came to China.

RW, AF

141 Quilted shoe

From the Mazār-Tāgh. Late 8th–mid-9th century AD.

Woollen felt with leather patches. L. 25cm.
OA MAS 495 (M. Tagh. a. 0041).

Stein, *Serindia* pp. 1288, 1293; Whitfield, ACA vol. 3, pl. 84.

This shoe was found, together with other items, in a fort at the end of a ridge of a hill range called the Mazār-Tāgh, which extends north-west from the Khotan River for about 40km. The majority of finds were from the fort's rubbish pits and date from the period of Tibetan occupation of the south Taklamakan during the late 8th and first half of the 9th centuries. Tibetan documents were found in considerable numbers as well as Chinese and Khotanese records.

Modest finds such as weapons, wooden seal cases, wooden keys and locks, wooden dice for games, netting for catching fish and footwear show the conditions of daily life at this desert guard-station. Shoes found at this site are made from felt or thick wool. The uppers of this shoe are stitched in a design of overlapping scales, and the sole is lined with close-set rows of long pieces joined respectively along the middle of the sole and the front of the shoe, and up the back of the heel. The edges of the sole are well turned up at the toe, heel, and sides to reduce friction with the ground. For protection, rough leather patches have been added to the sole at the toe and heel and on the edge of the uppers. Inside the shoe are two fragments of red woollen cloth. There are signs of a draw-string which would have pulled the shoe up right around the ankle.

RW, AF

142 Figurine of a woman

From Astāna. Gaochang kingdom, AD 499–640.

Painted wood. H. 22.5cm. OA 1928.10–22.102 (Ast. vi. 4. 04).

Stein, *Innermost Asia* pp. 662, 701, pl. CIV; Whitfield, ACA vol. 3, pl. 87.

This figure was found in an isolated tomb in the northern part of the Astāna cemetery together with a number of other wooden figures and caskets. A tablet in a similar tomb nearby is dated to AD 365. This figurine is carved with the minimum of detail, the lower part being simply a tapering rectangular oblong with chamfered edges. In the early Tang dynasty more sophisticated figurines from Astāna graves were made with a painted clay head on a wooden body and some were elaborately dressed in silks. RW, AF

143 Shoe

From Gaochang. Song dynasty, late 11th–early 12th century AD.

Silk embroidery. L. 22cm. OA 1928.10–22.197 (Kao. III. 063).

Stein, *Innermost Asia* pp. 594, 604, pl. LXXXVIII; Whitfield, ACA vol. 3, pl. 85.

This slipper was found in rubble filling the north-eastern side of a narrow passage which ran around the domed circular chamber of a stūpa outside the walled city of Gaochang. Nearby and at the same level in the débris was a hoard of metal objects containing items of everyday use as well as sixty-one Chinese copper coins of the Tang and Song dynasties. The latest coins were from the Chongning period (AD 1102–7) thus suggesting a date in the first quarter of the 12th century for the deposit and hence for this slipper. The shoe is joined down the centre at the heel and toe and is made up of many superimposed layers of woven material. It is lined with a soft, loosely woven woollen cloth; on the outside is a fine crimson cloth, now faded. The slipper is quilted with even lines of stitching. Around the mouth is a layer of buff silk with three rows of stitches and on the toe is a fine band of decoration. RW, AF

142

143

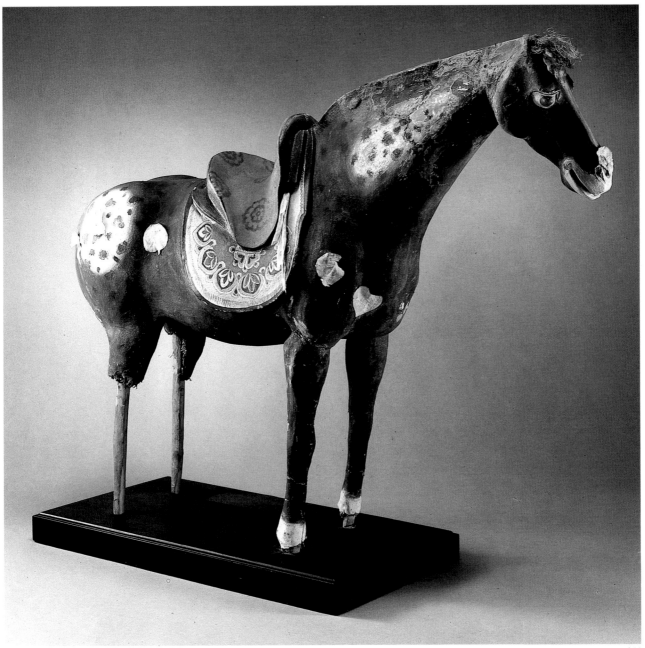

144

144 Figure of a horse

From Astāna. Tang dynasty, mid-8th century AD.

Clay and wood, painted and with pieces of silk. H. 60.5cm, L. 79cm.
OA 1928.10–22.117 (Ast. iii. 2. 057).

Stein, *Innermost Asia* pp. 652, 691–2, pl. XCVIII; Whitfield, ACA vol. 3, pl. 91.

This magnificent figure of a horse formed part of the furnishings of an important 8th-century tomb from the ancient cemetery of Astāna. The burials here were doubtless those of prominent personages from the walled city of Gaochang, the seat of a Governor-General until its destruc-

tion by the Tibetans in AD 791. The tomb from which this figure was recovered had two small antechambers, the inner one with rounded niches for clay figures. Two saddled horses and a camel were found in the eastern niche and a number of smaller horses with riders in the other. There were also splendid guardian figures of earth spirits and the body itself was wrapped in finely ornamented silk. The equipment of this horse shows that it was intended for a rider of high rank. The saddle-blanket is shown as magnificently embroidered and the stirrups were evidently hung on silk straps. RW, AF

171

146A

146B

145 Food offerings

From Astāna. Tang dynasty, mid-8th century AD.

Pastry. From upper left: H. 7cm; 6cm; 10.5cm; 5.2cm; 6.5cm; 4.7cm. From upper left: OA 1928.10–22.123 (Ast. iii. 1. 018); 128 (Ast. iii. 2. 034); 130 (Ast. iii. 2. 037); 132 (Ast. iii. 2. 042); 125 (Ast. iii. 1. 068); 124 (Ast. iii. 1. 024).

Stein, *Innermost Asia* pp. 651, 653, 688, 691, pl. XCII; Whitfield, ACA vol. 3, pl. 94.

These are a selection of the decorative pastries Stein recovered from the tombs Ast. iii.1 and iii. 2 in the Astāna cemetery. The pastries were deposited in the tombs to provide nourishment for the dead person in afterlife, and formed part of the sepulchral deposits which included bowls, chalices, cups, clothing and figurines. Several of the pastries came from the tomb Ast. iii. 2 which contained the fine horse figure of the previous entry. After the robbing of the coffin from the tomb Ast. iii. 1, about a hundred pastries were left on the coffin platform and survived, though without the trays and dishes on which the pastries would originally have been placed. Some of the flower-shaped tartlets retained traces of jam or a similar substance in the centre. RW, AF

146 Weaver's combs or beaters

From Khotan. *c.*3rd century AD.

Wood. A: H. 19.7cm. B: H. 14cm.

OA 1925.6–19.73, 75 (Sir Clarmont Skrine Collection).

Combs of this sort served for beating the picks of the weft in the course of weaving. The combs are in the shape of a wedge with short blunt teeth at the thin edge. The thick edge is rounded to fit into the palm of the hand and has a flat handle or knob for holding. A similar implement is shown in the votive panel depicting the legend of the Silk Princess from Dandān-oilik (*see* cat. no. 132). AF

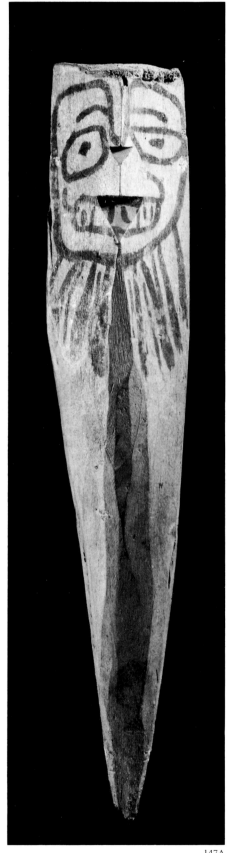 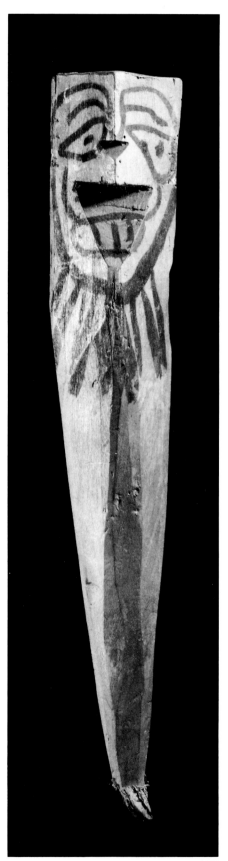

147A 147B

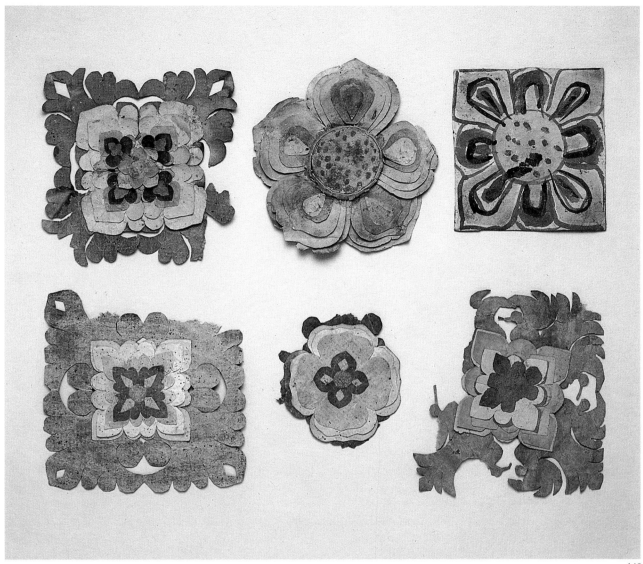

148

147 Pegs

From a military watch-tower on the Dunhuang *Limes*.
Western Han dynasty, 1st century BC.

Wood. From left: L. 23.7cm; 22cm.
OA MAS 739 (T. VI. b. i. 002); OA MAS 740 (T. VI. b. i. 003).

Stein, *Serindia* pp. 649, 769, pl. LII; Whitfield, ACA vol. 3, fig. 22.

These are two of a group of four wooden pegs which Stein
found among the miscellaneous relics in the refuse tips of the
ancient guard-station T. VI. b at the south-western end of
the frontier defence system of forts known as the *Limes*, just
north of Dunhuang. Stein notes several other examples of
such pegs found along the *Limes* (Stein, op. cit. p. 767). In the
19th century, similar pointed wooden pegs were used as
ransom strips in ceremonies to arrest or remove affliction
caused by hostile forces. Such strips were painted with the
figure of the man or woman who was to be helped (Zwalf,
Heritage of Tibet, 1981, pp. 38–9, fig. 13). RW, AF

148 Flowers

From Cave 17, Dunhuang. Tang dynasty, 9th–10th century AD.

Coloured papers, cut and pasted together (Ch. 00149. a–e); ink and
colour on paper (Ch. 00149. f).
From upper left: L. 13cm; D. 12cm; 10.7 × 10.1cm. From lower left:
11.7 × 13.5cm; D. 9cm; 10.8 × 13.2cm.
From upper left: OA 1919.1–1.230 (Ch. 00149. c, b), OA MAS 913
(Ch. 00149. f, d, a, e).

Stein, *Serindia* p. 967, pl. XCII; Whitfield, ACA vol. 3, pl. 45.

These six paper flowers were found with the deposit in Cave
17. Flowers and stylised rosettes were a common decorative
feature in painted mural decoration at Dunhuang (*see*
cat. no. 68) and it seems that paper flowers such as these were
also glued on to walls and ceilings. Extremely elaborate
examples of cut, folded and painted paper flowers have also
been found in tombs. RW, AF

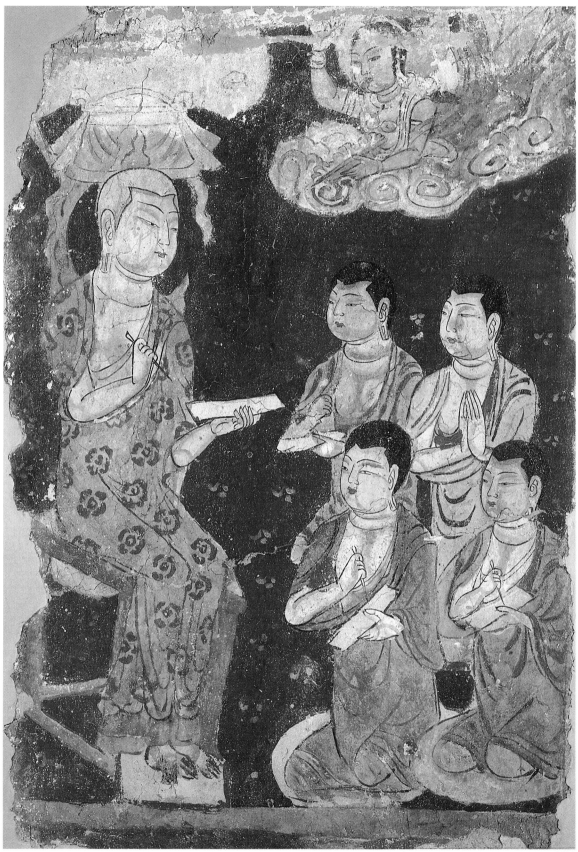

149A

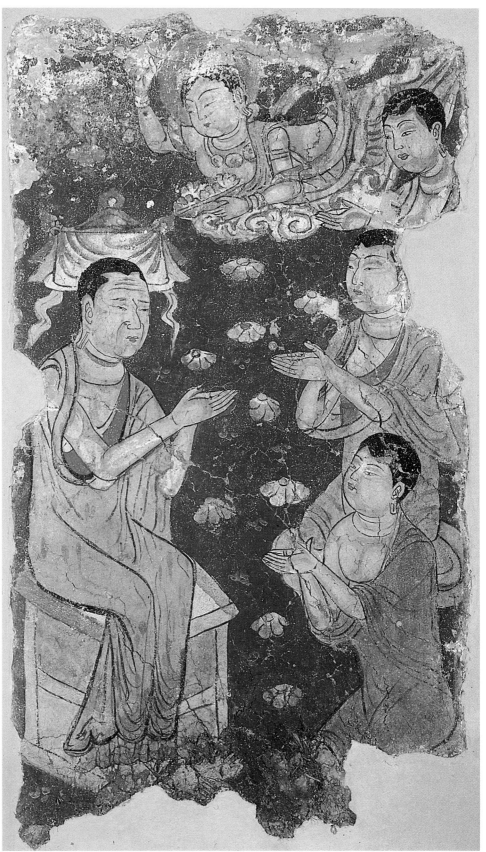

149B

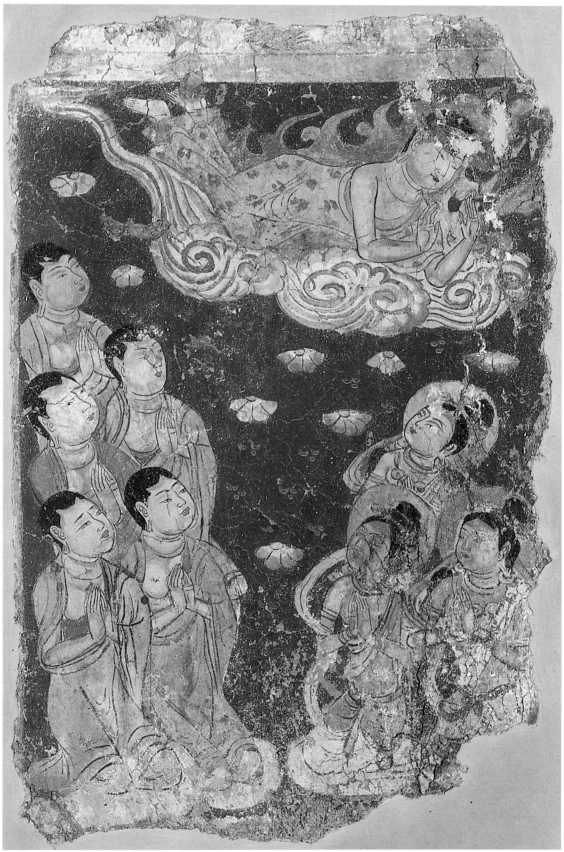

149C

149D

149E

149 Fragments of wall painting

From Ming-oi. Uighur period, 8th–9th century AD.

Colours on plaster. **A**: H. 71cm; W. 45.5cm. **B**: H. 76cm, W. 38.cm. **C**: H. 71cm, W. 48cm.
D (from left): H. 47cm, W. 18.5cm; H. 67cm, W. 15.5cm.
E: H. 54cm, W. 43cm. **F**: H. 42.5cm, W. 53cm. **G**: W. 56cm.
H: H. 71.5cm, W. 59.5cm. **I**: H. 69cm, W. 49cm.
OA 1919.1–1.0279 (Mi. xiii. 1–4, 5–9, 11–12).

Stein, *Serindia* pp. 1196, 1213–15, 1283, pls. CXXIV–CXXVI; Whitfield, ACA vol. 3, pl. 95.

When the shrines at Ming-oi were destroyed by fire in antiquity, very little wall painting survived. The fragments shown here and two larger sections now in Leningrad were recovered from a temple in the north-western part of the site. The Stein fragments came from a position low on the rear wall of the rear chamber of the shrine. Colourful as they are, they were probably only a relatively minor feature of the painted decoration of the building that housed them. The two Leningrad sections are larger and more finely drawn with lavish use of colour and gold (Oldenbourg, 1914, pls. IX, X). They may well have flanked the doorway to the main hall of the shrine.

The series begins with scenes of kneeling young monks receiving instructions from older monks seated on square stools. In the first scene (149A), both master and pupils are writing on tablets which have the long narrow shape of *pothī* leaves. In the sky above, the descending *apsaras* brings a writing brush. The figure descending on clouds in another scene (149C) appears from his dress to be a Buddha; below him two groups of monks and devatas kneel in adoration. Another scene only partially preserved (149F) shows a monk prostrating himself in front of his master.

The fragments showing monks transcribing texts, with some monks on seats in a niche or cave, are of particular interest (149G, H, I); the highly stylised device of indicating successive ranges of hills used in these three fragments is close to that found in illustrations of *jātaka* stories on the ceilings of the Kizil caves, the earliest of which have been dated to the 4th and 5th centuries AD. The costume and hair fashion of the small kneeling boy in one of the fragments (149E) is clear evidence that they date from the Uighur period in the 8th or 9th century AD. RW, AF

179

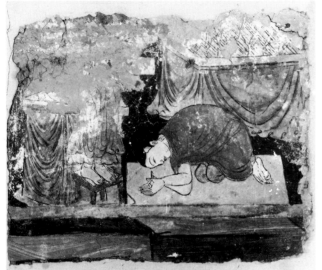

149F

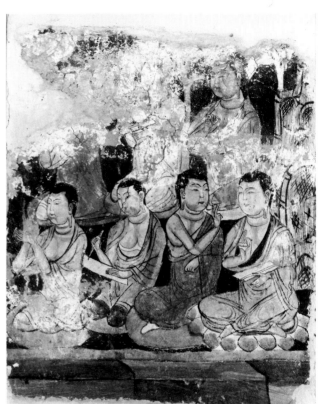

149G

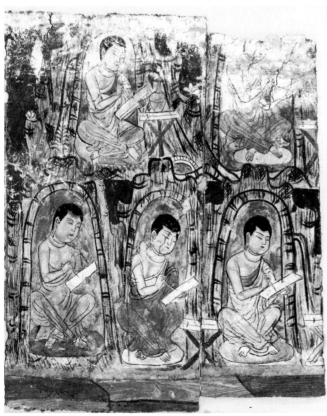

149H

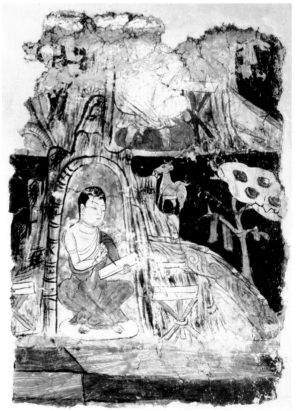

149I

150

151

150 Figure of a warrior

From Ming-oi. 6th–7th century AD.

Stucco with traces of pigment, and wood. H. 42.8cm.
OA MAS 1061 (figure: Mi. xii. 0010); OA MAS 1065 (shield: Mi. xii. 0015; lance: Mi. xii. 0017).

Stein, *Serindia* pp. 465, 1193, 1209sq., 1210, 1212, pl. CXXXV; Whitfield, ACA vol. 3, pl. 98.

This figure of a warrior has been assembled from different parts found separately in the same shrine at Ming-oi. The shrine was decorated with friezes of relief figures attached to the walls on a wooden framework. This figure was one of a large group of soldiers made from moulds and originally brightly coloured. The eyebrows and eyeballs were black, the lips crimson and the face red and ochre. The helmet was red or green. The tunic of scale armour, made of iron or lacquered leather, is arranged in double rows coloured red, green or gilded. Many elements of the warrior's appearance, from the projection on the helmet to the long suit of armour, recall soldiers of Sassanian or Iranian type. RW, AF

151 Head of a Bodhisattva

From Ming-oi. 7th–8th century AD.

Stucco. H. 20.5cm. OA MAS 1082 (Mi. xv. 0010).

Stein, *Serindia* pp. 1197, 1217, pl. CXXIX; Whitfield, ACA vol. 3, pl. 101, fig. 130.

This head comes from shrine xv at Ming-oi, which was damaged by fire. Here Stein discovered some fine wood-carvings (*see* cat. no. 156) and stucco sculpture. The original colouring of the present head disappeared in the fire but the fine modelling remains undamaged. This head was probably part of a figure which belonged to a group of life-size or larger sculptures of Bodhisattvas. It is close to classical Gandharan sculpture with its half-closed eyes, pointed nose, prominent lined eyebrows and deeply sculpted lips. RW, AF

152

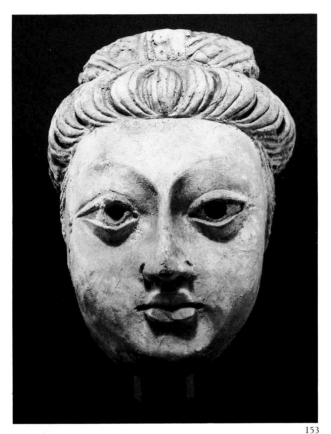

153

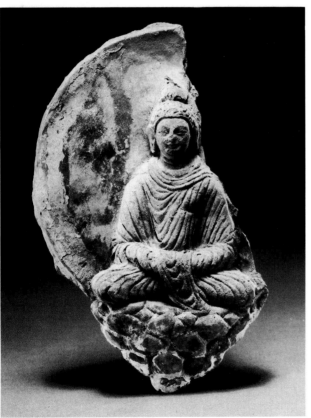

154

152 Head of a Bodhisattva

From Ming-oi. Tang dynasty, 8th–9th century AD.

Painted stucco. H. 30cm. OA MAS 1102 (Mi. xviii. 0010).

Stein, *Serindia* pp. 1199, 1220, pl. CXXXI; Whitfield, ACA vol. 3, pl. 102.

The Gandharan influence seen in the previous example clearly contrasts with the strong Chinese influence on the present head. This is evident in the square-shaped face, the heavier facial features, the eyes which curve down at both ends and the hair parted in the centre and falling in overlapping waves. RW, AF

153 Head of a Buddha

From Ming-oi. 6th–7th century AD.

Stucco. H. 22.8cm. OA MAS 1094 (Mi. xvii. 003).

Stein, *Serindia* pp. 1198, 1218, pl. CXXX; Whitfield, ACA vol. 3, pl. 103.

Stein found this finely finished, almost life-sized head together with similar heads in shrine xvii in the north-west portion of the Ming-oi site. The shrine was set apart from the rest of the neighbouring buildings and was raised on a high-walled terrace. The interior of the shrine was filled with hard-burned débris which contained no trace of the stucco bodies belonging to the heads. Stein suggested that they were insufficiently hardened in the fire that destroyed the shrine to have survived. However, Whitfield suggests that the heads may have been made separately from the bodies and hardened in the open, whereas the bodies may have been made *in situ*, so remaining softer and more vulnerable to destruction. RW, AF

154 Seated Buddha

From Ming-oi. 6th–7th century AD.

Clay plaque with traces of paint. H. 15cm.
OA MAS 1111 (Mi. xxiv. 001).

Stein, *Serindia* pp. 1190, 1222, pl. CXXXVII; Whitfield, ACA vol. 3, pl. 110.

This figure has a slender tapering torso and is seated on a base of lotus petals. The thick drapery folds of the Buddha's robe are shown with incised lines. One end of the robe falls over the hands touching the seat. The arrangement of the drapery folds and the proportions of the figure are similar to those of an ascetic Buddha in Cave 248 at Dunhuang of a Northern Wei date (*Chūgoku Sekkutsu, Tonkō Makkōkutsu,* vol. 1, pl. 80). This suggests a probable 6th-century date for the Ming-oi figure. RW, AF

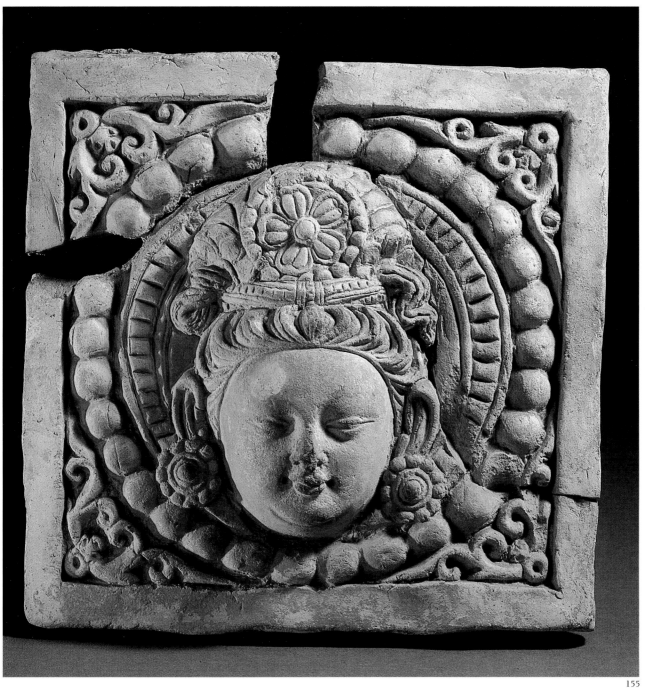

155

155 Head of a Bodhisattva

From Ming-oi. 6th–7th century AD.

Moulded clay tile. H. 22.5cm, W. 23.6cm.
OA MAS 1108 (Mi. xxiii. 1).

Stein, *Serindia* pp. 1189, 1198, 1200, 1210, 1218, 1221sq., pl.
CXXXIX; Whitfield, ACA vol. 3, pl. 112.

This Bodhisattva head is set in a roundel with a large petal border on a clay tile. In the Bodhisattva's hair, held by a twisted fillet inlaid with jewels, is a large lotus flower within a border of pearls. The tile seems to have been moulded in one piece to which details such as the sidelocks and pearl ear ornaments were added. The style of the face and hair is closely related to that of Gandharan sculpture. By the Sui dynasty (AD 581–618), the use of the pearl border had reached Dunhuang and was well established, so the mould for the tile clearly dates from the 6th century AD and the tile itself was presumably made shortly afterwards. RW, AF

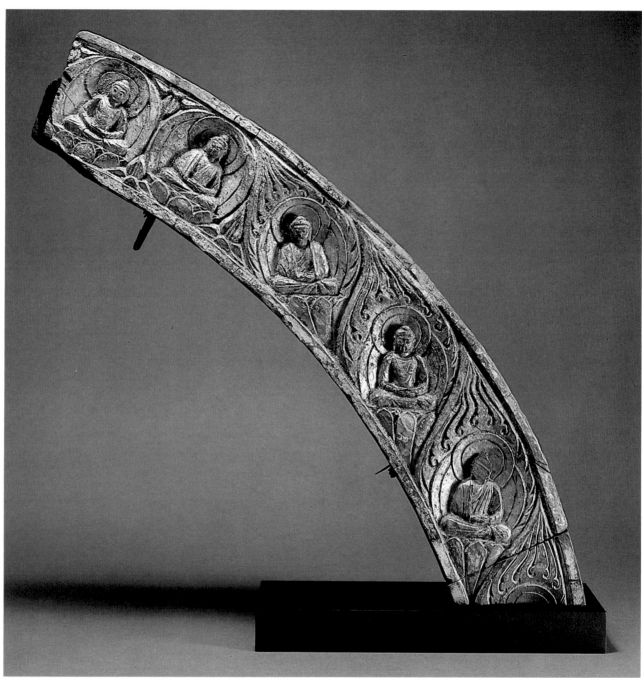

156

156 Part of a vesica

From Ming-oi. 6th–7th century AD.

Carved and gilt wood. H. 51.3cm, W. 12.2cm.
OA MAS 1090 (Mi. xv. 0029).

Stein, *Serindia* pp. 1197, 1217–18, pl. CXXVIII; Whitfield, ACA vol. 3, pl. 115.

This segment of a vesica would originally have surrounded a large Buddhist figure. Five meditating Buddhas are carved on it and gilding has been applied over a white ground. The section seen here would have formed roughly one-third of the upper section of the complete vesica. Other examples of carved and gilded wooden surrounds, from the sites at Subāshi and Duldur-ākhur near Kucha, are in the Pelliot collection in Paris (*Mission Paul Pelliot* IV, figs. L39, L41). A further piece comes from the Great Nirvana Cave at Kizil (Bhattacharya, 1977, fig. 35). RW, AF

157 Figure of a devata

From Ming-oi. 6th–7th century AD.

Stucco. H. 47cm. OA MAS 1012 (Mi. xi. 002).

Stein, *Serindia* pp. 1191, 1205, pl. CXXXIV; Whitfield, ACA vol. 3, pl. 96.

This figure of a devata, in Chinese *tianshen* (divinity), was one of a large number of stucco reliefs which Stein found in temple-cella xi in the north-west of the Ming-oi site. They were hardened, and thus preserved, by the fire which destroyed the temple. Such stucco figures would originally have been painted; there are traces of polychrome painting which have disappeared on all but a few pieces. The stucco reliefs would have been fixed to the walls of the cella by wooden posts whose position is marked by three rows of square holes. The lack of fragments of larger sculptures or image bases suggests that the temple's decoration must have consisted of relief friezes covering its walls. This standing devata is one of the most complete of the Ming-oi stucco sculptures.

Moulds were used extensively in the construction of these figures. The core of the figure was built up using many layers of clay over a matrix of bound reeds, and the moulded form was added as a final layer. Ornaments such as the earrings, three-beaded floral rosettes and strings of beads have been added as moulded appliqué decoration. The scarf around the shoulders frames the figure and masks the join to the wall. In this figure fire has destroyed the original reed core, leaving only its impression and that of its binding. Stein's original dating of most of the stuccos on this site as 8th century AD was based on his discovery of 8th-century coins in an adjoining cella. On stylistic grounds, however, Whitfield feels that the still close resemblance to Gandharan sculptural styles suggests an earlier 6th- to 7th-century date, and that coins would have continued to be deposited for as long as the site remained accessible to pilgrims.

RW, AF

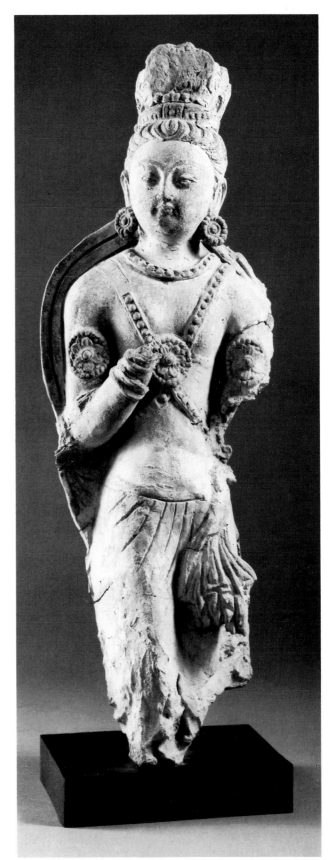

157

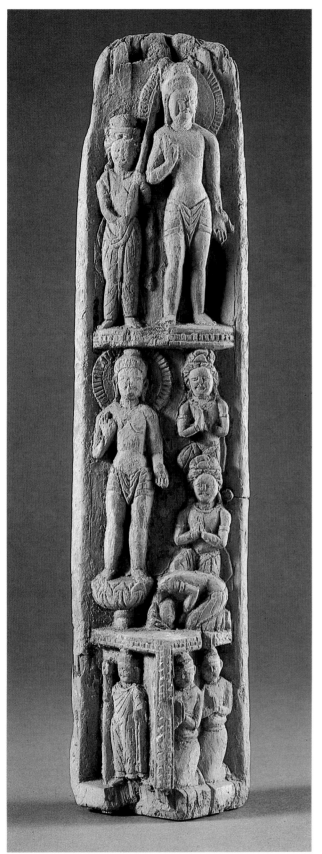

158

158 Leaf from a portable Buddhist shrine: The Vow before Dīpaṃkara

From Ming-oi. 5th–6th century AD.

Wood, with traces of pigment. H. 28.2cm.
OA MAS 1000 (Mi. ix. 001).

Stein, *Serindia* pp. 1189, 1203–4, pl. CXXVII; Whitfield, ACA vol. 3, pl. 117.

This is the lefthand section of a rare wooden travelling shrine. When closed it would have formed a cylinder which tapered to a point. The top scene shows a standing Buddha with an attendant holding a lotus flower. The principal scene is in the centre and depicts a standing Buddha on a lotus flower, two kneeling figures in attitudes of adoration and a third figure kneeling so that its head touches the ground below Buddha's feet. This scene may be identified as showing the Buddha as a Brahmin student spreading his hair in front of Dīpaṃkara Buddha, the twenty-fourth predecessor of Śākyamuni, and taking his Bodhisattva vow to become a Buddha himself (Zwalf, 1985, no. 15). Dīpaṃkara promised fulfilment of the vow and the Bodhisattva rose in a circle of light.

The lowest register of this leaf from the portable shrine shows a standing Buddha with a staff and two kneeling male donors on the right. Another comparable shrine, dating from the 9th century AD, was found at Gaochang by Le Coq (Le Coq, 1913, pl. 57c; *Along the Ancient Silk Routes*, no. 105). What remains is the lefthand leaf with seated figure of Kṣitigarbha holding a *cintāmaṇi*. In addition there would have been a central Buddha with another Bodhisattva on the righthand leaf. RW, AF

159 Buddha seated in meditation

From Khōra. 5th (?) century AD.

Wood, with traces of pigment. H. 16.3cm, W. 5.2cm.
OA MAS 981 (Khora. I. ii. 001).

Stein, *Serindia* pp. 1224, 1229, pl. XLVII; Whitfield, ACA vol. 3, pl. 119.

This beautiful piece was found in a small cella at Khōra in the Karashar Valley. The Buddha sits on a base and parts of the mandorla and nimbus still remain. The head is inclined forward and has high domed hair crowned by a distinct *uṣṇīṣa* (the cranial protuberance which is one of the Buddha's prominent physical features, thought to indicate wisdom); the earlobes are turned out. The Buddha's robe closely follows the contours of the body and is only evident from the raised collar and the folds which fall from the wrists and over the feet. The figure would originally have been entirely covered in polychrome painting which would to a large extent have obscured the roughness of the woodcarving. The same type of gentle meditating Buddha is found in early caves at Dunhuang, particularly Cave 259 of the Northern Wei period (AD 386–535). This Khōra figure is also very similar to a wooden figure of a Buddha found by Le Coq further west near the large stūpa at Tumshuk. This piece is now in the Museum of Indian Art in Berlin (Le Coq, 1922, vol. I, pl. 42; *Along the Ancient Silk Routes*, no. 47). RW, AF

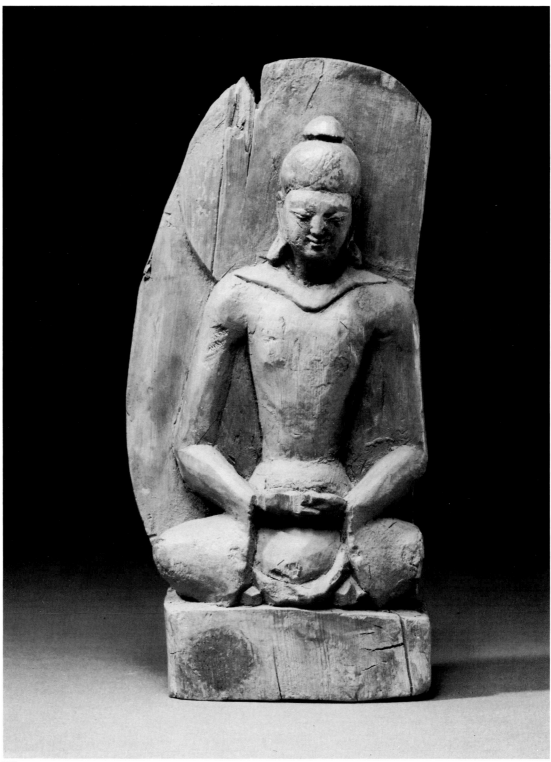

159

161

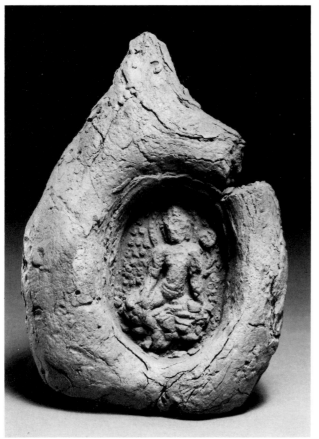

160

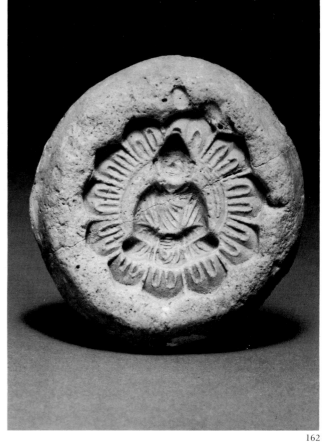

162

163A

163B

163C

163D

160 Votive plaque

From Kara-yantak, near Domoko. 8th century AD.

Terracotta. H. 12.7cm. OA MAS 474 (K.Y. I. 0011).

Stein, *Serindia* p. 1268.

One of the most common Buddhist votive objects was the impressed clay plaque such as this example of a Bodhisattva. It was found at Kara-yantak in the remains of a completely destroyed Buddhist shrine, probably abandoned at the end of the 8th century AD. The site was in an area of scrub-covered low sandy hillocks in the Domoko oasis on the southern Silk Route. AF

161 Votive plaques

From Karakhoto. 11th–12th century AD.

Terracotta. From left: D. 5cm; 5.4cm.
OA 1928.10–22.73, 74 (K.K. V. 087, K.K. V. 050).

Stein, *Innermost Asia* p. 500; Whitfield, ACA vol. 3, fig. 15.

These two clay relief plaques show a seated Buddha in a trefoil halo flanked on both sides by two stūpas. AF

162 Mould for a plaque with a seated Buddha

From Khādalik. 5th–6th century AD.

Stucco. D. 7.6cm. OA MAS 426 (Kha. ii. N. 0014).

Stein, *Serindia* pp. 158, 165, 190, pl. XVI; Whitfield, ACA vol. 3, fig. 52.

The use of moulds to produce parts of larger images was widespread in Central Asia. This one shows a small seated Buddha surrounded by lotus petals. Small images made from moulds like these were affixed to vesicas surrounding much larger figures. AF

163 Mould for casting spiral curls of hair, and curls from a similar mould; Mould for casting a bead and lotus petal border, and part of such a border

From Khādalik. *c*.6th century AD.

Stucco. Top (mould): 11.5 × 12.5 × 5cm.
Bottom (mould): 15.5 × 12 × 2.5cm.
From top left: OA MAS 410 (Kha. ii. 0076), OA MAS 421 (Kha. ii. N. 0010).
From bottom left: OA MAS 408 (Kha. ii. 0074), OA MAS 414 (Kha. ii. C. 004).

Stein, *Serindia* pp. 158, 164, 179, 187, 188, 190, pl. XVI; Whitfield, ACA vol. 3, figs. 51, 53.

Small elements such as locks of hair or beads and lotus petals were commonly moulded separately and applied to a large image or as decorative borders. AF

Chronology of Chinese dynasties

SHANG				*c.*1700–*c.*1027 BC
ZHOU	Western Zhou	*c.*1027–771 BC		*c.*1027–256
	Eastern Zhou	770–256		
	'Spring and Autumn' period	722–481		
	Warring States period	480–221		
QIN				221–207
HAN	Western Han	206 BC–AD 9		206 BC–AD 220
	Xin	9–25		
	Eastern Han	25–220		
THREE KINGDOMS	Shu (Han)	221–263		221–265
	Wei	220–265		
	Wu	222–280		
SOUTHERN (Six Dynasties)	Western Jin	265–316		265–581
	Eastern Jin	317–420		
	Liu Song	420–479		
	Southern Qi	479–502		
	Liang	502–557		
	Chen	557–589		
NORTHERN DYNASTIES	Northern Wei	386–535		
	Eastern Wei	534–550		
	Western Wei	535–557		
	Northern Qi	550–577		
	Northern Zhou	557–581		
SUI				581–618
TANG				618–906
FIVE DYNASTIES	Later Liang	907–922		907–960
	Later Tang	923–936		
	Later Jin	936–946		
	Later Han	946–950		
	Later Zhou	951–960		
Liao			907–1125	
Xixia			990–1227	
SONG	Northern Song	960–1126		960–1279
	Southern Song	1127–1279		
Jin			1115–1234	
YUAN				1280–1368
MING				1368–1644
QING				1644–1912
REPUBLIC				1912–1949
PEOPLE'S REPUBLIC				1949–

大英博物館所蔵西域美術目録

1

樹下説法図

唐時代（8世紀初）

2

報恩経変相図

唐時代（9世紀前半）

3

普賢菩薩像

唐時代（8世紀末～9世紀初）

4

千手千眼観世音菩薩図

唐時代（9世紀前半）

5

四観音文殊普賢図

唐時代　咸通五年（864年）

6

霊鷲山釈迦説法図断片

唐時代（8～9世紀）

7

二観世音菩薩像

唐時代（9世紀中頃）

8

景教人物図

唐時代（9世紀）

9

行道天王図

唐時代（9世紀）

10

天王像断片

唐時代（9世紀）

11

如意輪観音菩薩像

唐時代（9世紀後半）

12

観世音菩薩像

五代時代　天復十年（910年）銘

13

地蔵菩薩像

五代時代（10世紀初）

14

引路菩薩図

唐時代（9世紀末）

15

引路菩薩図

五代時代（10世紀初）

16

弥勒下生経変相図

唐時代末期～五代時代初期

（9世紀末～10世紀初）

17

普賢菩薩図

唐時代末期～五代時代初期

（9世紀末～10世紀初）

18

文殊菩薩図

唐時代末期～五代時代初期

（9世紀末～10世紀初）

19

地蔵菩薩図

北宋時代　建隆四年（963年）銘

20

地蔵十王図

五代時代（10世紀中頃）

21

観世音菩薩像

北宋時代　開宝四年壬申

（正しくは同五年：972年）銘

22

観世音菩薩・弥勒菩薩図

五代もしくは北宋時代

（10世紀中頃）

23

菩薩像

唐時代（9世紀）

24

金剛力士像

唐時代（9世紀末）

25

仏伝図断片 （別離・捜索）

唐時代（8世紀）

26

仏伝図 （燃燈仏授記・三苦・入胎）

唐時代（9世紀）

27

仏伝図（仏の七宝・九龍による灌水・七歩）

唐時代（9世紀）

28

仏伝図断片 （学習・武勇）

唐時代（8世紀～9世紀初）

29

仏伝図断片 （四門出遊）

唐時代（8世紀～9世紀初）

30

仏伝図 （別離・剃髪・苦行）

唐時代（8世紀～9世紀初）

31

菩薩像

唐時代（9世紀末）

32

菩薩像

唐時代（9世紀末）

33

地蔵菩薩像

唐時代（9世紀）

34

菩薩像

唐時代（9世紀初）

35

菩薩像 （蓮華手菩薩？）

唐時代（9世紀初）

36

金剛菩薩像

唐時代（9世紀初）

37

観世音菩薩像

唐時代（9世紀）

38

文殊菩薩像

唐時代（9世紀）

39

菩薩像

唐時代（9世紀末）

40

金剛力士像

唐時代（9世紀末）

41

金剛力士像

唐時代（9世紀末）

42

広目天像

唐時代（9世紀）

43

持国天像

唐時代（9世紀）

44

多聞天像

唐時代（9世紀）

45

日曜菩薩像幡

唐時代（8世紀）

46

花鳥文幡

唐時代（8世紀）

47

菩薩像長幡

五代時代（10世紀中頃）

48

菩薩像長幡

五代時代（10世紀中頃）

49

仏坐像長幡

五代時代（10世紀中頃）

50

観世音菩薩像幡

唐時代末期～五代時代初期
（9世紀末～10世紀初）

51

観世音菩薩像幡

唐時代末期～五代時代初期
（9世紀末～10世紀初）

52

観世音菩薩像

唐時代（9世紀初～中頃）

53

菩薩像 （虚空蔵菩薩？）

唐時代（9世紀初～中頃）

54

迦理迦尊者像

唐時代（9世紀初～中頃）

195

55
浄土図断片
唐時代（8～9世紀）

56
高僧像
唐時代（9世紀末～10世紀初）

57
水月観音図
五代時代（10世紀中頃）

58
維摩経変相図
五代時代（10世紀中頃）

59
観世音菩薩像
唐時代末期～五代時代（9世紀末～10世紀初）

60
獅子図
唐時代（9世紀末）

61
馬・駱駝図（文書紙背）
唐時代（9世紀末）

62
烏枢沙摩明王像
唐時代（9世紀末）

63
人龍図
唐時代（9世紀）

64
北方神星・計都星像護符
五代時代（10世紀中頃）

65
地蔵十王図画巻（断簡）
五代時代（10世紀）

66
千手千眼観世音菩薩像
五代時代（10世紀中頃）

67
観世音菩薩像
五代時代（10世紀中頃）

68
薬師如来・如意輪観音・金剛蔵菩薩像
五代時代（10世紀中頃）

69
護諸童子女神像（護符）
唐時代（9世紀）

70
仏五尊像型紙
五代時代～北宋時代初期（10世紀中頃）

71
仏坐像型紙
五代時代～北宋時代初期（10世紀中頃）

72
維摩経変相図
唐時代（10世紀）

73
手印図巻
唐時代（9世紀末）

74
観相図巻断簡
唐時代（9世紀末）

75
仏名経
五代時代（10世紀初）

76
仏説法図（金剛経冊子口絵）
五代時代（10世紀初）

77
二天王像（仏説廻向輪経冊子口絵）
唐時代（9世紀）

78
摩利支天図（冊子口絵）
唐時代末期～五代時代初期
（9世紀末～10世紀初）

79
仏説続命経冊子
唐時代～五代時代初期
（9世紀末～10世紀初）

80
仏坐像版画
唐時代（8～9世紀）

81
仏坐像版画
唐時代（9世紀）

82
観世音菩薩像版画
五代時代（10世紀）

83, 84
観世音菩薩像版画
五代時代　晋開運四年丁未（947年）銘

85
毘沙門天像版画
五代時代　晋開運四年丁未（947年）銘

86
光明仏・文殊菩薩像版画
五代時代（10世紀中頃）

87
大隨求陀羅尼輪曼荼羅版画
北宋時代　太平興国五年（980年）銘

88
刺繍霊鷲山釈迦説法図
敦煌将来
唐時代（8世紀）

89
袈裟
敦煌将来
唐時代（8～9世紀）

90
垂幕
敦煌将来
唐時代（8～9世紀）

91
経袱
敦煌将来
唐時代（8世紀）

92
龍鳳文経錦断片
敦煌　漢代国境の烽火台址出土
漢時代

93
龍文経錦断片（幡頭断片？）
敦煌将来　3～5世紀

94
経錦断片　敦煌烽火台址出土
後漢時代（25～220年）

95
毛毯断片
楼蘭将来
3世紀末～4世紀初

96, 97
幡頭断片
敦煌将来
唐時代（8世紀）

98
綾地花鳥文刺繍袋
（但し，縫糸を除去して展開）
敦煌将来　　　唐時代（9～10世紀）

99
刺繍仏立像
敦煌将来
唐時代（7～8世紀）

100, 101
羅地花文刺繍断片
・綾地花文刺繍断片
敦煌将来　　唐時代（8～9世紀）

102
紋羅断片・平絹断片
敦煌将来
唐時代（8～9世紀）

103
羅地花鳥獣文刺繍断片
敦煌将来
唐時代（おそらく9世紀頃）

104
平絹地鹿文夾纈断片（絹幡断片）
敦煌将来
唐時代（9世紀）

105
平絹地連珠双鳥唐草文夾纈断片
（幡頭）
敦煌将来　　　唐時代（8～9世紀）

106
羅地花鳥文夾纈垂飾（垂幕の一部）
敦煌将来
唐時代（8～9世紀）

107
平絹地小花文夾纈断片
（絹幡断片・吊輪）
敦煌将来　　　唐時代（8世紀）

108
平絹地花文夾纈断片
敦煌将来
唐時代（8～9世紀）

109
平絹地小花文夾纈断片
（絹幡断片・吊輪）
敦煌将来　　　唐時代（8～9世紀）

110
平絹地小馬文夾纈断片（絹幡断片）
敦煌将来
唐時代（8～9世紀）

111
彩画・剋絲（綴織）幡頭
敦煌将来
唐時代（8世紀）

112
剋絲（綴織）断片
敦煌将来
唐時代（8世紀）

113
孔雀文二色綾幡頭
敦煌将来
唐時代（8～9世紀）

114
綾地彩画仏坐像幡頭
敦煌将来
五代時代（10世紀）

115
木彫建築部材
楼蘭出土
3世紀頃

116
浮彫花文梁（はり）
楼蘭出土
3世紀頃

117
浮彫花唐草文梁
楼蘭出土
3世紀頃

118
棚干
楼蘭出土
3世紀頃

119
肘木
楼蘭出土
漢時代 （3世紀頃）

120
木彫仏塔尖端装飾
楼蘭出土
3世紀頃

121
建築部材
カダリク出土
6世紀頃

122
浮彫花文梁
カダリク出土
6世紀頃

123
浮彫飾板
ニヤ将来
3世紀頃

124
木彫家具脚部 （小卓もしくは祭壇）
ニヤ将来
1〜4世紀

125
塑造仏頭
ミーラン将来
5世紀

126
壁画断片
カダリク将来
6世紀頃

127
彩塑仏頭
ダラブザン・ドン （ドモコ近郊）将来
唐時代 （7〜8世紀）

128
板絵仏像
カダリク将来
6世紀頃

129
半肉塑像 （仏立像）
カラサイ将来
5世紀

130
板絵毘廬遮那仏像
ファルハード・ベグ・ヤイラキ将来
6世紀頃

131
板絵三神像
ダンダン・ウイリク将来
6世紀頃

132
板絵養蚕西漸伝説図
ダンダン・ウイリク将来
6世紀頃

133
板絵騎乗人物図
ダンダン・ウイリク将来
6世紀頃

134
板絵シヴァ神像・絹の守護神像
ダンダン・ウイリク将来
6世紀頃

135
板絵仏立像
ダンダン・ウイリク将来
6世紀頃

136
塑造光背断片
ダンダン・ウイリク将来
6〜7世紀

137
陶製寺院模型断片
ヨトカン将来
4〜5世紀

138
貼花文壺
ヨトカン将来
1〜4世紀

139
獣耳小壺
ヨトカン将来
1〜4世紀

140
象牙ミトゥナ像
ホータン将来 （おそらく西北インド製）
6〜7世紀

141
フェルト製靴
マザー・ター将来
8世紀末〜9世紀中頃

142
婦人像木俑
アスターナ将来
高昌国時代 （499〜640年）

143
絹製刺繍飾履物
高昌将来
11〜12世紀

144
木芯泥造馬俑
アスターナ将来
唐時代 （8世紀中頃）

145
練菓子
アスターナ将来
唐時代 （8世紀中頃）

146
木製機織用梳具 （筬）
ホータン将来
3世紀

147
木彫神像
敦煌燧火台址出土
漢時代 （前1世紀）

148

紙製花飾り

敦煌将来

唐時代（9〜10世紀）

149

壁画　窟院修業僧図

カラシャール（ミン・オイ）将来

ウイグル時代（8〜9世紀）

150

塑造武人像

カラシャール（ミン・オイ）将来

6〜7世紀

151

塑造菩薩頭部

カラシャール（ミン・オイ）将来

7〜8世紀

152

彩塑菩薩頭部

カラシャール（ミン・オイ）将来

唐時代（8〜9世紀）

153

塑造仏頭

カラシャール（ミン・オイ）将来

6〜7世紀

154

塑造仏坐像

カラシャール（ミン・オイ）将来

6〜7世紀

155

浮彫菩薩像磚

カラシャール（ミン・オイ）将来

6〜7世紀

156

木彫金彩仏坐像光背断片

カラシャール（ミン・オイ）将来

6〜7世紀

157

塑造天部像

カラシャール（ミン・オイ）将来

6〜7世紀

158

木彫彩色厨子断片

カラシャール（ミン・オイ）将来

5〜6世紀

159

木彫彩色仏坐像

コーラ将来

5世紀

160

土製型押像

カラ・ヤンタク将来

唐時代（8世紀）

161

土製型押坐仏像

カラホト出土

11〜12世紀

162

仏坐像陶型

カダリク将来

6世紀頃

163A, B

螺髪陶型と陶製螺髪

カダリク将来
6世紀頃

163C, D

蓮弁文縁飾陶型とその製品

カダリク将来
6世紀頃

List of exhibits by registration number

Catalogue entry numbers are listed below alongside their British Museum registration numbers, first in catalogue order and then in order of registration number, as an aid to finding and identifying individual objects within both the exhibition and this catalogue.

As a general guide, entry numbers 1–87 refer to paintings and prints from Cave 17 at Dunhuang; nos. 88–114 are non-painting textile items found in the same cave; and nos. 115–163 consist of a variety of finds from other sites.

Exhibits in catalogue order

Catalogue number	BM registration number	Catalogue number	BM registration number	Catalogue number	BM registration number
1	1919.1–1.06	26	1919.1–1.096	51	1919.1–1.0144
2	1919.1–1.01	27	1919.1–1.099	52	1919.1–1.0160
3	1919.1–1.0131	28	1919.1–1.090	53	1919.1–1.0168*
4	1919.1–1.035	29	1919.1–1.088	54	1919.1–1.0169*
5	1919.1–1.05	30	1919.1–1.097	55	1919.1–1.0178*
6	1919.1–1.020	31	1919.1–1.0136	56	1919.1–1.0163
7	1919.1–1.03	32	1919.1–1.0125*	57	1919.1–1.015
8	1919.1–1.048	33	1919.1–1.0118	58	1919.1–1.031*
9	1919.1–1.045	34	1919.1–1.0101	59	1919.1–1.0157*
10	1919.1–1.069	35	1919.1–1.0102	60	1919.1–1.0169
11	1919.1–1.010	36	1919.1–1.0103	61	1919.1–1.077
12	1919.1–1.014	37	1919.1–1.0130	62	1919.1–1.040
13	1919.1–1.04	38	1919.1–1.0141	63	1919.1–1.0157
14	1919.1–1.047	39	1919.1–1.0139	64	1919.1–1.0170
15	1919.1–1.046	40	1919.1–1.0132	65	1919.1–1.080
16	1919.1–1.011	41	1919.1–1.0123	66	1919.1–1.0159
17	1919.1–1.033	42	1919.1–1.0106	67	1919.1–1.030*
18	1919.1–1.034	43	1919.1–1.0129	68	1919.1–1.071
19	1919.1–1.019	44	1919.1–1.0138	69	1919.1–1.0177
20	1919.1–1.023	45	1919.1–1.0121	70	1919.1–1.072
21	1919.1–1.052	46	1919.1–1.0127	71	1919.1–1.073(1)
22	1919.1–1.059	47	1919.1–1.0214(2)	72	1919.1–1.076
23	1919.1–1.0120	48	1919.1–1.0205	73	1919.1–1.083*
24	1919.1–1.0134	49	1919.1–1.0195	74	1919.1–1.042
25	1919.1–1.095	50	1919.1–1.0142	75	1919.1–1.074

Catalogue number	BM registration number	Catalogue number	BM registration number	Catalogue number	BM registration number
76	1919.1–1.0212	109	MAS 932	140	1907.11–11.49
77	1919.1–1.0208	110	MAS 885	141	MAS 495
78	1919.1–1.0207	111	MAS 905	142	1928.10–22.102
79	1919.1–1.0209	112	MAS 906a,b	143	1928.10–22.197
80	1919.1–1.0256		MAS 907	144	1928.10–22.117
81	1919.1–1.0254		MAS 908a,b	145	1928.10–22.123
82	1919.1–1.0234	113	MAS 889		1928.10–22.124
83	1919.1–1.0242	114	MAS 888		1928.10–22.125
84	1919.1–1.0244	115	MAS 699		1928.10–22.128
85	1919.1–1.0245	116	MAS 704		1928.10–22.130
86	1919.1–1.0239	117	MAS 707		1928.10–22.132
87	1919.1–1.0249	118	MAS 729	146	1925.6–19.73
88	Ch. 00260		MAS 708		1925.6–19.75
89	MAS 856	119	1928.10–22.11	147	MAS 739
90	MAS 855	120	MAS 706		MAS 740
91	MAS 858	121	MAS 435	148	MAS 913
92	MAS 820	122	MAS 391		1919.1–1.230
93	MAS 926a,b	123	MAS 535	149	1919.1–1.0279
94	MAS 793a,b	124	1907.11–11.85	150	MAS 1061
95	MAS 693	125	MAS 627		MAS 1065
96	MAS 862a,b	126	1919.1–1.0261	151	MAS 1082
97	MAS 863		1919.1–1.0268	152	MAS 1102
98	MAS 857		1919.1–1.0275	153	MAS 1094
99	MAS 911	127	MAS 452	154	MAS 1111
100	MAS 912	128	MAS 419	155	MAS 1108
101	MAS 915	129	MAS 340	156	MAS 1090
102	MAS 955		MAS 344	157	MAS 1012
103	1919.1–1.05	130	MAS 459	158	MAS 1000
	1919.1–1.052*	131	1907.11–11.72	159	MAS 981
104	MAS 875	132	1907.11–11.73	160	MAS 474
105	MAS 876	133	1907.11–11.70	161	1928.10–22.73
	MAS 877	134	1907.11–11.71		1928.10–22.74
106	MAS 884	135	1907.11–11.67	162	MAS 426
107	MAS 931	136	1907.11–11.62	163	MAS 408
108	MAS 878a,b	137	MAS 5		MAS 410
		138	MAS 4		MAS 414
		139	1907.11–11.39		MAS 421

Exhibits in order of registration number

BM registration number	Catalogue number	BM registration number	Catalogue number	BM registration number	Catalogue number
Ch. 00260	88	MAS 858	91	MAS 1111	154
MAS 4	138	MAS 862a,b	96	1907.11–11.39	139
MAS 5	137	MAS 863	97	1907.11–11.49	140
MAS 340	129	MAS 875	104	1907.11–11.62	136
MAS 344	129	MAS 876	105	1907.11–11.67	135
MAS 391	122	MAS 877	105	1907.11–11.70	133
MAS 408	163	MAS 878a,b	108	1907.11–11.71	134
MAS 410	163	MAS 884	106	1907.11–11.72	131
MAS 414	163	MAS 885	110	1907.11–11.73	132
MAS 419	128	MAS 888	114	1907.11–11.85	124
MAS 421	163	MAS 889	113	1919.1–1.01	2
MAS 426	162	MAS 905	111	1919.1–1.03	7
MAS 435	121	MAS 906a,b	112	1919.1–1.04	13
MAS 452	127	MAS 907	112	1919.1–1.05	5
MAS 459	130	MAS 908a,b	112	1919.1–1.05	103
MAS 474	160	MAS 911	99	1919.1–1.06	1
MAS 495	141	MAS 912	100	1919.1–1.010	11
MAS 535	123	MAS 913	148	1919.1–1.011	16
MAS 627	125	MAS 915	101	1919.1–1.014	12
MAS 693	95	MAS 926a,b	93	1919.1–1.015	57
MAS 699	115	MAS 931	107	1919.1–1.019	19
MAS 704	116	MAS 932	109	1919.1–1.020	6
MAS 706	120	MAS 955	102	1919.1–1.023	20
MAS 707	117	MAS 981	159	1919.1–1.030*	67
MAS 708	118	MAS 1000	158	1919.1–1.031*	58
MAS 729	118	MAS 1012	157	1919.1–1.033	17
MAS 739	147	MAS 1061	150	1919.1–1.034	18
MAS 740	147	MAS 1065	150	1919.1–1.035	4
MAS 793a,b	94	MAS 1082	151	1919.1–1.040	62
MAS 820	92	MAS 1090	156	1919.1–1.042	74
MAS 855	90	MAS 1094	153	1919.1–1.045	9
MAS 856	89	MAS 1102	152	1919.1–1.046	15
MAS 857	98	MAS 1108	155	1919.1–1.047	14

BM registration number	Catalogue number	BM registration number	Catalogue number	BM registration number	Catalogue number
1919.1–1.048	8	1919.1–1.0136	31	1919.1–1.0275	126
1919.1–1.052	21	1919.1–1.0138	44	1919.1–1.0279	149
1919.1–1.052*	103	1919.1–1.0139	39	1919.1–1.230	148
1919.1–1.059	22	1919.1–1.0141	38	1925.6–19.73	146
1919.1–1.069	10	1919.1–1.0142	50	1925.6–19.75	146
1919.1–1.071	68	1919.1–1.0144	51	1928.10–22.11	119
1919.1–1.072	70	1919.1–1.0157	63	1928.10–22.73	161
1919.1–1.073(1)	71	1919.1–1.0157*	59	1928.10–22.74	161
1919.1–1.074	75	1919.1–1.0159	66	1928.10–22.102	142
1919.1–1.076	72	1919.1–1.0160	52	1928.10–22.117	144
1919.1–1.077	61	1919.1–1.0163	56	1928.10–22.123	145
1919.1–1.080	65	1919.1–1.0168*	53	1928.10–22.124	145
1919.1–1.083*	73	1919.1–1.0169	60	1928.10–22.125	145
1919.1–1.088	29	1919.1–1.0169*	54	1928.10–22.128	145
1919.1–1.090	28	1919.1–1.0170	64	1928.10–22.130	145
1919.1–1.095	25	1919.1–1.0177	69	1928.10–22.132	145
1919.1–1.096	26	1919.1–1.0178*	55	1928.10–22.197	143
1919.1–1.097	30	1919.1–1.0195	49		
1919.1–1.099	27	1919.1–1.0205	48		
1919.1–1.0101	34	1919.1–1.0207	78		
1919.1–1.0102	35	1919.1–1.0208	77		
1919.1–1.0103	36	1919.1–1.0209	79		
1919.1–1.0106	42	1919.1–1.0212	76		
1919.1–1.0118	33	1919.1–1.0214(2)	47		
1919.1–1.0120	23	1919.1–1.0234	82		
1919.1–1.0121	45	1919.1–1.0239	86		
1919.1–1.0123	41	1919.1–1.0242	83		
1919.1–1.0125*	32	1919.1–1.0244	84		
1919.1–1.0127	46	1919.1–1.0245	85		
1919.1–1.0129	43	1919.1–1.0249	87		
1919.1–1.0130	37	1919.1–1.0254	81		
1919.1–1.0131	3	1919.1–1.0256	80		
1919.1–1.0132	40	1919.1–1.0261	126		
1919.1–1.0134	24	1919.1–1.0268	126		

Selected bibliography

Akiyama Terukazu, 'The Tun-huang Caves and their Wall Paintings', trans. Alexander C. Soper, *Arts of China II, Buddhist Cave Temples: New researches*, Tokyo and Palo Alto, 1969.

Along the Ancient Silk Routes: see Metropolitan Museum of Art

Andrews, F. H., *Catalogue of Wall Paintings from Ancient Shrines in Central Asia and Sīstān Recovered by Sir Aurel Stein*, Delhi, 1933.

Andrews, F. H., *Descriptive Catalogue of Antiquities Recovered by Sir Aurel Stein during His Explorations in Central Asia, Kansu and Eastern Iran*, Delhi, 1935.

Andrews, F. H., *Wall Paintings from Ancient Shrines in Central Asia Recovered by Sir Aurel Stein*, 2 vols, London, 1948.

Bannières: see Mission Paul Pelliot

Beal, Samuel (trans.), *Si-Yu-Ki: Buddhist Records of the Western World*, 2 vols, London, 1884; 1906.

Becker, John, *Pattern and Loom: A practical study of the development of weaving techniques in China, Western Asia and Europe*, Copenhagen, 1987.

Bergmann, Folke, 'Loulan Wood-carvings and Small Finds Discovered by Sven Hedin', *Bulletin of the Museum of Far Eastern Antiquities* (Stockholm), no. 7 (1935), pp. 71–144.

Bhattacharya, Chhaya, *Art of Central Asia (with special reference to wooden objects from the Northern Silk Route)*, New Delhi, 1977.

Binyon, Laurence, *A Catalogue of Japanese and Chinese Woodcuts in the British Museum*, London, 1916.

British Museum, *Guide to an exhibition of paintings, manuscripts and other archaeological objects collected by Sir Aurel Stein, K.C.I.E. in Chinese Turkestan*, British Museum, London, 1914.

Bussagli, Mario, *Painting of Central Asia*, Geneva, 1963; London, 1978.

Chavannes, Édouard, *Les documents chinois découverts par Aurel Stein dans les sables du Turkestan chinois*, Oxford, 1913.

Chūgoku Sekkutsu, Tonkō Makkōkutsu: see Dunhuang Research Institute

Drège, Jean-Pierre, 'Les Cahiers des Manuscrits de Touen-houang', *Contributions aux Études sur Touen-houang*, ed. Michel Soymié, Genève–Paris, 1979, pp. 17–28.

Dunhuang Research Institute (ed.), *Chūgoku Sekkutsu, Tonkō Makkōkutsu* (Chinese Cave Temples series: The Mogao Caves at Dunhuang), 5 vols, Tokyo, 1980–82.

Dunhuang Research Institute (ed.), *Dunhuang bihua* (Dunhuang Wall Paintings), Beijing, 1959.

Dunhuang Research Institute (ed.), *Dunhuang cai shuo* (Dunhuang Painted Sculptures), Beijing, 1978.

Fairbank, J. K., Reischauer, E. O. and Craig, A. M., *East Asia: Tradition and transformation*, London, 1973.

The Flying Devis of Dunhuang, Beijing, 1980.

Getty, Alice, *The Gods of Northern Buddhism*, Oxford, 1914; Tokyo, 1962; Rutland, Vermont and Tokyo, 1977.

Giles, Lionel, *Descriptive Catalogue of the Chinese Manuscripts from Tun-huang in the British Museum*, London, 1957.

Gray, Basil and Vincent, J. B., *Buddhist Cave Paintings at Tun-huang*, London, 1959.

Gropp, Gerd, *Archäologische Funde aus Khotan Chinesisch-Ostturkestan*, Die Trinkler-Sammlung im Übersee-Museum Bremen, Bremen, 1974.

Hou Ching-lang, 'Physionomie d'après le teint sous la dynastie des T'ang (une étude sur le manuscrit P.3390)', *Contributions aux Études sur Touen-houang*, ed. Michel Soymié, Genève–Paris, 1979, pp. 55–70.

Jao Tsung-yi and Demiéville, Paul, (preface), *Peintures monochromes de Dunhuang*, 3 fascicules, Paris, 1978.

Klimburg-Salter, Deborah (ed.), *The Silk Road and the Diamond Path: Esoteric Buddhist art on the Trans-Himalayan trade routes*, Los Angeles, 1982.

Le Coq, Albert von, *Die buddhistische Spätantike in Mittelasien*, vols. 1–5, Berlin, 1922–6.

Le Coq, Albert von, *Chotscho: Koeniglich Preussische Turfan-Expeditionen*, Berlin, 1913.

Ma Shichang, 'Guanyu Dunhuang cangjingdong de jige wenti' (A Few Questions about the Sealed Library at Dunhuang), *Wenwu*, no. 12 (1978), pp. 21–33.

Maspéro, Henri, *Les documents chinois de la troisième expédition de Sir Aurel Stein en Asie centrale*, London, 1953.

Matsumoto Eiichi, *Tonkōga no kenkyū* (Research on Dunhuang Paintings), 2 vols, Tokyo, 1937.

Matsumoto Kaneo, *Shōsō-in no senshoku* (Textiles of the Shōsō-in), *Nihon no Bijutsu* (Tokyo), no. 102, 1974.

Metropolitan Museum of Art, *Along the Ancient Silk Routes: Central Asian art from the West Berlin State Museums*, New York, 1982.

Mirsky, Jeannette, *Sir Aurel Stein: Archaeological explorer*, Chicago and London, 1977.

Mission Paul Pelliot (M. Hallade and S. Gaulier), *IV, Douldour-Aqour et Soubachi*, Paris, 1982.

Mission Paul Pelliot (K. Riboud, G. Vial and M. Hallade), *XIII, Tissus de Touen-houang conservés au Musée Guimet et à la Bibliothèque Nationale*, Paris, 1970.

Mission Paul Pelliot, XIV, XV, Bannières et peintures de Touen-houang conservées au Musée Guimet, 2 vols, Paris, 1974, 1976.

Nanjiô, B., *A Catalogue of the Chinese Translation of the Buddhist Tripitaka*, Oxford, 1883.

Oldenburg, S., *Russkaya Turkestanskaya Ekspedicija 1909–1910 goda*, St Petersburg, 1914.

Oldham, C. E. A. W., 'Sir Aurel Stein', *Proceedings of the British Academy*, vol. 29 (1943).

Shepherd, D. G. and Henning, W. B., 'Zandanījī Identified?' *Aus der Welt der Islamischen Kunst, Kühnel Festschrift*, Berlin, 1959, pp. 15–40.

Shi Weixiang, 'Liu Sahe yu Dunhuang Mogaoku' (Liu Sahe and the Mogao Caves at Dunhuang), *Wenwu*, no. 6 (1983), pp. 5–13.

Shōsō-in no garasu (Glass in the Shōsō-in), Tokyo, 1965.

Shōsō-in no kaiga (Paintings in the Shōsō-in), Tokyo, 1968.

Shōsō-in no senshoku: see Matsumoto Kaneo

Sichou zhilu: Han Tang zhiwu (The Silk Road: Textiles of the Han to Tang dynasties), Beijing, 1972.

Soper, Alexander C., *Literary Evidence for Early Buddhist Art in China*, Ascona, 1959.

Soper, Alexander C., 'Representations of Famous Images at Tun-huang', *Artibus Asiae*, vol. XXVII (1964–5), pp. 349–64.

Stein, M. Aurel, *Ancient Khotan: Detailed report of archaeological explorations in Chinese Turkestan*, 2 vols, Oxford, 1907.

Stein, M. Aurel, *Innermost Asia: Detailed report of explorations in Central Asia, Kansu and Eastern Iran*, 4 vols, Oxford, 1928.

Stein, M. Aurel, *On Ancient Central Asian Tracks: Brief narrative of three expeditions in Innermost Asia and North-Western Kansu*, Chicago, 1974.

Stein, M. Aurel, *Ruins of Desert Cathay: Personal narrative of explorations in Central Asia and Westernmost China*, 2 vols, London, 1912.

Stein, M. Aurel, *Sand-buried Ruins of Khotan: Personal narrative of a journey of archaeological and geographical exploration in Chinese Turkestan*, London, 1903.

Stein, M. Aurel, *Serindia: Detailed report of explorations in Central Asia and Westernmost China*, 5 vols, Oxford, 1921.

Stein, M. Aurel, *The Thousand Buddhas: Ancient Buddhist paintings from the cave-temples of Tun-huang on the Western Frontier of China*, London, 1921.

Tang Yongtai gongzhu mu bihua ji (Selection of Paintings from the Tomb of Princess Yongtai of the Tang), Beijing, 1963.

Tissus de Touen-houang: see Mission Paul Pelliot

Waley, Arthur, *A Catalogue of Paintings Recovered from Tun-huang by Sir Aurel Stein*, London, 1931.

Whitfield, Roderick, *The Art of Central Asia: The Stein collection in the British Museum*, vol. 1 (Paintings from Dunhuang), vol. 2 (Paintings from Dunhuang), vol. 3 (Textiles, sculpture and other arts), Tokyo, 1982–5.

Whitfield, Roderick, 'The Monk Liu Sahe and the Dunhuang Paintings', *Orientations*, March 1989, pp. 64–70.

Williams, Joanna, 'The Iconography of Khotanese Painting', *East and West* (I.S.M.E.O.), no. 23 (1973), pp. 109–54.

Xia Nai, *Jade and Silk of Han China*, trans. and ed. Chu-tsing Li, Lawrence, Kansas, 1983.

Xia Nai, *Kaoguxue he keji shi* (Archaeology and the History of Technology), *Kaoguxue zhuankan, jiazhong* no. 14, Beijing, 1979.

Xuanzang, *Da Tang xiyu ji*, Shanghai, 1977.

Zhongguo meishu quanji: Gongyi meishu bian 6: Yin ran zhixiu (shang), Beijing, 1987.

Zürcher, Erik, *The Buddhist Conquest of China*, 2 vols, Leiden, 1959.

Zwalf, W. (ed.), *Buddhism: Art and faith*, London, 1985.

Zwalf, W., *Heritage of Tibet*, London, 1981.

Index